EDWARD BOND

BONDIAN DRAMA AND YOUNG AUDIENCE

Edited by

Uğur Ada

Tokat Gaziosmanpasa University, Türkiye

Foreword by Tony Coult

with

Author's Note by Edward Bond

Series in Performing Arts

VERNON PRESS

In the Americas:	*In the rest of the world:*
Vernon Press	Vernon Press
1000 N West Street, Suite 1200,	C/Sancti Espiritu 17,
Wilmington, Delaware 19801	Malaga, 29006
United States	Spain

Series in Performing Arts

Library of Congress Control Number: 2023938922

ISBN: 978-1-64889-913-3

Also available: 978-1-64889-700-9 [Hardback]; 978-1-64889-765-8 [PDF, E-Book]

Contents

Acknowledgements

This book is based on the research conducted on Edward Bond's latest plays, primarily written for young audiences from the 1990s onwards. This book introduces recent studies by researchers from different countries, including Britain, Türkiye, Germany, Taiwan, and Spain, among others. The variety of international researchers enables diverse, authentic voices and presents a broader perspective on Bond's plays which are staged all around the world.

I would like to acknowledge the extraordinary debt to British playwright Edward Bond. I would not be able to complete the book without his great support and encouragement. He followed the process, gave feedback to the chapters, and enabled communication among researchers worldwide. It is a great pleasure for me to collaborate with him and share the hope for the future of humanity through drama.

I would like to express my special thanks to Tony Coult, whom I benefited from his research on Edward Bond during my Ph.D. The book will be incomplete without his contribution, which shares his valuable experiences in the foreword of the book. He also created opportunities to get in touch with the other researchers studying Edward Bond's plays. That was enormously helpful in leading an international perspective for the book.

I am grateful to the researchers and colleagues for their time and efforts they provided during the publication process. The book would not have been possible without their contribution. I owe an enormous debt of gratitude for their trust and support. The valuable advice and suggestions were really constructive and encouraging during the process.

I would like to thank the editorial board of Vernon Press. As an independent publisher of academic books, they enabled enough time and support to develop and complete the book project. Their patience with the extended deadlines kept me going throughout the process.

Edward Bond: Bondian Drama and Young Audience is the latest academic work of a longtime study beginning with my Ph.D. thesis on Big Brum plays of Edward Bond and including several published research papers on Bondian Drama and a book on Theatre in Education. I could not have undertaken this journey without my lifelong partner Ayşe Derya AKSOY ADA and my son Deniz Kağan ADA. They make both the journey and destination worthwhile.

As one last word, I want to dedicate this book to my beloved parents, Aysel & Hüseyin ADA.

Contributors

Abir AL-LAHAM is a Ph.D. candidate and lecturer at the English department of Heidelberg University. Abir's research is an analysis of the influence of Arabic and Muslim culture on contemporary British drama. Her further academic interests are the effects of colonization on the contemporary discourse surrounding race, as well as the politics of religion in contemporary society. She has recently published a contribution to the essay collection *Finance, Terror and Science on Stage: Current Public Concerns in 21-century British Drama.*

Chien-Cheng CHEN is an Assistant Professor in the Department of Theatre Arts at Taipei National University of the Arts, Taiwan. He holds a Ph.D. in Drama, Theatre, and Dance from Royal Holloway, University of London.

Cüneyt ÖZATA is an Associate Professor Doctor at the Department of English Language and Literature at Ordu University in Türkiye. He teaches Drama and Theatre courses and deals with English for specific purposes. In 2005, he embarked on his doctoral education; he also holds a master's degree from Ataturk University, majoring in British literature. His greatest strength is his performance, in particular 20th British Drama. He has presented and published some of his studies in several conferences and journals, both national and internationally wide.

Edward BOND is a working-class English playwright born in 1934 who left state education aged 15 to work in factories and offices. Among his formative experiences was being sent away as a child from his London home to avoid German bombing, only to return to a London being destroyed by Hitler's V1 and V2 missiles. His drama has been performed on every continent, starting in 1963 in London and continuing to the present day. Working for and with young people, both as citizens and artists, has always been a special site of activity for Bond. All his work, whether plays, poetry, or theoretical writing about drama, addresses the most urgent questions about the social and political crises faced by the human species.

Gamze ŞENTÜRK is currently working as an Assistant Professor at Munzur University in Türkiye. Her teaching and research areas are British theatre, Anthony Neilson, Sarah Daniels, Caryl Churchill, gender studies, film studies, and performance studies. She presented several papers on contemporary British theatre and feminist theatre at (inter)national conferences.

Kadriye BOZKURT is currently working as a Research Assistant Doctor at Manisa Celal BAYAR University in Türkiye. Her research areas are English

Literature, English Drama, Contemporary Writings, Woman Literature, and Cultural Studies. She published articles and book chapters, some of them are *Modern Trickster in the Play Love and Understanding, Revisiting Shakespeare for Young Audiences: Tim Crouch's Shakespeare Adaptation Plays,* and *Experiencing Violence through Your Ears in Debbie Tucker Green's Hang.*

Kağan KAYA got his MA in 2004 and completed his Ph.D. studies at Erzurum Atatürk University in 2009. He has been attending English Poetry, English Novel, and English Drama classes at Sivas Cumhuriyet University, English Language and Literature Department since 2010. He has been working on contemporary English Drama for a long time. He has several academic essays on the plays of some English dramatists such as Alan Ayckbourn, Howard Brenton, and Tom Stoppard. He is planning to publish his book about Jez Butterworth's art and drama in 2023.

Kate KATAFIASZ was Programme Leader for Drama at Newman University, Birmingham, in the UK, until she retired in 2022. Originally a schoolteacher specializing in Drama in Education, Kate obtained her Ph.D. in 2011. She has published extensively on Edward Bond's post-millennial plays and shares his interest in the correlation between drama and politics. Her work investigates the pleasure of plays and playing in ancient, educational, and post-structural contexts, specifically, how drama can disturb habitual relationships between bodies and words in profoundly creative ways.

Nevin GÜRBÜZ-BLAICH holds a Ph.D. in English Language and Literature from Istanbul Yeni Yüzyıl University, Turkey (2020). Her research covers a spatial analysis of Tom Stoppard's plays. Her further academic interests are space, place, the geography of literature, and literary representations in contemporary British drama. She is currently a visiting scholar at Heidelberg University, Germany, and carries out her post-doctoral research on eco-drama.

Selina BUSBY is an academic and theatre practitioner who makes performances with community groups and is a National Teaching Fellow. She is a professor of applied and social theatre at The Royal Central School of Speech and Drama. Her research and practice focus on theatre that invites the possibility of change. Current projects include working with communities living in informal housing settlements and those living with gender-based violence in India. Recent publications include *Applied Theatre: A Pedagogy of Utopia* (2021, Methuen).

Susana Nicolás ROMÁN is a Senior Lecturer in the English Department at the University of Almeria (Spain). Her research areas principally focus on the connection between theatre, violence, precarity, and vulnerability. She has published extensively on educational and social drama. She is an active collaborator in theatre and research projects in Spain.

Tony COULT is a playwright and arts journalist who has worked since 1971 in many companies specializing in drama for young people. He has written drama for the BBC and Scandinavian educational output and is currently helping to curate the histories of many of the companies specialising in this field of work through the *Unfinished Histories* project based in the UK. Coult wrote the first English-language study of Bond in 1977. His doctoral thesis traces the history of drama for young people as supported by the Arts Council of Great Britain 1945-1994. He is currently curating Edward Bond's online website at https://edwardbonddrama.org/

Uğur ADA is working as Assistant Professor Doctor at Tokat Gaziosmanpasa University in Türkiye. He is currently the head of the Foreign Languages Teaching Department. His research areas are Contemporary British Theatre, Applied Theatre/Drama, In-Yer-Face Theatre, Theatre in Education, and Theatre about/for/by/with Young People. Recent publications include *Eğitimde Tiyatro/Theatre in Education (TiE)* (2021, PegemAkademi), *Publications in the Field of Theatre: Bibliometric Analysis of International Theatre Studies* (2022), *"What Will It Be Next?": The Process of 'Dramatic Child' in Edward Bond's Eleven Vest* (2022), *The Representation of Time through Female Characters in Edward Bond's Play, At The Inland Sea* (2020).

Foreword:
Five Challenges – Five Personal Responses to Bond Plays

Tony Coult

Playwright and arts journalist

In 2016, I was in the French city of Amiens for a conference about the work of Edward Bond. The streets were decorated with images of World War I which suffered its final battles on the outskirts of the city. On the morning of November 9th, Edward and others came into the hotel dining room for breakfast. We watched as a TV screen announced Donald Trump's election win.

The world changed. A challenge was issued.

I have chosen five plays that have challenged me in various ways and still do. (Actually, I could have chosen many other five-Bond play groupings to make my point.) Not all of these plays are for young people, but his work is as challenging for youth as for so-called maturity. The essays by scholars in this volume take us on journeys far into the rooms and streets of these plays. These, however, are my more personal reflections.

Saved (1965)

LEN: … Yer can't let it lie on its back. Someone's got a pick it up (Bond, 2000a, p.45).

One generation from the end of World War II in 1965 feels like a pivotal year as the so-called baby-boomer generation comes to adulthood. In the summer of 1969, hoping to look better-read than I was, I borrowed a play text to quote in my final university exams. The play was *Saved*, and it was different, apparently simple, sharp, and strangely familiar. The challenge to me was why I, a middle-class boy from a rural background, knew these working-class Londoners and shared the same world. How was it that the playwright did not morally judge a group of young men (one an ex-soldier from Britain's colonial wars) who murder a baby that is as helpless as they are? It was for the audience to deal with a crime that came from the culture that those young men and I shared. The Cold War, and its violent proxies in places like Vietnam, were the backdrop to the action onstage. The play was begun only one year after the Cuban Missile crisis that had narrowly avoided global nuclear annihilation.

My thought as I first closed the page on *Saved* was, "Oh. *That* is how plays can be written. That is how plays should be written." That was my challenge.

Lear (1971)

> LEAR: … *Listen Cordelia. If a god had made the world, might would always be right, that would be so wise, we'd be spared so much suffering. But we made the world – out of our smallness and weakness* … (Bond, 1998, p. 98).

Bond's reworking of the King Lear story that had attracted Shakespeare opened at the Royal Court Theatre in London in 1971. The director Bill Gaskill persuaded the actor Harry Andrews to play Lear, an actor who had made his name in films about the military. (There were many of these in my 1950s childhood.) Andrews had been a serving Army officer in World War II, including the D-Day landings that began the end of the war in Europe. I watched Lear's certainties crumble through the persona of wartime heroism embodied by Andrews as his daughters attempted to usurp his power. His revolutionary counterpart Cordelia sought to silence his public opposition to her plan to control the state. The casting of Andrews seemed to re-enact a conventionally patriotic film star trying to dig up a fortification he had caused to be built. Yet this was also a challenge to most of the younger Royal Court audience, myself included, in a period when socialist groupings were all around British political life and flourishing in the theatre. We may have applauded the change that Lear/Harry Andrews embodied, but we had to come to terms with the Cordelias in our own lives.

At The Inland Sea (1994)

> BOY: *The soldiers have guns! How will a story stop them* … (Bond, 2014, p. 11)?

Over the years, I have been involved in projects that help young people to repair damaged mental health and facilitate creative lives for people with special educational needs. There is a new set of demands on workers in these fields. We have to *prove* we are doing something *instrumentally* effective in order to get money to do the work. Can we prove we have improved a young person's mental health? Can we prove we have at least one element in a therapeutic process? There is growing research literature about art and mental health. Young people's mental health has been badly neglected in public policy and threatens to remain so as austerity budgets undermine good practice. So this work is focussed very closely on achieving instrumental outcomes.

In 1994, I encountered *At The Inland Sea*, Edward Bond's first play for a Theatre-in-Education company (Big Brum, in Birmingham). I was asked to

write an introduction to the play but it resists the instrumental in so many ways - you shouldn't approve of them concentration camps, young people shouldn't be encouraged to build gas chambers! I also had to contend with Bond's declaration that theatre cannot teach. But I'd spent years claiming that it can/ought to. This was a profound challenge!

The play seemed the opposite of the instrumental. It was complex, its actions demanding of its performers, its length and richness of language and image formidable, depicting events that would nowadays demand "trigger warnings" in every school doorway.

Seeing the play performed in an inner-city school by the Big Brum company made it clear to me that this play - this Theatre-in-Education programme - was about Art and the engine of Art - Imagination. The workshop before the performance by the Big Brum Company was not about concentration camps, the Nazis, or young people's difficulties with exams but how to *use* a work of dramatic art. If there is an instrumental purpose that may be allowed to much of Bond's work, it is perhaps the cultivation of the ability to use drama to see the humanity behind ideologies.

The Children (2000)

MOTHER: From now on this'll be a house of silence. O I'll talk to you: "shut the door – don't be late- wash your hands." But it's the last time I'll tell you anything that matters to me. A stone'd say more than I will. ... (Bond, 2000b, p. 13).

This play is unique in Bond's work in at least one way. Great swathes of it are to be performed and rehearsed by young people using script suggestions but no more. A Drama class or similar must take possession of the story and embody it. This is surprising, given the absolute care and discipline with which Bond endows his scripts.

The opening sequence (and a later iteration when children from the local housing estate gather) has an echo of a notorious child murder case in Liverpool when a child was abducted and murdered by other children, hit with bricks, by a railway line. But this is not a documentary about child crime, any more than *At The Inland Sea* is about gas chambers. *The Children* challenges young people to take a journey in the adult world where their own future is at risk and where there is no certainty of success. Bond's inability to offer an easy outcome challenges the normal expectations of children's work, which is to look for a resolution based in optimism.

The Under Room (2005)

DUMMY: I want my knife. I have told you. I am nothing. Nobody. One day I could forget what I have done. Then I am this nothing with no past. The knife is to tell me who I am. It is my pass to myself (Bond, 2013, p. 64).

Already in *The Children*, a puppet figure had appeared as Joe's companion and the victim of his attack with bricks. Now there is a character on stage which is a Dummy, a puppet figure, like Joe's, roughly assembled, making no claim to charm or obvious significance. Unlike the puppet in The Children, the Dummy is a "real" member of the cast. It/he/she has lines to be heard but they are spoken by an actor who is upstage left. Other characters in the play address the Dummy and respond to it as if it has spoken. This is a challenge to the conventions of naturalistic drama. The Dummy is not a fantasy, nor is it a "Brechtian" alienation device. It is a means to draw the audience into the action. The Dummy is a refugee in the play's actions but visibly not from any ethnic, or national, or identity group. Its crude gaze, for the most part, is on the audience, and only the audience can endow it with identity. This is an unprecedented device in drama directly challenging the conventions of the actor-audience connection.

And a Sixth Challenge –Commentary and Theory

Few playwrights reflect as vigorously and frequently as Edward Bond in commentary about his work. Those reflections can be about the practicalities of producing his plays but often sit within longer and richer pieces that situate his work theoretically in the history of Western Drama, particularly the importance of Drama to Greece, the first nation-state to develop democracy. For Bond, Drama is more than an art-form; it is the core activity of human social development. Much of his theoretical reflection is therefore rooted in the early days and months of childhood.

This aspect of his work- theory, and commentary - is manifest in essays and poems published alongside playscripts, and in the series of published letters edited by Ian Stuart for Harwood Academic Publishers. Most recently, his website (https://edwardbonddrama.org) carries a regular pulse of challenges to our culture and the political crisis we inhabit.

The first draft of this Introduction was written weeks into the bloody invasion of Ukraine. Never has it been truer what one of Bond's correspondents says, that we are now living in the world of his later plays. Many of these are set in 2077. The challenge is that it is 2022.

References

Bond, E. (1998). *Edward Bond: Plays 2*. Great Britain: Methuen Drama.

Bond, E. (2000a). *Saved*. Great Britain: Methuen Drama.

Bond, E. (2000b). *The children & have I none*. Great Britain: Methuen Drama.

Bond, E. (2013). *The chair plays*. Great Britain: Methuen Drama.

Bond, E. (2014). *At the inland sea*. Great Britain: Methuen Drama.

Author's Note

Edward Bond

Recently workshops on my War Plays were held for young students in Strasbourg. The workshop directors found that the students – teenagers in their early twenties – had hardly any sense of history (not even the history their parents had lived through) and no focused sense of a larger world beyond their own lives.

This is a symptom of modernity. It is as if the students lived in an electronic cocoon manufactured by the media and the commercial market. They exist in society as consumers, not as citizens. They have no sense of belonging but instead of isolation. It's odd because they share their sense of isolation, and *it can even be quite amicable!* But it is dangerous because it denies them responsibility for themselves and their society.

Until the Enlightenment and the Industrial Revolution, each new generation lived in the world of their parents and ancestors, in the same houses and on the same land. But the Industrial Revolution drove them from the land into cities of suburbs and slums. This caused great suffering – but later, it was compensated for by the new mass consumption and the distractions of the electronic market. We are just beginning to live with the consequences. Mass consumption can be as socially and individually devastating as historic destitution. Our world is many times more dangerous than the world of our forebears. We live with chemical and nuclear dangers; we destroy the climate, pollute the sea, and poison the earth – that is modern cannibalism.

Modernity has changed the surface of our lives. But it can't abolish the millions of evolutionary years that made us human. We are a social species. We either live together or die together. The War Plays (the subject of the Strasbourg workshops) showed this; in fact, in working on the plays, the students *proved* it to themselves! First, it was necessary to explain that the plays' events came from World War II and were real. Once the students knew this, they became intensely involved, understanding, and creative. They astonished themselves. They were studying the plays but were 'workshopping' and *re-creating* themselves and their lives. They took control of their future.

Most modern theatre tries to give the audience a feeling of instant satisfaction. In fact, that is damaging, even corrupting. The audience forgets their problems for a few hours and then goes home and finds their problems waiting for them on the doorstep.

Two cautions. Material facts can't create moral values. Nor can imagination – imagination can be immoral and destructive. (Hitler had a vivid imagination.) But the combination of material fact and imagination is the logic of morality. This logic is the basis of drama.

Secondly, not all authorities are repressive. In *Tune,* material fact and imagination are divided. In the play, this makes both the mother and son victims. Such divisions may be tragic. But in tragedy, there may be hope.

Whenever Students study or work on the plays in this book, they should first be given to read Tony Coult's *Introduction*. He has brilliantly selected texts that combine to restore our lost sense of past and present and our responsibility for the future. Doing that should be the aim of all modern drama. He achieves this by relating the texts to his own life. I shall follow his example.

When I was thirteen, I walked through a London suburb of bombed houses to see an adult performance of Macbeth. For the first time, someone spoke to me about my life. I found that morality makes us human. It defines the human good. Morality isn't law but understanding. Everything else is foggy transitory or a mechanism. I write this as Putin wages a war against Ukraine. He says his war is going to plan. He lies. The war was meant to be over in a week. Who would start a war when the only possible outcome was such a delayed and botched victory? The trouble with Putin is he isn't in control of himself. The aim of drama is to give the self-control of the self. Without that, we are not human, and the broken foundations of society are not mended. Regret is too late, and triumph too soon, but we try to run society on regret, triumph, and technology

I've described our outline situation. We live with two great dangers. The capitalist market and nuclear power. Our present political institutions can't control this situation. Perhaps there will be more wars between sides armed with nuclear weapons. Each war would be more destructive than the one before it because the opponents would have used the time between the wars to construct more powerful nuclear weapons. Putin would describe this as going according to plan. Trump's battle cry would be America First and Last. What survived would hardly be human.

That is our situation. Nuclear war, global warming, pandemics. They are all the outcomes of the rabid money market.

Each generation should hand to the next generation a world more human than its own. We will hand on a ruin according to plan.

Chapter 1

Pedagogy of Alterity: Edward Bond's TIE Plays and Dramaturgy of the Invisible Object

Chien-Cheng Chen

Taipei National University of the Arts, Taiwan

Abstract

The dramatic devices that Bond uses to active the young spectator's imagination can be understood through his concept of 'the invisible object' (IO). Bond emphasizes the importance of the use of objects because, through the interaction between actor and object, the actor can demonstrate how different values are attributed to objects. Through this process of value attribution, the object can be freed from its ideologized use and reinvested with a new significance. In Bond's dramaturgical model, the spectator is conceived to be part of this process through which the spectator is prompted to reconsider the ideological presumptions that underlie how the value of the object is defined. Thus, the chapter analyzes the plays, The Under Room, The Hungry Bowl and The Angry Roads within the concept of Bond's concept of invisible object.

Keywords: Invisible Object, The Under Room, The Hungry Bowl, The Angry Roads

Bond and Theatre-in-Education

Since the 1990s, British playwright Edward Bond has been commissioned by Big Brum, a Theatre in Education Company based in Birmingham, to write plays for young people. However, the collaboration between Bond and Big Brum ended due to artistic differences in 2016, with *The Angry Roads* being the final play Bond wrote for Big Brum. Although Bond's plays are renowned for his use of violence, in his TIE plays, he eschews using explicit violent images and

adopts dramaturgy of alterity that center around the problematizations of visibility, audibility, presence, and intelligibility. Instead of offering direct educational messages, Bond's dramaturgy of alterity aims to enhance the spectator's sense of responsibility towards the other. Like his other later plays, one of the thematic concerns of Bond's TIE plays is engagement with the operation of ideological totalization epitomized by Nazism and Thatcherism. In a letter written to Phil Davey on 26 May 1989, Bond comments on how the government uses education as a means for specific political ends:

> Children are going to be educated into being adroit and disciplined at taking instructions in school – and that means, in later life, orders – without the sensitivity to ask themselves if they ought to follow their orders and without the understanding of society and psychology to enable them to give a human answer. Really its [sic] preparing the mentality which makes it possible to use people as apparatuses of government. That is what Nazi education was about (Stuart, 1998, p. 1).

For Bond, 'Nazi education' means the type of education that cultivates a collective conformist mentality among students in order that the authorities can exert their power without being questioned. Through this type of education, the individual is made to be merely a means to execute orders. For Bond, Nazi education is not restricted to the Nazi regime but may possibly take other contemporary forms.

In a statement given at the public meeting organized by Belgrade TIE on 24 February 1996, commenting on the crisis of neoliberalism, Bond related this type of education to Thatcherism: "The reduction of education to training, the frenetic activity of Thatcherism, the Sisyphean task of maintaining the economy – these are not creative responses to the crisis" (p. 120). For Bond, education after Nazism is the same as education after Thatcherism, and in opposition to this, he advocates the type of education that resists ideological totalization in service of the interest of the state or capital. For Bond, a civilized society is based on an ethics that calls for responsibility for others, and this ethics also constitutes the foundation of education. To counter the conformism of education under Thatcherism, Bond stated,

> TIE performs education's most fundamental duty. Today education is being reduced to learning how to make money and fit into the economy. These things are necessary but they will never teach children what a civilized society is – what moral sanity is – what responsibility for others is (Stuart, 1998, p. 113).

Bond's thoughts on education resonate with the TIE movement in Britain. As Roger Wooster (2016) argues, the battleground for education and the TIE movement revolves around the aim of education – whether education is to

socialize or to promote change (p. 25). The emergence of the TIE movement in the mid-1960s was "born out of an expectation of social reform, an implicit trust in progressive education ideas and the hope for prosperity after fifty years of thwarted aspirations" (Wooster, 2016, p. 77), but this optimism for change diminished in the 1980s and 1990s due to the rise of Thatcherism and the fall of the Berlin Wall, both of which testified to the decline of left-wing ideologies commonly shared by TIE practitioners (Nicholson, 2009, pp. 35-36). After the 1990s, it became commonsensical to regard education as a way of socialization that manufactures students according to the needs of the neoliberal social-economic order. The challenge for the TIE movement after the 1990s, therefore, is how to retain the purpose of education to promote change and cultivate autonomy (p. 43).

As Helen Nicholson (2003) observes, Bond's education work provides a moral education that promotes young people's self-creativity through the engagement of imagination (p. 13). In fact, Bond's TIE dramaturgy that engages young people's imagination shares common ground with Big Brum's TIE methodology. For Big Brum, "the task of TIE is to use theatre to explore the human condition and behavior in order that it may be integrated into young people's minds and, in doing so, make them be more human by allowing them to know themselves" (Ballin & Cooper, 2013, p. 6). Regarding Bond's TIE plays, Big Brum states that his dramaturgy employs "dramatic devices to get behind the ideology that constrains and determines both thought and action and brings us imaginatively into the situation" (Ballin & Cooper, 2013, p. 7). It is therefore understandable that Big Brum has maintained a sustained relationship of cooperation with Bond since the way in which Bond's TIE plays encourage young audiences to actively interact with imagined dramatic situations is in line with Big Brum's TIE methodology.

Bond's TIE Dramaturgy and The Invisible Object

The dramatic devices that Bond uses to activate the young spectator's imagination can be understood through his concept of 'the invisible object' (IO). Regarding the meaning of the invisible object, Bond (2005) states, "It is called *Object* because it objectifies the situation on the site: it is its meaning. Before the IO is enacted, it is hidden in ideology and convention. The actor enacts the meaning in the IO and makes it visible" (p. 90). Bond (2004) also explicates that "drama searches for the IO. It may be almost anything – the actor himself, a thing such as a cup, chair or button, words, a sound, a situation, an interchange with another" (p. 28). For Bond, anything can be made invisible by ideology, that is, a set of values and ideas that legitimatize the status quo and determine how we understand reality. Therefore, in Bond's theatre, searching

for the invisible object means seeking to expose and make visible the ideological assumptions embedded in what is perceived as usual and natural (p. 28).

Bond emphasizes the importance of the use of objects because, through the interaction between actor and object, the actor can demonstrate how different values are attributed to objects. Through this process of value attribution, the object can be freed from its ideologized use and reinvested with a new significance. In Bond's dramaturgical model, the spectator is conceived to be part of this process through which the spectator is prompted to reconsider the ideological presumptions that underlie how the value of the object is defined. According to Bond (2004), children can be more easily motivated to participate in this process as he states that "all children are close to drama. It is easier for them to see the visible object. Childhood is not burdened by the necessity of ideology" (p. 31). For Bond, before the child accepts the social and economic value of the object through socialization, the child is in a stage of development where the self can freely endow external objects with subjective significance without being influenced by how these objects are habitually defined. How the self interacts with the object in this transitional stage can be further understood through D. W. Winnicott's psychoanalytical concepts of 'transitional phenomena' and 'transitional objects.'

According to Winnicott (2005), when infants begin to separate from their union with their mothers, that is, when they start to interact with outside objects, they need some specific objects, such as a bundle of wool, to ease their anxiety about separation. Winnicott describes these objects as transitional objects and the phenomena as transitional phenomena (pp. 4-5). He proceeds to explain that the meaning of transitional objects is to be gradually decathexed when transitional phenomena are diffused across the field between "the inner psyche" and "the external world" (p. 7). The intermediate area of experience aims to ease the infant's anxiety of being separated from the mother, who adapts to the infant's needs by providing the illusion that what the infant wants really exists (p. 19). Even after transitional objects are decathexed, transitional phenomena can still be "retained in the intense experiencing that belongs to the arts and to religion and to imaginative living, and to creative scientific work" (p. 19). It is noteworthy that Winnicott's concept of transitional phenomena is closely related to Bond's idea that there exists a phase of child development in which the child can freely endow objects with subjective meaning. Similarly, the persistence of transitional phenomena throughout life is comparable to Bond's idea that the human subject's "radical innocence," which serves as the source of value attribution, cannot be corrupted (Bond, 2000, p. 181). We can observe that, in Bond's theory, it is the persistence of radical innocence that makes possible the process of revealing the ideological presuppositions that

determine the meaning of what is regarded as normal, and it is this process that makes the invisible object visible.

Big Brum's TIE methodology is also concerned with the relationship between the child's development and the sociocultural context in which the child is situated. Regarding the theoretical influences on the development of their working methods, Big Brum refers to L. S. Vygotsky's theory of child development, especially his insight into the importance of play and his concept of "the zone of proximal development" (Ballin & Cooper, 2013, p. 9). According to Vygotsky (1978), "In fundamental, everyday situations, a child's behaviour is the opposite of his behaviour in play. In the play, action is subordinated to meaning, but in real life, of course, action dominates meaning" (p. 101). Since children can deal with meaning and concepts through play, for Big Brum, such ability to construct imaginary situations, "can be understood as a means of developing abstract thought" (Ballin & Cooper, 2013, p. 9). This process of mental development is closely related to Vygotsky's concept of the zone of proximal development. Vygotsky (1978) uses this concept to define those "functions that have not yet matured but are in the process of maturation" (p. 86) - in contrast to the actual development level that characterizes mental development in a retrospective manner, the zone of the proximal development characterizes mental development in a prospective manner (p. 86). The implications of Vygotsky's theory that children are capable of action and thought ahead of their actual mental development are important for Big Brum since their methodology emphasizes activating the child's imagination through drama and viewing the child as an active knowledge seeker (Ballin & Cooper, 2013, p. 9). Bond's use of the invisible object can thus be understood through Vygotsky's theory as a dramaturgical tool that can potentially initiate the child's prospective mental maturation since the process of making the invisible object visible encourages the child to use imagination actively.

In Bond's TIE works, in order to promote the child's journey of self-creation, he adopts a dramaturgy of alterity that calls attention to otherness and creates a gap of meaning that obliges the spectator to fill in creatively and imaginatively. This gap makes it possible for the child to attain self-creativity without repeating the logic of violence through which the universal subsumes the particular - a logic that Bond senses in Nazism and Thatcherism. In the following, I will analyze three of Bond's TIE plays - *The Under Room* (2005), *The Hungry Bowl* (2012), and *The Angry Roads* (2015) - and his dramaturgy of alterity, which is manifested in the form of a foreigner, a specter, and an untold story. In these plays, Bond demonstrates how the invisible object can be made visible through the subject's sensibility towards the otherness of the object.

Foreigner and Hospitality: *The Under Room (2005)*

The Under Room was first staged by Big Brum on 12 October 2005. At the start of the play, the Dummy, an illegal immigrant, breaks into Joan's house to escape from soldiers. Regarding the use of the Dummy, it is important to note that Bond makes a distinction between the Dummy as a human effigy and the Dummy Actor, who stands on the corner of the stage and speaks the Dummy's words. Throughout the play, except for Scene Six, other characters only interact with the Dummy and ignore the existence of the Dummy Actor. After the Dummy tells Joan that he has no papers, Joan asks him to stay for the sake of security. Later, Joan asks Jack to help them to get the necessary documents for the Dummy to cross the border. However, the Dummy's money has been stolen, so he is unable to pay Jack. Jack insists that Joan must pay the money and suggests that she can prostitute herself to cover the cost; otherwise, he will betray them to the army. In fact, it is Jack who has stolen the money, and his sole motive is to make as much money as he can out of the Dummy's predicament. Although Joan promises that she will try to get the money, she fails to obtain a loan from the bank due to the political situation under martial law. When Jack returns with the Dummy's pass, he reveals that he has always been part of the army and threatens Joan and the Dummy that he can turn them in whenever he likes. As a double-crosser, Jack's way of making money is to befriend and then turn in illegal immigrants and their sympathizers to them, unless the immigrants and their friends can pay him more. Later, Joan suggests that the Dummy could escape with her. However, the Dummy falls into a coma and starts to speak his native language, which makes Joan so uneasy that she even starts to attack the Dummy. Finally, the Dummy decides to escape with Jack, and Joan kills the Dummy out of fear and uncertainty. The play ends with the Dummy Actor speaking the Dummy's native language.

As can be observed, this play pivots on the problem of hospitality, and one of the Bond's methods to tackle this problem is through his use of language. As Jacques Derrida points out, the question of hospitality starts with language: "Must we ask the foreigner to understand us, to speak our language, in all the senses of this term, in all its possible extensions, before being able and so as to be able to welcome him into our country?" (Derrida & Dufourmantelle, 2000, p. 15). When the Dummy is awake, he can speak English, the same language as Joan speaks; however, when he falls into a coma, he speaks his native language, which is totally incomprehensible to Joan. In order to seek asylum, the Dummy must speak a foreign language that enables him to communicate with Joan. Without this shared language, the Dummy for Joan would become an incomprehensible foreigner. The foreignness of the Dummy effigy foregrounds the fact that it is language itself as a linguistic operation that communicates - Joan can communicate with the Dummy without knowing who he is. The

difference between the Dummy, who remains silent and interacts with Joan, and the Dummy Actor, who speaks, thus demonstrates the difference between communicating in the same language and understanding foreignness. Although Joan can communicate with the Dummy, their shared language also conceals the irreducible otherness embodied in the Dummy.

At the end of Scene Three, the Dummy Actor puts his shirt on the Dummy, and at the end of Scene Four, the Dummy Actor puts his jeans on the Dummy and the knife in the pocket of the Dummy's shirt. These gestures suggest that the Dummy is gradually humanized, and, in the process of humanization, the Dummy starts to speak his native language in Scene Five when he falls into a coma. During the Dummy's coma, Joan not only expresses her obligation to the Dummy but also reveals that she is - or feels like - an immigrant in the country. The totalitarianization of the state makes Joan feel as if she is an immigrant in her own country despite the fact that she is the country's native. However, when the Dummy keeps speaking his native language to articulate his inner anxiety, Joan dislodges her hatred of the Dummy suppressed under her benevolent appearance. Once her inner suppression is removed, it turns into violence towards the Dummy, as Bond describes Joan as one who "contains in fact a lot of unexpressed aggression, probably based on fear" (as cited in Tuaillon, 2015, p. 95). Joan's fear is twofold: she fears the real foreignness embodied by the Dummy, but she also fears the foreignness within herself - her desires and anxieties are repressed within the process of being civilized as a law-abiding citizen who must follow the legal regulations on immigration.

How Joan's emotional reactions to the Dummy reveal her ideological inclinations is also manifested in Scene Six, where it is the Dummy Actor, instead of the Dummy, who interacts with Joan and Jack. The Dummy confesses that he was once forced by the soldiers to choose to kill either his mother or father, and he decided to kill his mother. Hearing this, Joan responds with horror; Jack, however, understands the aporetic nature of the involuntary choice and the atrocious crime committed by the Dummy. After Scene Six, the Dummy Actor puts on his shirt and jeans, leaving the Dummy seemingly inanimate again. In Scene Seven, after Joan tears the Dummy into shreds out of fear, she is uncertain about whether she should expose the torn pieces of the Dummy's body or hide them. She finally decides to hide them out of fear of being punished. In this scene, Joan's morality of hospitality is clearly revealed to be based on the suppression of her fear and uncertainty. The process of learning to follow legal rules and moral norms is also a process of repressing the fear and anxiety of violating the regulations, and the internalized repression turns out to be the cause of violence. In Scene Eight, when Jack decides to escape with the Dummy but finds that he has been killed, he states, "I never turned t' crime out a' weakness. I 'ad a different reason. Hope" (Bond, 2006, p. 202). Unlike

Joan, Jack understands the nature of the totalitarian state, so he has no consistent morality: he can be a comrade with the army, but he can also potentially offer help to the Dummy. By making Joan, who initially offers shelter to the Dummy, eventually, kill the Dummy, and making Jack, who at first makes use of the Dummy's predicament to make money, willing to offer help at last, Bond avoids being didactic and encourages the spectator to examine the moral ambiguity in these situations and make judgments. In Scene Nine, when the Dummy Actor looks at the Dummy's shreds and speaks his native language, it is suggested that the foreignness embodied by the Dummy cannot be eradicated and remains to be understood.

In this play, Bond's dramaturgy of the invisible object can be seen through his use of the Dummy. At first, Joan can communicate with the Dummy in a shared language and express her sympathy towards the Dummy. After the Dummy Actor puts his shirt and jeans on the Dummy and makes the Dummy humanized, the Dummy starts to speak his own language. The foreignness of the language then arouses Joan's fear and incites her violent reactions. When the Dummy Actor directly plays the Dummy, it seems to imply that Joan can really interact with the Dummy as a human being. However, the Dummy reveals that it is Jack who can really understand the meaning of the murder he committed against his mother. Later, the Dummy Actor puts on his shirt and jeans, leaving the Dummy lifeless - this suggests that Joan can never comprehend the otherness within the Dummy as a human being. Joan's initial benevolent attitudes toward the Dummy, her shock of hearing the Dummy's matricide, and her final resort to violence against the Dummy demonstrate that Joan's understanding of the Dummy has been conditioned by certain established moral and ideological attitudes. However, it is only possible to understand the foreignness and singularity of the Dummy when one is not restricted by conventional standards. According to Bond's dramaturgy of the invisible object, it is through this engagement with alterity can the invisible ideological presuppositions be made visible.

The discussion of *The Under Room* (2005) also demonstrates that the problem of hospitality entails certain ethical and legal conditions. According to Derrida, absolute or unconditional hospitality "requires that I open up my home and that I give not only to the foreigner (provided with a family name, with the social status of being a foreigner, etc.) but to the absolute, unknown, anonymous other" (Derrida & Dufourmantelle, 2000, p. 25). However, for Derrida, unconditional hospitality is difficult, if not impossible, since the subject tends to regard the other who encroaches on the subject's power of hospitality as "an undesirable foreigner, and virtually as an enemy" (p. 55). Therefore, there must be "the conditions, the norms, the rights and the duties that are imposed on hosts and hostesses" (p. 77). This ethical aporia of hospitality is foregrounded when the

demands of the homeless and foreigners who ask for asylum cannot be met due to practical and legal obstacles.

According to Derrida's logic, if Joan can truly be open to the Dummy as an intruder who breaks into her house and threatens her safety, she should unconditionally accept the Dummy without knowing his identity or asking for any identity documents. However, considering that the Dummy is an illegal immigrant, Joan asks him to stay until she can obtain the legal documents. In response to Joan's willingness to help, the Dummy remarks, "You are a good person. You do not cause trouble for the authorities" (Bond, 2006, p. 175). In fact, the Dummy does not ask for any legal documents - it is Joan who wants to help the Dummy to obtain such documents. In addition, she does not want the Dummy to be shot just because she fails to take care of him. However good-intentioned Joan may be, it is this problematic 'good' will that causes her and the Dummy the trouble that follows. In Derrida's words, Joan's actions involve her and the Dummy within the logic of conditional hospitality determined by the law of the state. The only true document for the Dummy is his knife - he is not only an illegal immigrant but also an outlaw who knows how the rule of the state can be destructive instead of protective. However, Joan cannot understand this, nor can she detect the irony in the Dummy's remark that she is 'a good person'. In fact, Joan's 'goodness' is conditional since it abides by the logic of self-preservation and the law of the state. She seems unaware of the conflict between her logic of action that must be defined within the established legal framework and the Dummy's logic of action that can only be made possible by transgressing the law.

Moreover, this desire to abide by the law of self-preservation may necessitate psychic repression. In analyzing the relationship between psychic apparatuses and xenophobia, Julia Kristeva (1991) argues that "the psychic apparatus represses representative processes and contents that are no longer necessary for pleasure, self-preservation, and the adaptive growth of the speaking subject" (p. 184). In other words, in the process of growth, the speaking subject must repress those elements that arouse displeasure and threats to self-preservation. While Kristeva's analysis focuses on the psychic mechanism, it is notable that the process of 'adaptive growth' necessarily entails adaptation to the environment conditioned by extra-psychic rules. This mechanism explains why Joan bursts into violence when she recognizes that the Dummy is a foreigner who threatens her sense of safety. This violence is the result of the psychic operation conditioned by psychic apparatuses and extra-psychic ideologies. However, it should still be pointed out that Joan is not innately violent towards foreigners, nor is the law necessarily formulated against foreigners.

With regard to the psychic operation of xenophobia, Kristeva (1991) reminds us of the importance of facing the inner otherness that, in fact, uncovers the contours defining the identity of a community (p. 192). In a similar manner, Derrida also interprets the stranger as a liberating force: "The stranger could save the master and liberate the power of his host; it's *as if* the master, *qua* master, were a prisoner of his place and his power, of his ipseity, of his subjectivity" (Derrida & Dufourmantelle, 2000, p. 123). Given that Joan feels uneasy in her own country and intends to escape with the Dummy, the Dummy could be a liberating force for Joan in the sense that the Dummy can make Joan aware of the oppression the state imposes on foreigners as well as natives. However, since the possibility of emancipation presupposes Joan's ability to alter her perception of the status quo, her failure to question the established legal order thus forecloses the possibility of undergoing a transformation.

In Big Brum's production, Joanne Underwood's performance of Joan emphasized Joan's emotional transition from sympathy to anxiety. At first, her performance showed Joan's kind willingness to take care of the Dummy. When she performs Joan's abrupt violent attacks against the Dummy, she also displays Joan's hesitation as if Joan herself cannot completely control her emotional reactions. Underwood's performance thus persuasively demonstrated how Joan's suppressed anxiety makes her resort to violence against the Dummy. Ian Holmes's performance of Jack demonstrated Jack's cunningness and cleverness; however, his interpretation also captured Jack's brooding quality at the moment when he considers escaping with the Dummy in Scene Eight. As the Dummy Actor, Adam Bethlenfalvy's acting remained neutral and emotionless throughout the play except for the moment when the Dummy screams during his coma. Even in Scene Six, when the Dummy Actor interacts directly with Jack and Joan, Bethlenfalvy's playing tended to remain detached. In contrast with Holmes's calmness and Bethlenfalvy's neutrality, Underwood's performance foregrounded Joan's psychological change from sympathy to anxiety and demonstrated how the dominant ideology affects her attitude towards foreigners. Through their controlled use of emotions and interactions with the Dummy, the actors made the invisible object - the hidden ideological conditions that determine the border between hospitality and hostility - visible.

Specter and Precariousness: *The Hungry Bowl* (2012)

Many of Bond's plays are haunted by specters - both visible and invisible. In *At the Inland Sea (1995)*, the Woman appears as a ghost who returns from the gates of Auschwitz to demand a story; in *Have I None (2000)*, Sara is haunted by her ineradicable memory shared by her and her brother; in *Coffee (1993-94)*, Nold is haunted by Gregory, who guides him through the forest to the site of the Babi Yar Massacre. The specter is disquieting because it signals that the perceived

reality may not be the only reality - behind the normalized reality, there always exists the repressed produced by the structural violence of reality that excludes the forbidden. *The Hungry Bowl*, first presented by Big Brum on 24 April 2012 under the title of *The Broken Bowl*, is another play that directly uses the specter as a dramatic device.

In a city towards the end of 2077, the Girl's family lives on rationing because of food shortage. Despite this, the Girl has an imaginary invisible friend, and she prepares a chair and a bowl for him to feed him food. While the Mother thinks the imaginary friend only reflects the Girl's natural psychological need, the Father cannot bear the thought that the Girl has an imaginary friend who keeps consuming their food. In the middle of the play, however, the Girl's imaginary friend appears as No One, dressed in a white jump suit, and only the Girl can see him. Later, when No One reappears, he becomes starved and drained because the Father has eaten the food left for him. In addition, this time, the Father can see No One - this shocks him and makes him so unstable that he thinks his wife, who actually stands beside him, has gone to the street. The Mother then follows the Father into the street in order to try to bring him back. Meanwhile, because of the Girl's strange behaviour, their house has been marked by a red X - an ominous sign suggesting that the family might have been singled out and excluded. The play ends with No One appearing again as Someone wearing an ordinary white jump suit, and he remarks that he has not seen the Girl before. Bond implies that the Girl finally obtains a heightened awareness of ethical obligations towards others from her negotiation with her father and interaction with No One/Someone, as she states that they should "feed the hungry," "shelter the poor," and "bring the lost home" (Bond, 2018, p. 205).

Relating Emmanuel Levinas's idea of the face to the precariousness of life, Judith Butler (2004) states: "To respond to the face, to understand its meaning means to be awake to what is precarious in another life or, rather, the precariousness of life itself" (p. 134). However, the condition of one's being awake to the precariousness of another life requires that another life should be 'recognized' as a life. As Butler (2009) points out, any act of recognition presupposes recognizability, and this recognizability depends on selective norms and power operations (p. 5). In *The Hungry Bowl*, the Girl's family live in precarious conditions, but they are still recognized by the authorities as living beings to whom rationing should be allotted. Their subsistence depends on the fact that their lives are still recognized by the norms of recognizability. When the Father categorizes the Girl's imaginary friend as a "zombie" (Bond, 2018, p.189), he, in fact, unconsciously duplicates the biopolitical logic of exclusion employed by the authorities. For the Father, the Girl's imaginary friend is a zombie instead of a living human being. However, dramaturgically, Bond

refutes the Father's categorization by making the imaginary friend appear as a living human being. It is important to note that by making the friend appear as a boy, Bond renders questionable the norms that the Father adopts in categorizing the boy as a zombie instead of a living being. Butler (2009) describes the figure that destabilizes the norms of recognizability as a "specter" that endangers the boundaries and must be exorcised (p. 12). It is thus possible to posit that the boy is a living human being who, despite being a living being, is excluded from the norms and therefore becomes a specter.

Butler (2009) also distinguishes recognition from apprehension by arguing that the latter is not limited by established norms of recognition and that it is possible to apprehend something not yet recognized (p. 5). In this play, although the boy is not recognized by the authorities, the Girl is still capable of 'apprehending' him as a friend. The boy, as a specter, indicates the possibility of being apprehended despite being an unrecognized being. His spectral presence not only casts into relief his existence as a remainder outside the norms but also attests to the precariousness of the situation of the Girl's family. When encountering the 'zombie' that is excluded from the norm, the Father is reminded of the fact that his status of being categorized as a living being is never guaranteed. His anger towards the Girl and his anxiety to protect his house from outer danger demonstrate his inconvenient awareness of the precariousness inherent in the predicament. As Butler (2009) states, "precariousness underscores our radical substitutability and anonymity in relation both to certain socially facilitated modes of dying and death and to other socially conditioned modes of persisting and flourishing" (p. 14). The 'substitutability' inherent in precariousness is manifested in *The Hungry Bowl* when the Girl's family finds that they may have been labeled as a target of exclusion and banishment.

Invoking Theodor W. Adorno and Max Horkheimer's *On the Theory of Ghosts (1972)*, sociologist Avery Gordon (2008) argues that haunting is an appearance of social figuration that signals the historical atrocity that reduces individuals into a mere succession of experiences without traces (p. 20). He maintains that haunting is a particular social figure that makes us aware of what has occurred and what is occurring (p. 8). In this light, engaging with haunting as a social figure directs our attention to the historical and social conditions that determine specific hauntings and precarious circumstances. In Butler's terms, the historical and social conditions in Bond's plays are those that determine the "differential distribution of precarity" (Butler, 2009, p. 25). Therefore, in certain cases the specter's appearance reflects and reminds us of how various forms of atrocity in society keep systematically producing disposable and ungrievable lives.

According to Derrida (1994), the specter is always related to the problem of justice: "If I am getting ready to speak at length about ghosts ..., it is in the name

of *justice*. Of justice where it is not yet, not yet *there*, where it is no longer" (p. xviii). Derrida further states that justice is impossible without responsibility - justice requires that responsibility should be taken for those who have been exterminated by the injustice of violence, war, and oppression (p. xviii). For Derrida, the exemplary specter that demands justice is Hamlet's father, whose ghostly appearance endows Hamlet with the responsibility to confront injustice and restore order. In opposition to Derrida's Levinasian hauntology, in which the messianic justice is always yet-to-come, Slavoj Žižek (1994) proposes a Lacanian hauntology: "Symbolization ultimately always fails, that it never succeeds in fully 'covering' the real, that it always involves some unsettled, unredeemed symbolic debt. This real (the part of reality that remains non-symbolized) returns in the guise of spectral apparitions" (p. 21). For Žižek, the specter is a residue that symbolization fails to incorporate into the symbolic order, and it demands that we should take a transgressive action of freedom to establish a new reality. Therefore, Žižek (1994) states, "The act of freedom qua real not only transgresses the limits of what we experience as 'reality,' it cancels our very primordial indebtedness to the spectral Other" (pp. 27-28). By nullifying our 'indebtedness to the spectral Other,' Žižek's hauntology aims to renounce the endless deferral prior to the impossible justice and calls for actions of freedom despite the fact that the founding action as a renewal of the symbolic order may produce new residues of symbolization and necessitate further actions.

Žižek's response to Derrida's hauntology, instead of refuting Derrida's argument, broadens how the specter can be comprehended: whereas in Derrida's view, the specter attests to the unjust oppression of ideological apparatuses, in Žižek's view, the specter as an unideologized residue calls for a revolt against the established order of oppression. These philosophical speculations about the specter can clarify the implication of Bond's dramaturgical deployment of the specter as an invisible object and the process of making the invisible object visible. The Girl's interactions with her invisible imaginary friend and No One demonstrate that she can discern and recognize the spectral presence of those who have been made invisible due to their exclusion from society, and her decision to go with Someone into the street implies that she starts to take actions in response to the suffering which she shares with others. Furthermore, towards the end of the play, Bond implies that the Father also perceives No One's presence when he appears the second time, suggesting that the Father can also potentially recognize what has been excluded from his perception of reality conditioned by his ideological beliefs.

In Big Brum's production, it can be observed that Danny O'Grady's performance of No One/Someone aims to differentiate the character's spectral mode of existence from his real mode of existence. When O'Grady first appears as No

One in an ordinary jump suit, he constructs his spectral presence by remaining still and showing no intention to interact with others. As he appears for the second time as No One in filthy rags, he presents himself as severely starved and physically fatigued, as if he has almost become a revenant. However, when he reappears as Someone, he acts and interacts with the Girl like a normal boy. The interplay between visibility and invisibility is also foregrounded when the Girl touches Someone as if she intends to check if he is 'real.' In performance, the contrast between No One as a spectral existence and Someone as a real one is made explicit when the Girl asks if she can touch Someone since the spectator is made aware that it is only until now that the Girl tries to verify whether No One is spectral or real. Furthermore, since No One and Someone are required to be performed by the same actor, Bond visibly demonstrates the spectral structure of subjectivity - underneath every human subject's normal and livable life, there exist potentially shared conditions of vulnerability - and uses this spectral structure to interrogate the ethics in a period of precarity. We can therefore see that how Bond tackles the Girl's imaginary friend's transformation from an invisible being through No One to Someone can be understood through his dramaturgical logic of making the invisible object visible. Furthermore, in line with Bond's logic, Big Brum's staging thus encourages the spectator to negotiate with the ideological presuppositions that determine the border of inclusion and exclusion.

Storyability and Self-Knowledge: *The Angry Roads (2014)*

The final play I will analyze is *The Angry Roads (2014)*, premiered by Big Brum on 6 October 2015. Since the main theme of the play is concerned with the relation between self and story, I will first examine Bond's understanding of storytelling in order to facilitate my analysis. For Bond, human action is always mediated by storytelling that integrates individual experiences and social interactions (Stuart, 2001, p. 42). Storytelling is not only about constructing a story, but it is also an essential part of the human capacity to understand the self in relation to the world. According to Bond (2000), 'culture' designates an agglomeration of stories that constitutes a plot in which the self can be defined (p. 3). Within this collection of stories as culture, the dominant and grand narratives can be apprehended as ideologies that determine how the self perceives and understands the world. For Bond, "story can release energies and change meanings in ways that laws and institutions cannot" (Stuart, 2001, p. 48). Thus, the significance of the self's ability to tell stories lies in its potential to question the narratives of the dominant ideology. As Bond (2000) states, the power of storytelling is "to conceive of justice yet *question* [emphasis added] it" (p. 4). Bond's idea of the human subject is therefore mediated by 'storyability': "The ability to analyse and calculate is characteristic of isolated reason: when

it is combined with emotion, to produce imagination, it becomes 'storyness' (storyability etc.). Imagination is essentially storyability. Imagination needs to relate experience as story or as potentially storyable" (Bond, 1996, p. 8). Storyability derives from the storyteller's imagination that produces imagined stories in relation to the storyteller's experience, and these storyable stories determine and reveal how the storyteller understands the self in relation to the other.

Bond's concept of storyability is resonant with philosopher Richard Kearney's argument about the relationship between self and narrative. Based on Paul Ricoeur's concept of narrative identity, Kearney defines storytelling as an act of the self's self-definition: "The story told by a self about itself tells about the action of the 'who' in question: and the identity of this 'who' is a narrative one" (Kearney, 2002b, p. 152). For Kearney, the narrative identity of a person does not necessarily rely on an external narrative, although he by no means intends to exclude engaging with external narratives as a way for the self to gain the experience of selfhood defined by storytelling. He emphasizes that the self is defined by the stories told by his or her self. In addition, while Kearney regards storytelling as an act of repetitive self-affirmation, he considers the self's ethical commitment to the other to be an act that destabilizes the certainty of selfhood. He proposes that "for narrative selfhood to be ethically responsible, it must ensure that self-constancy is always informed by *self-questioning* [emphasis added]" (Kearney, 2002a, p. 93). The self's "self-questioning" can even entail "the possibility of its own self-destruction" (p. 93). The possibility of self-destruction inherent in the self's storytelling is obviously reminiscent of Levinas' conception of the subject as a substitution for the other. In fact, Kearney (1999), basing his argument on Levinas' ethics, clearly states that ethical imagination "responds to the surprises and demands of the other" (p. 111). As Levinas defines subjectivity as the-one-for-the-other, the ethics of imagination originates from acknowledging the other's face that concerns the self, and this acknowledgment prevents the self from remaining indifferent to the other. This non-indifference to the other thus renders impossible the self's imagination solely as a means for self-affirmation. Therefore, subjectivity as storyability can be understood to be always connected with the other's questioning of the legitimacy of the self's story. Storytelling is not merely fabricating a fictional narrative, but it also entails constructing selfhood and connecting the self's ethical commitment to the other.

The Angry Roads (2014) revolves around the possibility of telling an untold story based on uncertain facts and how the process of telling a story can challenge the subject's sense of self and makes possible a new sense of self. The play focuses on the process of Norman's awakening to the truth about his father's past. In the process, however, because of his father's selective mutism,

Norman must recall the past by means of his imagination and his communication with his father through table-knocking. The truth repressed by his father is a case of murder: before Norman was born, the Father killed a woman with whom he had affairs and her baby by driving his taxi over their bodies. There are two interrelated details about the murder which are important but not specified: one is about the reason for the 'row' which gave rise to the murder; the other is about Norman's role in the murder. Norman once asks his father, "I was there? - There? - When you killed the - ?" (Bond, 2018, p. 168). It is implied that, although Norman was not yet born, he was also 'present' at the site of the killing. It is implied that the Father's wife could be pregnant at that moment, and Norman's existence might make the Father decide to end his affairs with the woman. However, the woman might quarrel with the Father over their relationship and their son, so the Father, feeling unable to cope with the situation, decides to kill the woman and the baby deliberately. Norman's mother knew about the murder, and she decided to leave Norman and his Father when Norman was six because she was unable to bear the intolerable pain caused by the event. According to Norman, his mother used to tell him about part of the event, but she never revealed the whole truth to him. Therefore, in reconstructing the truth of the murder, he can only rely on his imagination and his communication with his father through table-knocking.

Norman's quest for the truth is both a process of breaking the structure of egoism and a rite of passage toward a renewed understanding of the self in relation to the other. The significance of this process can be understood through Bond's conception of the child's quest for his or her right to be in the world and the adult's desire for justice: "The idea of the right to be in the world endures - for the same reason that it originates in the child, as a concomitant of coherence - in adults as the desire for justice. This is the origin of Value" (Bond, 2000, p. 116). Norman's quest for the truth of his brother's premature death is not a quest to affirm his right to be at home in this world but, rather, a quest to inquire why his brother is denied the right to be in this world. The question is why Norman and his brother fail to be 'at home' together, and the answer is that it is because Norman occupies the place of his brother. Norman's 'right to be in this world' therefore presupposes his brother's death, and Norman's awareness of this fact puts the value of his own existence into question.

Norman's recollection is not completely motivated by his own will. Rather, he is obliged by a heterogeneous force to bear witness to his brother's death, as he admits that he is "haunted by sounds no one else notices" (Bond, 2018 p. 164) and feels guilty without knowing the reasons: "I don't even know what Im [*sic*] supposed to be guilty of!" (p. 162). Norman's rite of passage does not lead to an autonomous self but a traumatized ethical self who acknowledges the violence

inherent within the assertion of the self and recognizes the irreversible death of the other due to his existence.

Levinas (1998) states, "To be oneself, the state of being is a hostage, is always to have one degree of responsibility more, the responsibility for the responsibility of the other" (p. 117). For Levinas, the ethical subject as the one-for-the-other is always already a subject of responsibility, a subject who bears "guilt without fault" (Levinas, 2001, p. 52). Therefore, although Norman was not directly involved in the death of his brother, this by no means diminishes his sense of guilt for his brother's death. The fact that he cannot be indifferent to his brother's death testifies to his being a subject who is, to use Levinas's terms, 'non-indifferent' to the other.

While Norman can communicate with his father through table-knocking, he can also understand his father through silence. His father's mutism, caused by the traumatic event, is an enigma for Norman, and it is this enigma that situates Norman within the shadow of the tragedy even though he has never experienced it in person. Unlike the silence that refuses communication, Norman can hear his father's voice even in his silence, as he states, "I heard my father's voice" (Bond, 2018, p. 174). For Norman, the dead brother's spectral return also "seeps out of the silence" (p. 174). According to Levinas (1969), "silence is not a simple absence of speech; speech lies in the depths of silence like a laughter perfidiously held back. It is the inverse of language: the interlocutor has given a sign, but has declined every interpretation; this is the silence that terrifies" (p. 91). Silence thus "appears within a relation with the Other, as the sign the Other delivers, even if he dissimulates his face" (Levinas, 1969, p. 93). Norman's endeavor to understand his father's table-knocking and silence is thus not merely about discovering the traumatic past. Rather, this endeavor to understand is about approaching the otherness that obliges the subject to respond to it - for Norman. This means confronting the unbearable truth about his own birth as the cause of his brother's death. Norman's own story can never be complete if he fails to tell the insupportable story, nor can his future be possible without basing his self-knowledge on this truth.

In Big Brum's production, Richard Holmes's performance of the Father's action of table-knocking retained an enigmatic quality. While it is tempting for the actor and spectator to try to decipher the meaning of the sound, Holmes's performance made this method of communication seem 'natural' for the Father and Norman without emphasizing its peculiarity - it is just another language that is shared by him and Norman. This nuanced effect can be difficult to achieve, as Holmes states,

> The hardest thing I found as an actor was not to over-explain the story through the knocks or make the father's silence mystical or menacing. I

couldn't do the audiences work for them, while at the same time doing enough to let them into the story and accept, quickly, this is how it is" (as cited in Wooster, 2015, p. 15).

The way Danny O'Grady performed Norman also preserved the enigmatic quality of the interaction between the Father and Norman. Notwithstanding the difference in age between him and Norman, O'Grady's performance remained demonstrative and neutral instead of trying to imitate a teenager's behavior. It was this method of performance that made it possible for the spectator to feel distanced and involved simultaneously.

Moreover, when the Father goes into the kitchen after Norman leaves the house, the spectator can hear the Father's two knocks from off stage. Since Norman, who can understand the Father's knocking sound, has left the house, the spectator is encouraged to decipher what the Father is trying to convey and communicate. As Norman, through his interaction with the Father, has made the invisible object visible, that is, he has discovered the hidden truth of the past - the spectator is now invited to actively participate in interpreting the Father's knocking in order to make the invisible object visible. Therefore, we can see that Bond's dramaturgy of the invisible object not only demonstrates through the performance how the invisible object can be made visible, but this dramaturgy also aims to make the spectator's theatrical experience participatory.

Conclusion

In this chapter, I have analyzed the dramaturgical features utilized by Bond in his TIE plays that open the possibility of ethical learning in response to the post-Auschwitz neoliberal world order. According to Big Brum, "in the specific site of the story, Bond's dramaturgy creates a gap in meaning for the audience as the site of the imagination to step into and fill for itself" (Ballin & Cooper, 2013, p. 24). Through analyzing *The Under Room (2005), The Hungry Bowl (2012),* and *The Angry Roads (2014),* I have argued that what makes this gap possible is Bond's dramaturgy of the invisible object through the deployment of various forms of alterity. The invisible object in these plays is manifested in the form of an intruding foreigner, an invisible specter, or an untold story. In dealing with the invisible object, the characters always need to face the hidden structures of injustice, take action, and undergo a transformation of the self. In production, Bond's dramaturgy of the invisible object also encourages the actors to adopt a style of performance that can invite the spectator to experience this process of encountering otherness. For Bond, only by basing TIE plays on the experience of encountering alterity can the aims of TIE education - to cultivate autonomy and responsibility for others among students - be achieved.

References

Ballin, B. & Cooper, C. (2013). 'The edge': Teachers' resource. Big Brum Archive, Birmingham.

Big Brum TIE. (2013, January 8). *The Broken Bowl - full play - part 1* [Video file]. Retrieved from https://www.youtube.com/watch?v=QkwOugxkBqE

Big Brum TIE. (2013, January 9). *The Broken Bowl - full play - part 2* [Video file]. Retrieved from https://www.youtube.com/watch?v=eIaL0S1CNU0

Big Brum TIE. (2013, January 9). *The Broken Bowl - full play - part 3* [Video file]. Retrieved from https://www.youtube.com/watch?v=-_7LEnxVn1c

Big Brum TIE. (2013, January 10). *The Broken Bowl - full play - part 4* [Video file]. Retrieved from https://www.youtube.com/watch?v=DgzLc9k70xA

Big Brum TIE. (2013, January 10). *The Broken Bowl - full play - part 5* [Video file]. Retrieved from https://www.youtube.com/watch?v=yqxFAzwmo64

Bond, E. (1996). Rough notes on theatre. *SCYPT Journal*(31), pp. 8-17.

Bond, E. (2000). *The hidden plot: Notes on theatre and the state.* London: Methuen.

Bond, E. (2004). Modern drama and the invisible object. *Journal for Drama in Education, 20*(2), pp. 24-32.

Bond, E. (2005). Drama devices. In D. Davis (Ed.), *Edward Bond and the dramatic child: Edward Bond's plays for young people* (pp. 84-92). Stoke on Trent: Trentham Books.

Bond, E. (2006). *Plays: 8.* London: Methuen.

Bond, E. (2018). *Plays: 10.* London: Methuen.

Butler, J. (2004). *Precarious life: The power of mourning and violence.* London: Verso.

Butler, J. (2009). *Frames of war: When is life grievable?* London: Verso.

Cooper, C. (Director). (*n.d.*) *The under room.* [Video file]. Big Brum Archive, Birmingham.

Cooper, C. (Director). (2015, February 10). *The angry roads.* Live performance at Midlands Arts Centre, Birmingham.

Derrida, J. (1994). *Specters of Marx: The state of the debt, the work of mourning and the new international* (P. Kamuf, Trans.). New York: Routledge.

Derrida, J., & Dufourmantelle, A. (2000). *Of hospitality: Anne Dufourmantelle invites Jacques Derrida to respond* (R. Bowlby, Trans.). Stanford: Stanford University Press.

Gordon, A. F. (2008). *Ghostly matters: Hauntings and the sociological imagination.* Minneapolis: University of Minnesota Press.

Horkheimer, M. & Adorno, T. (1972). On the theory of ghosts. In T. Adorno, & M. Horkheimer, *Dialectic of enlightenment*, (trans. John Cumming). London: Allen Lane.

Kearney, R. (1999). *Poetics of modernity: Toward a hermeneutic imagination.* New York: Humanity Books.

Kearney, R. (2002a). Ethics of the narrative self. In M. Verdicchio & R. Burch (Eds.), *Between philosophy and poetry: Writing, rhythm, history* (pp. 91-98). New York: Continuum.

Kearney, R. (2002b). *On stories.* London: Routledge.

Kristeva, J. (1991). *Strangers to ourselves* (L. S. Roudiez, Trans.). New York: Columbia University Press.

Levinas, E. (1969). *Totality and infinity* (A. Lingis, Trans.). Pennsylvania: Duquesne University Press.

Levinas, E. (1998). *Otherwise than being or beyond essence* (A. Lingis, Trans.). Pennsylvania: Duquesne University Press.

Levinas, E. (2001). *Is it righteous to be?: Interviews with Emmanuel Levinas.* Stanford: Stanford University Press.

Nicholson, H. (2003). Acting, creativity, and social justice: Edward Bond's The Children. *Research in Drama Education, 8*(1), 9-23. doi:10.1080/13569780308325

Nicholson, H. (2009). *Theatre & education.* Basingstoke: Palgrave Macmillan.

Stuart, I. (Ed.) (1998). *Edward Bond: Letters 4.* New York: Routledge.

Stuart, I. (Ed.) (2001). *Edward Bond: Letters 5.* New York: Routledge.

Tuaillon, D. (2015). *Edward Bond: The playwright speaks.* London: Bloomsbury.

Vygotsky, L. S. (1978). *Mind in society: The development of higher psychological processes.* Cambridge, Massachusetts: Harvard University Press.

Winnicott, D. W. (2005). *Playing and reality.* London: Routledge.

Wooster, R. (2015). *The Angry Roads*: Richard Holmes and Danny O'Grady interviewed by Roger Wooster. *The Journal for Drama in Education, 31*(1), pp. 15-23.

Wooster, R. (2016). *Theatre in education in Britain: Origins, development and influence.* London: Bloomsbury.

Žižek, S. (1994). The specter of ideology. In S. Žižek (Ed.), *Mapping ideology* (pp. 1-33). London: Verso.

Chapter 2
Bond's Psychological Drama:
Neurosis in *The Children*

Cüneyt Özata
Ordu University, Türkiye

Abstract

Children have mostly been perceived as pillars of innocence in literature and this theme has been restated by many literary figures in their works since time immemorial. This notion is frequently juxtaposed with adulthood, either through peopling works with older figures or attributing the qualities of adulthood to children. This liberal humanist take on binary oppositions, such as innocence vs adulthood, has seen decline with postmodern thinking by which grand narratives are no longer deemed influential. Children in literary works of recent times have more complex narratives whereby psychological, sociological or political implications can be witnessed and Edward Bond and his dramatic works are no exception to this rule. In many of his works, Bond tackles the issues surrounding children and their relationship to their surroundings in terms of family, parenthood and what childhood means. The children's victimised and otherised status, the ageist attitude of adult figures in the play towards them and the abuse and harassment they are subjected to are some of these instances Bond has problematised. In his play *The Children*, similar problems persist and a reading of the work with regards to the dynamics between children and adults shows how abuse, in any form, has affected not only the children's current state but also their future parental decisions. The family dynamics, unsurprisingly dysfunctional, causes the figures in the play to have the characteristics of a neurotic being, best witnessed in the character Joe, whose indecisive nature, and lack of agency and self-confidence illustrate his neurotic existence.

Keywords: Edward Bond, Bondian Drama, Children

Introduction

It is inevitable that different social and cultural circumstances will impact how some abstractions are susceptible to change. There has never been a time when human nature did not play a significant role in determining what constitutes good and evil, and religion is not an exception to this rule. The story of Jesus and the woman who committed adultery is an example of how these abstractions are mutable. In the passage, a woman caught red-handed in an adulterous affair is brought before Jesus, who judges the woman, saying, "let any one of you who is without sin be the first throw a stone at her" (John 8, 7). One by one, each man withdraws from the scene as they, one way or another, have committed a sin; therefore, they are not a bastion of innocence. Jesus is the only one left and deemed to be the one to have the first throw, yet he hesitates and asks the woman whether anyone condemned her, to which she says no. Upon hearing this, Jesus does not condemn her either and lets her go off with a warning: to sin no more. What most scriptures rely on is the relationship between innocence and mercy. Through Jesus, for instance, it is told that to be merciful is an act innate in the hearts of the innocent. However, human nature and condition are never stable enough to provide continuity to the universally accepted notions of innocence and mercy as history has repeatedly proven. A brief look at the state of the so-called modernized world of our time would no doubt lead one to contemplate the likelihood of the woman being torn to shreds by the very men who were supposed to stone her, let alone showing mercy, had the incident occurred at a closer period. Indeed, all Jesus could do in such a case would be to face the bloodied body of the wronged woman, each limb occupying a kind of space that is filled with indifference as well as disregard for the notion of innocence, and to shed tears of contempt, thinking of how misplaced and spiteful the seemingly advanced world and its 'loving' inhabitants really are.

At the top of this chain consisting of man and woman regarding innocence and mercy in this earthly sphere, it is expected to ask where children stand. In general understanding, they are entitled or more truly 'gifted' with innocence. However, children, associated universally with innocence and purity of the soul, are disregarded by many when the idea that the end justifies the means comes into play. Countless wars have seen children as the victims of hard-hearted men whose agenda is not one of a place of perpetual harmony but one of chaos from which they gain the power to exert their authority. Thus, the innocent and the merciful passing judgment on those considered to be malicious and malevolent have turned into the victims of oppressive evil behavior, action, or ideology. The mutable nature of abstractions such as mercy and innocence are then parallel to how socio-political contexts and religious-cultural factors

shape the human condition and agency, a fact a political playwright, Edward Bond, has consistently demonstrated through his works time and again.

The Second World War, when humanity's psychology was shattered and suffered a great number of losses as well as immense amounts of destruction, is considered to be the most shocking incident in human history. Many people believe that the worst and most agonizing tragedy in human history was the moment when Hell mixed with Earth. When Bond was too young to see such tragic events, in 1934, he was forced to face the most terrible and nightmare-inducing violent sights that resulted in the deaths of many people. Bond felt the catastrophic impacts of this conflict. Bond speaks in a statement on his own experiences growing up amid such turmoil and terror; "I was first bombed when I was five, the bombing went on till I was eleven" (Bond, 2000b, p. 2). He strongly felt the tragic atmosphere of the war's aftermath when, in 1944, he and his parents traveled to London. When Bond's schooling began, the production of Macbeth by Donald Wolfit at the Bedfort Theatre marked a turning point in his life since it was the first time he realized that theater is a genre that discloses reality in a specific and vivid manner. After seeing this act live, he states: "if only more teachers were like Macbeth" (Bond, 2005, p. 4) to demonstrate how he was influenced by the theatre itself and how this experience urged him to be a playwright. In light of his career, it is quite possible to divide Bond's playwriting into three basic periods; the plays of the first period can be classified from *The Pope's Wedding* in 1962 to *The Sea* in 1973, the plays of the second period include the ones starting from *Bingo* (1973) to *In the Company of Men (1992)* and the plays which can be thought as the ones of the third period start with *Olly's Prison* (1993), continue with *Tune* (2007), ending with the Big Brums plays written on behalf of children. As the author emphasizes, children are the ones who change the world in these plays, and the importance of Big Brum's plays in Bond's life is entirely undeniable. Bond emphasizes the importance of children and their contribution to society by advocating for 'radical innocence,' a concept used by the writer and defined as every inborn kid is naturally pure. However, according to Bondian philosophy, this innocence perishes over time as a result of the ideological frameworks and systematic impositions of the society itself, as well as the infectious violence that is "always principally a product and symptom of corrupt and exploitative social organizations" (Billingham, 2014, p. 6). Within a gradual process of dehumanization, children become indifferent to their environment, thereby being victimized systematically.

According to Bond, who views children as the building blocks of future civilizations, children have been seen and understood in culturally distinct ways throughout history. A child's psychological, physical, and emotional development is greatly influenced by the social and familial milieu into which he or she is born. The mother figure serves as both the kid's mysterious carrier

into the world and a type of refuge where the infant is continuously supported, nurtured, and loved without condition. Having emotional interactions with the mother is crucial for a child's growth. Thus, the child primarily needs intimacy in interaction, pursuing a warm and healthy relationship with his mother (Bolwby, 1952, p. 11). In this situation, the mother should make the initial move toward securing the child's position in society. The father, who also has a big influence on the development of the kid, must help the mother since she is unable to shield the child from external threats on her own. When both parents struggle with 'parenting,' they make kids more susceptible to child abuse, which is more prevalent and on the rise in today's society than ever. Oxford Dictionary identifies child abuse as "the crime of harming a child in a physical, sexual or emotional way" (oxfordlearnersdictionaries.com, n.d.), whereas Cambridge labels this case as "cruel and violent treatment of children by adults." However, World Health Organization (WHO) elaborately defines this maltreatment as;

> ... the abuse and neglect that occurs to children under 18 years of age. It includes all types of physical and/or emotional ill-treatment, sexual abuse, neglect, negligence, and commercial or other exploitation, which results in actual or potential harm to the child's health, survival, development, or dignity in the context of a relationship of responsibility, trust or power (who.int, n.d.).

In light of the above definitions, child abuse, or more specifically, ignoring or taking advantage of a kid's physiological, sexual, or emotional needs, has been considered a severe issue that may disrupt a child's development and cause permanent trauma to the 'self.' This mistreatment of children has a negative influence on their social and moral development in addition to their psychology and physiology. A child who has experienced ongoing abuse, or more accurately, maltreatment, is more prone to develop neuroses throughout infancy and into adulthood. He or she goes through a lifetime-long psychological process known as neurosis. The term 'neurosis' , which was initially used by William Cullen and then developed or reinterpreted by Sigmund Freud, refers to a psychological disorder with visible behavioristic symptoms that may affect people of all ages (Freud, 2011). Although it is mostly linked to a human situation in which the ego struggles with the id to maintain equilibrium and the "repressed" emerges (Freud, 2015), it can be labeled as a disorder coming to light in being with anger, anxiety, and fear. This human condition can also be defined as "the formation of behavioral and psychosomatic symptoms as a result of the return of the repressed" (Felluga, 2011, line 2). In other terms, it is "a psychic disturbance brought about by fears and defenses against these fears, and by attempts to find compromise solutions for conflicting tendencies" (Horney, 1999, pp. 28-29). It is generally strongly correlated with the stages of a

child's growth, and its origins may even be seen in early infancy. Some signs of neurosis that seeps into one's 'self' include the need for attention from parents or others, the exploitation of sentiments, and persistent worry. Here, it may be accurate to draw a connection between child abuse and neurosis since it has the potential to be one of the factors that set off the onset of neurosis in an individual.

Neurotic 'Beings' in *The Children (2000)*

Bond, who portrays children as the victimized agents of society, reshapes his understanding of children and produces such works revolving around neurotic children victimized by every layer of society and the issue of child abuse which is harshly criticized by the playwright himself. He tries to replicate the exploited, mistreated, abused, and corrupted children in society via the portrayal of children, with the intention of making his subjects become neurotic individuals. One good example of the description of neurotic people is The *Children* (2000), the first performance of which was at Manor Community College in Cambridge by the Theatre of Classwork. The play, which is specifically directed at children, explores a tense family dynamic between a neurotic mother and a neurotic youngster who may be seen as 'innocent' but who is repeatedly and emotionally mistreated by his mother. The play's main focus is the little boy called Joe, who displays persistent worry, dread, rage, and internal conflict as typical symptoms of neurosis.

In the play's opening scene, Joe, dressed in his school uniform and standing in a lonely train station, exhibits apprehensive actions that are at odds with his own thoughts. As the performance goes along, it becomes clearer that he is speaking to a puppet that resembles Joe behaving affectionately toward it as if it were a real kid. He creates the idea that he either has uneasiness or loneliness because of his initial appearance in the play and his chat with an inanimate item. Due to his ongoing anxiety and loneliness, Joe is "vulnerable with a conviction of being isolated and helpless in a possibly unkind world" (Solomon, 2006, p. 14). He wants to get in touch with this puppet to communicate his compassionate side by feeding it 'sweets' to lessen his agonizing sensations. However, Joe's divided being and inability to heal it—or, to put it another way, to put a stop to the battle with himself – are shown by his violent acts on one side and compassionate views on the other, such as hitting the puppet first and then showing affection towards it. Joe's puppet's precarious existence serves as a sinister metaphor for his own shattered identity. (Billingham, 2014, p. 120). When his neurotic condition manifests itself, he reveals his suppressed emotions brutally via the puppet. His accusations against the puppet included such like "you get me into trouble. Didn't go to school because of you. Mom won't have you in the house" (Bond, 2000a, p. 5) and using the fag money his

mother gave him to purchase cigarettes to buy sweets are such that they suggest the mother in this situation has poor habits, and this case also raises the issue of why she provides money to a kid to buy something hazardous for him. In this instance, it is made clear that Joe's mother is the primary cause of his worry and internal conflict. He aggressively approaches the puppet in an effort to both overcome and empathize with his apprehensive state. Joe behaves toward the puppet in a way that combines anxiety and dread, two very different emotions, as they both follow him in his perplexing relationship with the toy. In fact, there is a transparent and constant idea in anxiety while fear, as "arguably the most sinister of the demons nesting in the open societies of our time" (Bauman, 2007, p. 25), is mostly associated with a concrete, feared object. In Joe's condition, a continuous anxious state, the genuine source of which remains unknown to the audience, is maintained with the fear of his mother, which frightens him to death. In other words, the conversations between Joe and the puppet emphasize how Joe's mother's attitudes and behaviors – constantly beating him or abusing him emotionally – fuel his neurotic fear. Because anxiety is the primary agent in all neuroses and is followed by defenses against it (Horney, 1999, p. 23), Joe's interaction with the puppet feeds his anxiety and defensive mechanisms. This case is pinpointed by Joe's remarks; "anything goes wrong in our house Mum hits me. Don't know why. Am I supposed to change the world?" (Bond, 2000a, p. 6). The words he makes reflect his protective posture against his controlling mother. Similar to how neurotic people lose their feeling of security or belonging, Joe represents this deficiency throughout the play as a neurotic youngster;

> ... does not develop a feeling of belonging, of "we," but instead a profound insecurity and vague apprehensiveness, for which I use the term *basic anxiety.* It is his feeling of being isolated and helpless in a world conceived as potentially hostile. The cramping pressure of his basic anxiety prevents the child from relating himself to others with the spontaneity of his real feelings, and forces him to find ways to cope with them (Horney, 1950, p. 18).

In addition to being abused by his mother, who is unable to shield him from harm and provide a safe haven, Joe also suffers from the absence of the other parent, an invisible father figure who acts as another unseen abuser by failing to perform what is required of him as a parent – to love his child. The chats between Joe and his mother provide insight into this father's personality. Joe, on the other hand, illustrates a child who is unable to complete his emotional development and build his superego because of the absence of his father because he is unable to overcome his Oedipal complex, which is a phase to be conquered in the phallic condition of child development. His condition causes neurotic conflict, which "can best be explained structurally as a conflict

between the forces of the ego on the one hand and the id on the other" (as cited in Horney, 1973, p. 13). As a consequence, through the lack of each parent's love and affection, Joe's self is devastated and fractured with the contribution of his self-hatred as "the greatest tragedy of the human mind" (Horney, 1950, p. 154). He beats the puppet as a gesture of getting revenge on his parents to use the puppet to express his anguish and sadness. Joe, in contradiction to his inner personality, develops into a neurotic child, which is expedited by the breakdown of his mother and father relationships in his so-called 'home,' which is supposed to be a safe place where the child may find refuge.

Additionally, as shown in the play's stage directions, the puppet whose head is often smashed with a brick serves as an objectification of his mother's beatings, humiliation, and multifaceted abuse; "he drops the brick on the puppet's head. He goes out and comes back with a brick. He drops it on the puppet's head" (Bond, 2000a, p. 6). Just as physical and psychological cruelty was meted out to Joe, so was torment inflicted on the puppet. In his interaction with this impersonal object, the inner, neurotic struggle that seems to have been passed down from his mother becomes visible. Ironically, a neurotic Joe treats the puppet, which serves as a mirror to his powerlessness and his urge for violence, as if he were pleading for forgiveness. The puppet is ruthlessly struck five times in the head with a brick before being taken home after he subsequently chooses to kill it in case no one tries to remove it from him. It might be said that by studying his delicate and complex connection with the puppet, his inconsistent actions and emotions reveal an unhealthy and unstable relationship with his mother. Joe, with whom Bond tries to spread awareness while also fostering sensitivity, is shown as a young child dealing with persistent behavioral issues. Joe, a neurotic youngster who seems to be devoid of parental affection in an unfair world, is pulled from one direction to the other while barely trying to hang on to life. In Bond's words and in the condition of Joe, a society that is shaped as unjust and governed by laws will possibly lead to violence and antisocial behavior (Bond, 1998, p. 117). Through a picture of an insecure society riddled with violent acts, Joe, as a symbol of innocence, is victimized first by his parents and then, more deeply, by the civilization itself. However, the innocent puppet, which is only a mirror of Joe's suppressed anger and violence, is assaulted by his owner, demonstrating the terrible circle of victimization and insecurity in contemporary society. Apparently, in the world of Bond pictures, nobody is secure, and everybody is likely to be the victim of revengeful anger no matter how s/he is innocent or guilty (Bauman, 2018, p. 41). A sharp transition from innocence to violence, the gradual destruction of innocent nature as well as the emergence of neurosis are the developmental steps being witnessed in Joe's actions toward his puppet, which displays a traumatic scene for Bond's audience and readers. Violence and caring, two opposite concepts, are intermingled (Allen, 2007, p. 124). Each of

Bond's creations paints a vision of a world that is traumatized and full of violence, fear, anxiety, loneliness, menace, and an unfulfilled longing to love and be loved (Sharma, 2012) and Joe is a pathetic child as the embodiment of all these social drawbacks.

Besides Joe's portrayal as a neurotic child, a mother image modeled as the source of love and affection is rebutted through a contrasting image with psychological issues in this play. No matter how she is unaware of her abuse, she unintentionally maltreats her child. The basic ways to abuse a child can be classified as despising, insulting, embarrassing, criticizing, threatening, accusing, and giving harsh responsibilities, all of which the mother figure shows in the play to corrupt and also to terrorize Joe. Once Joe arrives at his 'secure' home, his mother wants him to promise to do what she asks for without explaining the request, which makes Joe suspicious and want to know what it is. His mother tells him she has done everything for him and other children to do what their mothers ask for without questioning, and finally, she assaults the 'unfaithful' father to whom Joe is also accused of bearing resemblance. In the scene where child abuse becomes the matter, the mother attempts to make him do what she wants, and his neurosis is triggered, which becomes clear in his behaviors as a neurotic child "incapable of defending himself against attack, or of saying 'no'" (Horney, 1999, p. 38). In demanding full devotion from Joe, the mother is also portrayed as a neurotic one who expects something in return and also "who is proud of being the perfect mother ... in her imagination only" (Horney, 1950, p. 93). In line with this, Horney (1937) remarks about neurotic mothers that "there are mothers who rather naively feel justified in expecting blind devotion and sacrifices of all sorts from their children because they have 'borne them in pain'" (p. 133). Since she considers she has a right to ask for everything, Joe is supposed to turn into a puppet-like son that she can orient and shape as she likes it since she feels the pain to give him a life. Her explicit dissatisfaction with her daily life and hidden disappointments about her past life resonates in her abuse, inability to care, and frustration toward her son. These indicators of her neurosis are manifested through the play in such a way as to break the ties with her son, thus creating a dysfunctional mother-son relationship.

In accepting the insistent request, or imposition, in fact, of his mother, Joe asks about what he is going to do on his behalf of her. Yet, his mother seems hesitant about whether to tell or not due to her suspicion of his agreement or hesitation to do what she wants. Through several attempts to manipulate Joe and with refrainment from explicit statements, she implicitly persuades him to set a house on fire because the fear of losing the affection of his only parent outweighs his indisposition to a criminal act. Beyond this unwillingness, Joe is anxious about being disapproved by his mother in that the fear of disapproval is quite prevalent in neurosis (Horney, 1999, p. 235). His mother continues to

impose, putting him in danger of committing suicide in a situation when parenthood is called into question. Her argument that Joe will be lonely if she sets the home on fire and is apprehended by the authorities, but he won't be punished if he does, demonstrates her persuasive abilities. A youngster is mistreated by his unstable and mentally disturbed mother in this horrific discussion between a neurotic mother and her afflicted child, which features various neurotic conflicts:

> Mother: No - no -I couldn't! Couldn't! No- I'd never put you through that. If ever I kill myself I wouldn't tell you. You'd have to come home one day and find me on the floor. If you do this - for us - our suffering's over. (*she calms herself, straightens her dress.*) you haven't got a fag on you? I know what you kids get up to. I'm dying for a ciggie... (*No answer. She reaches for him.*) Don't pull away. I can tell you when you're close. Am I such a bad mother? – my own son thinks I'm asking him to help me do away with myself... poor kid.
>
> Joe: (*becoming calm*) Tell me Mum.
>
> Mother: I'll give you an address. A house on the new estate. You can't miss it. They've only finished one street. The rest's still mud. It's got a mauve door.
>
> Joe: Mauve.
>
> Mother: Go in daylight hours. Make sure you know the house. Go back in the dark. Set it on fire. Burn it down. Your father left his old cans in the shed – done some good for a change. Carry the petrol in that. The workmen leave wood and stuff lying round. It's all flammable. They're so lazy they probably left the petrol for the machines. Barrrow that (Bond, 2000a, p. 11).

As may be inferred from their conversation, Joe discovers he has little choice but to comply with his violent mother's ridiculous request and finds himself in a precarious position. Joe regrets returning home and, in a panic-like state, departs the house without even sipping the tea he has been heating up since he arrived. He cannot find tranquility or love from his relatives here. Although his mother is supposed to be the one who loves and cares for him without conditions, she even disregards Joe's sustenance, which violates a child's fundamental need and drives him to commit a crime. Joe suppresses his angry impulses toward his mother, whom he both loves and hates and instead directs his rage toward himself and the outside world, which is replicated in the puppet. Horney discusses suppression, which is shown in the formation of neurosis in relation to Joe's condition:

> But whether one controls or represses hostility is not a matter of choice, because repression is a reflex-like process. It occurs if in a particular

situation it is unbearable to be aware that one is hostile. In such a case, of course, there is no possibility of conscious control. The main reasons why awareness of hostility may be unbearable are that one may love or need a person at the same time that one is hostile toward him, that one may not want to see the reasons, such as envy or possessiveness, which have promoted the hostility, or that it may be frightening to recognize within one's self hostility toward anyone. In such circumstances repression is the shortest and quickest way toward an immediate reassurance. By repression the frightening hostility disappears from awareness, or is kept from entering awareness (Horney, 1937, p. 66).

Shocked by his mother's attitude and struggling with suppressed emotions, Joe rushes to see his friends and asks them what he should do. They demonstrate that they go through the same process – neurosis arising from their severed family ties – by telling him that they would set the home on fire if they were in his shoes. A guy dressed as a child approaches them in the midst of their chat, showing the neurotic issues that have been sparked. It feels really uncomfortable. The kids inquire about the strange man's name out of irritation at his sudden entrance, but he quickly leaves. The audience is not informed as to whether or not this scene is a creation of the children's imagination. Bond's portrayal of this unusual figure blurs the line between fact and fiction.

Through the words and support of his friends, Joe, who is disoriented in both reality and his fantasy, begins to see his mother's request as a straightforward deed that any youngster should be willing to execute. He feels he can set the home on fire since he isn't old enough to ask why his mother wants what she wants. At this point, Joe, who has been turned into a neurotic by his own mother, accedes to the demands of his corrupting and abusive mother. Later, he presents his puppet to his friends, who begin swearing never to speak about the crime to anybody while pounding the puppet with a brick and seeming to pass out as if it were a ceremony. The beating and stoning of the puppet expose his companions' propensity for using violence. Through his puppet, Joe not only illustrates neurotic meanings but also his friends show their suppressed aggressive tendencies, which causes them to represent themselves as neurotic children. Joe and his friends are socially isolated from their surroundings and find it difficult to control their aggressive urges. They become estranged from and alienated from themselves as a result of losing contact with the world, which is Bond's universe is fairly hostile from the start. As a usual outcome of neurosis, highly suffocated by his/her inner stress, a person is likely to become alienated from his/her real self (Horney, 1950, p. 13). Their current situation can be best exemplified in the explanation of alienation which is generally attributed to loneliness, incapability, despair, fear, anxiety, and anger which come out instantly because the being detects and undergoes a kind of split

between who s/he is and whom s/he considers s/he should be (Rae, 2011, p. 1). Alienation which is observed through all the children in the play as much as acting as an agent to orient them also brings confusion to the surface as Horney (1950) propounds:

> His feelings and wishes thus cease to be determining factors; he is no longer, so to speak, the driver, but is driven. Also the division in himself not only weakens him in general, but reinforces the alienation by adding an element of confusion; he no longer knows where he stands, or "who" he is (p. 21).

The neurotic children in the play roam about helplessly to express their inner tension, displaying aggressive attitudes as a result of being trapped in a perplexing and mind-boggling environment. In this scenario centered on the formation of neurosis, Bond aims to demonstrate that violence is contagious since all children like using it and are already used to it. This violence has its origins in the home and spreads to society as a whole. When his friends leave him alone, Joe displays his innocence and childlike nature by giving candy to the puppet as if it were some kind of forgiveness for his wrongdoings. When he gets back home, he informs his mother that he has already set the house on fire, but she freaks out at the news. She accuses him of setting the home on fire and denies being involved in the case, tormenting him both mentally and physically in the process:

> Joe: Mum you told me to do -!
>
> Mother: Stop it! Stop it! Don't ever say that! I'll wash your mouth out in disinfectant! Told you to burn a house? What mother would tell her child to do that. She'd be a monster! No one would believe you! (Bond, 2000a, p. 22).

She seems very anxious as she moves frantically about the room, trying to clean Joe's clothing in a manner that would remove any evidence of his son's guilt – or perhaps her guilt – for the crime. As Furedi (2002) emphasizes, "the disposition to panic, the remarkable dread of strangers, and the feebleness of relations of trust have all had important implications for everyday life. These trends have also altered the way in which people regard each other" (p. 147). The fragile bond and shattered trust between a mother and a son put them in a position of being strangers to each other. This scene, in which a psychological clash appears between a neurotic mother and son is interrupted by the arrival of Jill, who tells them a boy has died in a house that has been instigated by Joe. Upon hearing this, his mother frightens into panic and starts to shout. Joe gradually recognizes his action as a crime when he understands this is not a childish game and heroic action for his mother, which results in the death of an innocent child. He is forced to be a murderer, not a hero, by his mother. The

words uttered by his mother reveal the fact that he is now alone to bear the consequences of his crime which dispels his innocence as much as preparing a future danger that is the fear of being caught and punished by the police. In the face of danger, he "remains infantile in his attitude towards danger, and has not grown out of antiquated conditions for anxiety" (Freud, 2001, p. 123). He leaves the house to meet his friends and share his fear with them, rushing into the railway station. All of them decide to run away from the police, embarking on their journey in which they are lost in meaninglessness. The children who surpass the boundary between morality and criminality are such to prove Bond's statement on this play; "it takes the audience on a journey across the cultural, political barriers to justice and understanding – and their counterparts in our psychologies" (Bond, 2001, p. 17). Already having lost their innocence and ability to seek human justice within this hostile environment, which victimizes them from the very beginning to the end, the children lose their identity, whereas their neurotic conflicts come forth from obscurity with an abrupt invasion of anxiety and fear. Bond clarifies this journey laden with neurotic anxiety in *The Children* in such a statement:

> The play does not describe the journey in an abstract way, but creates the experience of the journey through the intense concentration, which is the secret of drama. The young people who go on the journey in *The Children*, are the only ones who can save themselves-helped perhaps by adults who have also made journey and learnt to replace revenge with justice, anger with care (Bond, 2000c).

Inherited from their parents, the desire for justice and consuming rage against the unjust order they are stuck in are two close friends who accompany them on their journey as well as preparing them to be neurotic adults in the future. However, during their escape, the environment is deserted in that there is no sign of living, with which Bond endeavors to picture a world in which the children are left to their fate while setting out on a journey to "a post-apocalyptic world" (as cited in Allen, 2005, p. 149) or proceeding "from fear of the future and to a future of fear" (Furedi, 2018, p. 66). Their anxious and fearful behaviors are echoed in the conversation between Jill and Joe:

> Jill (*points*): Those trees are dying. I think the soil's turning grey.
>
> *They sit*
>
> Joe: They said this would happen. It was on the news.
>
> Jill: Not this. This is too quick.
>
> Joe: Suppose it comes to a point where it has to happen. After that, you can't stop it.
>
> Jill: Perhaps we should camp here and let it happen.

Joe: Have to move on for food

Jill: When winter comes –

Joe: (*stands, calls*) Oi! (*To* Jill.) We'll manage all right.

Jill: Don't believe it anymore. We're going towards something terrible.

Joe: Don't scare the others (Bond, 2000a, p. 39).

In the process of this self-war and war against the whole society, a man seeming to be in need of help approaches them and falls to the ground instantly. All the children want to help and carry him until they find medical help for this wounded man. Doing the right thing, which means helping a man in need. At that point, Joe endeavors to ease his conscience even if he turns himself into a murderer as a consequence of putting a house on fire. However, this escape into the unknown continues with the appearance of missing children each night. The children suppose that the missing children leave them because the burden on their shoulder, which is the body of the man, is too heavy to carry. Their only purpose on this journey is to stick together while growing up and losing their aim in life. All of them worry about being forgotten and being alone in this place with which they are bound. In Bond's words, their journey is "like the map of ancient rite of passage- the very ancient journey that all humans have had to go on since we first wanted to understand ourselves and take responsibility for our world" (2000c). Their path in front of them seems a long one, yet they do not give up carrying the helpless man. Carrying and helping this man turns into a mission, or a responsibility, which makes them feel better while easing Joe's conscience. They go on walking while talking about subject matters like eating and moving further, which is the sole significant thing on this journey.

In the middle of 'nowhere', one night, the man, seemingly incapable of walking, stands up and approaches Matt and Tasha, two of the children, with a brick covered by a towel, which is a suitable killing object. Since the dead bodies of the children are missing, the rest of the children cannot realize the dangerous situation they are in. When there are only five children left, the man gives them hope about arriving at a harbor in which they can find food and necessary materials. This empty hope infuses happiness and peace in their sleep. The hidden reality behind this unreal hope is the final action that the man takes to kill the rest of them before he dies from his injury. In their peaceful sleep, the man goes on with his killing of the children, starting with Donna. However, when he moves towards Marvin, he drops the brick with which he slaughters the children, which makes them awake. After they wake up, the children start to run away from the man. Being tired from this bloody chaos, the man lies down on the corpses of the children he has killed. It seems that the only child who is left alive is Joe. Appearing as a neurotic child psychologically triggered

by his mum at first, Joe turns into a pawn for the man in quest of inflicting violence on the outer world, for which he has his revenge. On the morning of the night of the massacre, Joe encounters a Stranger who wears the clothes of his puppet. It becomes evident later that he is indeed the ghost of the dead child in the burning house. The ghost tells the background story, thus giving information about the killer. He is revealed as his father who tries to save the child, which burns his hands and runs away from the hospital to take vengeance upon the killer of his innocent child. The child forgives Joe for what he has done. In contrast to the forgiving attitude of the dead child, the man appears to end his mission triggered by the emotion of vengeance by revealing the true story:

> My son's dead! (*Turns to Joe and suddenly shrinks into petty, seething rage.*) Your mother was a whore. She worked for me. I kept the money. Bought the house. She wanted to move in with me. No! I moved in with my wife! Your mother wanted revenge! She burnt the house! (*Gestures.*) They only knew- the ones I killed. You did it! (*Shudders as he takes the brick from his pocket.*) You killed my son! (Bond, 2000a, p. 51).

When the truth uttered by the man is revealed, everything takes on meaning, which highlights the cycle of revenge. The man abuses Joe's mother and uses her as a prostitute before taking all her money. He buys the house, which is burnt by Joe, with the stolen money and lives there a so-called peaceful life with his wife. So, to take her revenge on the man, Joe's mother uses or abuses in fact, her son to achieve her goal. Putting an end to his story riddled with agony, he attempts to kill Joe, yet he never accomplishes it. In the last scene, Joe stands alone at the harbor, thereby stating he has everything, but not a human standing by him and also 'caring' for him, which he excessively needs. Destructed by loneliness in an insecure and unjust world, which stands against innocence, the basic need for a neurotic child is interacting with a human being, as asserted that "he needs human contact and company because he cannot stand being alone for any length of time. He easily feels lost as if he were cut off from life" (Horney, 1950, p. 227). Losing all his friends to this hostile world, Joe underlines the boundary between a child and an adult world where he "marks the difference between self-discovery and self-creativity, and carries with him the experiences and attitudes of his friends into the adult world" (Nicholson, 2003, p. 17). Unable to experience a healthy childhood in which he is in pain of neurosis fuelled by his mother, Joe stands in the darkness, which marks the line between the already corrupted nature of adulthood and continually victimized childhood by adults.

Conclusion

The Children sheds further light on a child's world that has been shattered by adults who instill in them feelings of aggression, rage, despair, anxiety, and terror. With their cries for aid, as they are being taken to their deaths, the children's voices are audible through their screams, and it startlingly breaks their quiet. (Nicholson, 2003, p. 11). In line with this, in *The Children*, Bond attempts to illuminate the defenseless state of the children who are made to develop into neurotic people, whether as children or adults, via his vivid and realistic characterization. But he essentially says that childhood, a time of innocence in human existence, is when the seeds of neurosis are planted. As the main and the most victimized character of the play, Joe embodies a dramatic change from an innocent child to a murderer created by his mother as much as stepping into an adult world that is governed through unjust and corrupting social structures. However, not only Joe but also his mother is an obvious representation of an individual suffering from the neurotic disorder, which is considerably prevalent in the modernized world. In basic, she displays her harsh experiences in the past using her victimized son, which results in losing all her maternal duties, or in other words, instincts. They both are shown as being only the mirror image of this mental sickness or disturbance in contemporary society since they are both driven and devoured by their worry and terror throughout the play. With a focus on the root of neurosis, this hard work with a child-educational goal uses Joe as the mirror to her mother's past and his mother as the mirror to Joe's maturity, which is shaped through neurotic conflicts.

References

Allen, D. (2005). Something of myself. In. D. Davis, *Edward Bond and the dramatic child: Edward Bond's plays for young people* (pp. 149-162). UK: Trentham Books.

Allen, D. (2007). Going to the center: Edward Bond's *The Children. Studies in Theatre and Performance, 27*(2), 115-136.

Bauman, Z. (2018). *Retrotopya* (çev. A. Karatay). İstanbul: Sel Yayıncılık.

Billingham, P. (2014). *Edward Bond: A critical study.* Britain: Palgrave Macmillan.

Bolwby, J. (1952). Maternal care and mental health. A Report for World Health Organization.

Bond, E. (1998). *Letters 4* (ed. Ian Stuart). Amsterdam: Harwood Academic Publishers.

Bond, E. (2000a). *The Children and Have I None.* Britain: Bloomsbury Methuen Drama.

Bond, E. (2000b). *Hidden plot: Notes on theatre and the state.* Britain: Bloomsbury Methuen Drama.

Bond, E. (2000c). *Words about The Children*. Britain: Classworks Theatre Production.

Bond, E. (2001). *Letters 5* (ed. Ian Stuart). London: Routledge.

Bond, E. (2005). Something of myself. In. D. Davis, *Edward Bond and the dramatic child: Edward Bond's plays for young people* (pp. 1-9). UK: Trentham Books.

Freud, S. (2001). New introductory lectures on psycho-analysis and other works. *Vintage, 22.*

Freud, S. (2011). *From the History of an Infantile Neurosis: A Classic Article on Psychoanalysis.* Read Books.

Furedi, F. (2002). *Culture of fear: Risk-taking and the morality of low expectation.* Britain: Continuum.

Furedi, F. (2018). *How fear works: Culture of fear in the twenty-first century.* Britain: Bloomsbury Continuum.

Horney, K. (1950). *Neurosis and human growth: The struggle toward self-realization.* New York: W. W. Norton & Co.

Horney, K. (1973). *Feminine psychology.* New York: W. W. Norton & Co.

Horney, K. (1999). *The neurotic personality of our time.* New York: W. W. Norton & Co.

Nicholson, H. (2003). Acting, creativity, and social justice: Edward Bond's *The Children. Research in Drama Education, 8*(1), pp. 9-23.

Rae, G. (2011). *Alienation and the phenomenology of spirit: Realizing Hegel, Sartre, and the alienation of human being.* Britain: Palgrave Macmillan.

Sharma, S. (2012). On violence and justice in modern society: The role of theatre in building human society. A selective study of Edward Bond's plays. *Journal of Rajasthan for Studies in English, 8,* 49-57.

Solomon, I. (2006). *Character disorder.* New York: Springer.

Secondary Sources

Child Maltreatment, World Health Organization. (n.d.). retrieved from https://www.who.int/news-room/factsheets/detail/childmaltreatment#:~:text=It%20includes%20all%20types%20of,of%20responsibility%2C%20trust%20or%20power.

John, 8:7, the Bible, retrieved from https://www.biblegateway.com/passage/?search=John%208&version=NIV

oxfordlearnersdictionaries.com (n.d.). Retrieved from https://oxfordlearnersdictionaries.com. (accessed Jan 17, 2022).

Chapter 3

Family, Child and 'A Journey into the Psyche' in Edward Bond's *The Angry Roads*

Gamze Şentürk

Munzur University, Türkiye

Abstract

Children are one of the main concerns of Edward Bond's playwriting experience. Accordingly, children do not know that they are in the world, and instead, they think that they are the world unto themselves (Bond, 2011). They use their own imagination in making sense of the world. The children who internalize the external world with pure and innocent feelings and establish their own unique world model instinctively have a sense of justice, and they perceive the world in this way. Keeping their world full of innocence in their own ways, even so they have perceived the real world through these new contexts From his point of view, existing education can be problematized since it neglects the specific experience of children and forgets their uniqueness, and this system often forces children to accept a certain authority rather than discover their own uniqueness and capacities. At this point, Bond warns the public about the quality of current education, and also suggests drama for children, since it will help them discover their inherent parts as a child and make contribution to the upbringing of child with democratic values. His Big Brum plays, among his most radical works, generate an important part of further education for the young who are the adults of the future. In these plays, Bond acquaints the children with the harsh realities of the life, basic and serious problems in the adult world in order to make them understand the life process (as cited in Hemley, 2014). He guides them to discover themselves, their inner selves, and their society by teaching them and developing their thinking skills. Problematizing the child-parent relationship, these plays encourage children to see the difficulties of being an adult; but in these plays the problems are presented and children are invited to think about them and their solutions. The abovementioned discussion on Bond, children and drama is discussed within the context of his play, Angry Roads.

Keywords: Edward Bond, Angry Roads, innocence, imagination, education

<div align="center">***</div>

Introduction

Distinguished British playwright Edward Bond (1934 –) is one of the most controversial and foremost political figures of post-war British theatre. He first came to prominence with his provocative and shocking play *Saved*, staged in the Royal Court Theatre in 1965. He also wrote *The Pope's Wedding* (1962), *Narrow Road to the Deep North* (1968), *Early Morning* (1968), *Lear* (1971), *The Sea* (1973), *Bingo* (1973), *The Fool* (1975), *The Bundle* (1978), *Restoration* (1981), *Jackets or The Secret Hand* (1989), *Olly's Prison* (1993), *Coffee* (1996), *The Children* (2000), *Existence* (2002), *Born* (2006), *People* (2005), *Tune* (2007), *Innocence* (2008), etc. As one of the most prolific playwrights of British theatre, Bond is highly sensitive to the turbulent social and political events of his period and the world where he lives. He believes that the main function of the contemporary dramatist is "to analyze and explain our society and say what's probably going to happen to us" (as cited in Hay & Roberts, 1978, p. 45), and accordingly produces his leading plays with a strong sense of social responsibility. He also asserts that "[t]here's nothing complex or difficult in the things I am writing about. It's a very common-sense, straightforward assessment of what's wrong with the world and what one ought to do about it. There's nothing profound in what I say" (as cited in Hall, 1971, p. 10). Employing theatre as "a tool for learning" (Takkaç & Biçer, 2009, p. 168), he portrays human life in a realistic way. He mirrors society, criticizes social conditions, and reflects a deep insight into the human psyche.

The playwright, who felt violence and experienced war at an early age, explores violence from different perspectives in his plays like *Saved* (1964), *Pope's Wedding* (1961-62), and *Lear* (1969-71). He asserts that "violence shapes and obsesses our society, and if we do not stop being violent, we have no future" (as cited in Bowen, 2005). To him, our society is surrounded by violence, and it threatens our future. As a result, Bond has taken a particular interest in the necessity of bringing up the children well for a more liveable world. By using the power of drama, Bond dares both the young and the adult to take charge in creating social change or sustainable societies, shaping the future, and improving society. As Uğur Ada and Erdinç Parlak (2022) stress, for Bond, "the drama that bridges the blank space between both worlds is reality itself and represents the human journey that restores children's radical innocence. Reflecting contradictions and dilemmas, it encourages the children to act responsibly, thus defining themselves in free space" (p. 98). At that point, Bond has a great emphasis on the mission of drama in creating, confronting the world and interpreting it,

discovering our selves, and "recover[ing] our autonomy" (Allen & Handley, 2017, 311) through a journey into the darkness of our psyche. This chapter examines Bond's play *The Angry Roads* (2014) that leads us into "a journey into the psyche" (Davis, 2005, p. 155) of a young boy as an example of his Big Brum plays in terms of familial relation, child image, and human self.

Bondian Drama and Big Brum Theatre

Edward Bond's first encounter with theatre results from a school visit to the Bedford Theatre in Camden at the age of fourteen. The first play he saw was British director Sir Donald Wolfit's production of *Macbeth* in 1948. His first experience in theatre deeply affected young Edward because it was "the first thing that made sense to [his] life for [him]" (as cited in Hay & Roberts, 1978, p. 45). He defines that experience as follows:

> I obviously didn't understand a lot of it, but I understood enough of it, and it was the first time that anybody had spoken to me seriously about my life ... I'd lived through a war and been bombed so I knew all about Macbeth being a tyrant, but it seemed to me that somebody was telling the truth (Bond, 1972, p. 5).

This remarkable experience means meeting people who are interested in the problems of society, and as a matter of fact, his plays have also dealt with social problems. For Bond, experiencing the violence of the world as a young witness, that play had a structure that concretely talked about the violence in the world. Such kinds of theatrical encounters in his later life urged Bond to engage in his writing skills for the purpose of social change and to produce many controversial plays that portray violence and organized cruelty in the world.

Bond lays emphasis on the fact that the problems have continued exponentially from the past to the future unless they are solved. Accordingly, "[e]ach new generation goes back to the very basic problems, and therefore the very basic questions are never settled" (as cited in Villa Diez, 2016, p. 6), so it is essential to make an effort to produce a definitive solution to this situation. The playwright gets to the root of the problems in his plays. At this point, he sees drama as a platform to make people face the realities of the world, think about fundamental problems of society, and endeavor to produce alternative solutions to such problems. As Tony Coult (1979) argues, "by infecting the audience with responsibility for the events and confronting it with its own dark potential, his plays seek to generate antibodies against other more immediate plagues" (p. 37). By underlining the misconceptions in today's society, Bond warns people to save their society from a darker future and asks them to take action. In his plays, Bond displays the belief in the potentialities of the people to find the right and their capacities to change the problematic order and to search for

justice as children do. He also highlights the gap between the world of adults and the world of children. According to Coult (2005),

> The essential characteristic of being a child is to take on board experience, process it, and act upon it -to change. Taken as a whole, Bond's work is concerned with the human capacity to learn from often overwhelming experience, and the capacity of institutions to frustrate or assimilate that learning to their own purposes. The capacity to learn, to self-educate and to judge what is false learning and what is true, is the trust of all his work (p. 13).

In his theatre, Bond emphasizes the importance of education, learning, and self-instruction for change. He "construct[s] bridge between art and education" (Takkaç & Biçer, 2009, p. 167). He desires people to realize their own capabilities for change. As he points out, society is changing continually and rapidly, and in this constant change, people should take responsibility for social change, and he believes that the children, as the most active agents, will lead the change (Davis, 2005) because they will be the adults of the future. Instead of adapting to authority, they should be self-educated. Instilling a sense of responsibility in children is rather crucial for a better future, so Bond is interested in "the rhythms of learning, and the effect on young people of the inhibiting and corrupting culture … lurking at the heart of modern capitalist-individualist society" (Coult, 2005, p. 10) since early in his career. He stresses the importance of raising self-reliant individuals who trust in their own potential at the point of change. Through self-education, people can be active, not receptive.

In this respect, Bond tried to develop a creative collaboration with theatre in education companies, local and even regional theatre groups and supported Theatre in Education (TIE). Bond valued TIE as "the most valuable cultural institution the country has" (Bond, 2000a, p. 58). He appraises TIE as a form "fundamental to young people's development and education for sustainable development" (Takkaç, & Biçer, 2009, p. 168). He benefits from TIE to develop conceptual learning, not instrumental one. As he stresses, theatre should be useful to "to reach new social understandings about the world we inhabit, to explore the human condition and behavior so that it can be integrated into young people's minds and make them morally more human" (Takkaç, & Biçer, 2009, p. 168). According to Bond, this institution "came from children's need to take responsibility for themselves when that was being made difficult and replaced by bewilderment" (Bond, 2000b, p. 56), and it offered the young people to be active agents by participating fully in their own society and the wider world. In fact, the children of yesterday will be the adults of tomorrow. TIE "functions as a window opening from children's world to the outside world, allowing children to discover themselves irrespective of environmental factors and at the same time to directly recognize society" (Ada & Parlak, 2022, p. 98).

As he proposes, drama, nurturing the young culturally and artistically, imposes responsibilities on them and helps them to gain the ability to learn for sustainable development, critical thinking, and problem-solving (Takkaç & Biçer, 2009, p. 167). He utters that "to educate a child means to enable it to bear witness to its life. ... In bearing witness, a child seeks understanding and justice. ... Drama searches for meaning and expresses the need to bear witness to life" (as cited in Davis, 2005, p. 42). As can be understood from his words, drama takes an active role in the children's learning and self-development as a supportive element. It serves to activate children as the main power of the future. It dares them to be in a critical process and know themselves.

Children become one of Bond's main concerns, and he is interested in how we treat them and why we do not give them a place to live in this world (Bryanston, 2001, p. 29). He believes that children are "the defenseless creatures at the bottom of the violence pyramid" (as cited in Biçer, 2008, p. 30). Accordingly, newborn children do not know that they are in the world, and instead, they think that they are the world (Bond, 2011, p. xiii). They use their own imagination to make sense of the world. Children, who internalize the external world with pure and innocent feelings and establish their own unique world model instinctively, have a sense of justice, and they perceive the world in this way. He describes this process as 'radical innocence' (Davis, 2005, p. 42), which refers to "the state in which children discover and make sense of the world" (Ada & Parlak, 2022, p. 97). Bond notices that we are born radically innocent, and children desire "to be at home in the world, and that requires that the world be a home" (Bond, 2004: p. 25). They always seek emotional reassurance. Their main expectancy in this world is the act of being "born into a world waiting to receive it, and that knows how to receive it" (Bond, 1994, p. ix). Then children also seek justice, which is "a structural requirement in the human mind" (Bond, 2003). Bond sees radical innocence as a state "can never wholly be lost. (Allen & Handley, 2017, p. 307). When children step into the world of the adult, they try to adapt to the external factors of the real world by creating new contexts. Keeping their world full of innocence in their own ways, even so, they have perceived the real world through these new contexts (Bond, 2000b).

Bond believes that "children are not undeveloped adults but human beings in their own right with specific experiences that go to the heart of being human" (as cited in *Big Brum Theatre in Education Company*). From his point of view, existing education can be problematized since it neglects the specific experience of children and forgets their uniqueness, and this system often forces children to accept a certain authority rather than discover their own uniqueness and capacities. According to Bond (1998), children are trained in schools to accept social norms, and obey the rules instead of having a humane response to what's

going around them. He challenges the conservative structure of education. At this point, Bond warns the public about the quality of current education and also suggests drama for children since it will help them discover their inherent parts and make a contribution to the upbringing of children with democratic values. Remarking that "children map their world with drama" (Bond, 1996, p. 58), he underlines the sustainability of children's play-based world perception through drama. Accordingly, he sees drama as "a complex intervention, in reality, to get at truths society obscures or denies" (pp. 300-301). In his view, in brief, drama functions as a passage for children to connect their world with the adult's world or the outside world.

Bond, challenging conventional dramatic tradition with his very unusual techniques and his interest in controversial subjects ranging from violence to abuse, worked hand in hand with Big Brum Company. Founded in 1982 in Birmingham, Big Brum Company acts in line with the mission of TIE. This group comes to the fore in educating children and young people of any age. They attempt "to make meaning of their [children's] lives and the world around them" (as cited in *Big Brum Theatre in Education Company*). It brings together children with plays staged in schools at various levels every year. In a period of financial difficulties, this theatre group offered Bond to collaborate. With his acceptance of the offer, Bond's process of writing Big Brum plays for the children and the young had begun. He produced many Big Brum plays, including *At the Inland Land* (1995), *Eleven Vests* (1995-97), *Have I None* (2000), *The Balancing Act* (2003), *The Under Room* (2005), *Tune* (2006), *A Window* (2009), *The Edge* (2011), *The Broken Bowl* (2012), and *The Angry Roads* (2014). He asserts that "Big Brum reminds me why I first became a dramatist and shows its audiences why drama matters." (as cited in *Big Brum Theatre in Education*). Indeed, Bond's connection with Big Brum Company was recorded as "[his] last connection with professional English theatre" (as cited in Ada & Parlak, 2020, p. 36).

The main characters of Bond's Big Brum plays were mostly children. His Big Brum plays, among his most radical works, generate an important part of further education for the young who are the adults of the future. In these plays, Bond acquaints the children with the harsh realities of life and basic and serious problems in the adult world in order to make them understand the life process (as cited in Hemley, 2014). He guides them to discover themselves, their inner selves, and their society by teaching them and developing their thinking skills. Problematizing the child-parent relationship, these plays encourage children to see the difficulties of being an adult, but in these plays, the problems are presented, and children are invited to think about them and their solutions. They are not given ready-made answers and solutions to the children. Thus, he shows us his opposition to the idea of theatre as only a means of

entertainment and commercial activity. Instead, he draws attention to the fact that theatre should be instructional, didactive, and seminal. He explains the main purpose in his Big Brum Plays in his notes on *The Angry Roads* (2014) as follows:

> In time we will see that it is at war with young people. Inevitably youngsters shut their eyes in shock -what else can they do? - just as I did at the shock of war- but Big Brum's work lets them open their minds in understanding and gives them the power to make victories. I am not exaggerating -this is the power of drama and it has accompanied human beings throughout their history. These cuts are a wound to all young people- and they are an immeasurable debt that society will have to pay (Bond, 2014, p. 6).

Bond asserts that Big Brum plays encourage young people to stand up for life and think about ways to cope with uncomfortable problems they face in daily life. However, they do not profess them what is right and what is wrong. Thusly, to Bond, children's imagination is already strong enough to grasp what is right; however, adults may react and object to these kinds of plays. As David Lane (2010) states, "a lot of these plays are too challenging for some adults, because they are trying to identify a given answer, whereas kids experience it and it's a very open and powerful tool, for the kids to fill it with meaning" (p. 141). Despite all these objections, Bond did not hesitate to write didactic plays that educate children. To Bond, the imagination is an enormous power to change the ordinariness, stereotypes, and giving patterns in society. It should be kept alive in adult lives as well since imagination makes us human and helps us to "create a three-fold map of past, present and future" (as cited in Coult, 1977, p. 40). He adds,

> The future of our species depends on one and only one thing: The imagination of adults must be set as free as that of children. That's when adults will dream of what's real – that is, creating value in the real world. Adults thus take charge of the world: they become part of the world map. Adults become human when they dream of the real: otherwise they are not human – Imagination is monopolized by the state and as Ideology; it is produced as deceptions behind which the tales of murderers lie (Bond, 2000a, p. 101).

Bond believes that culture and society are important elements in forming human behavior. However, human imagination is the main instrument to develop people's selves and enhance the world. By trusting the power of imagination, he suggests that "imagination creates reality" (as cited in Davis, 2005, p. 7). Displaying the causes which lead to violence and injustice in society and criticizing oppressive and capitalist society in his plays, Bond claims that

the only remedy for people equipped with ideological prejudices is to use their imagination and find the reality as children do; otherwise, the world will remain a chaotic and violent place.

Bond sees imagination as a key to the progress of humanity, because it leads people to comprehend the differences between the realities and the idealized world or between how they live and how they might live life differently (Davis, 2005). According to Bond, new-born children do not "'read' ideology; it has to use its own imagination to make sense of the world. To enter society, however, the child must be corrupted; its imagination is 'ideologized'" (Allen & Handley, 2017, p. 311). Bondian drama forces people to revise their values, and think about the world and humanity, and take an action or responsibility. It invites them to respond to the changes and to explore "what it is to be human, the human imperative for justice, and the need to be at home in the world, which has been the age-old subject of drama since the ancient Greeks" (as cited in *Big Brum Theatre in Education Company*). He offers that in drama, "putting fiction into reality can isolate and dialecticise the fiction already in it. It is a practical way to steal ideology's clothes" (Bond, 2003, p. xii). Drama undertakes the educational function for both the young and the adult and ensures the sustainability of critical thinking, conscience and the sense of justice in adult life by preparing them for the future. In one sense, it is a means of "dramatizing the conflicts within the self" and "increasing human self-consciousness" (as cited in Billingham, 2007, p. 3).

Family, Child and 'A Journey into the Psyche' in *The Angry Roads* (2014)

One of Bond's Big Brum plays to be part of the TIE programme is *The Angry Roads*, staged in 2014. It is also known as one of Bond's family or home plays. As Mehmet Takkaç and Ahmet Gökhan Biçer (2009) emphasize, "[a] fundamental figure in much of Bond's work has been the child, and the correlation between past and present" (p. 169). Thus, the play focuses on the relationship between young Norman and his father, silenced by an accident. It portrays a dysfunctional family in a broken society by focusing on their present, ruined by the father's past acts. In his play, Bond problematizes and discusses the link between the young and the old by taking into consideration the subjects such as familial bonds, communication, the relationship between the past and the present, and imagination. It displays the familial tragedy for Norman in search of the truth about an accident that destroys his family and his future.

Norman, in his mid-teens, is the only person who uses words in order to express his thoughts, feelings, and opinions in the play. No words come out of his father's mouth. The father only speaks through his movements, gestures, and table-knocking. Nearly, the father's hands speak. We cannot learn the real name of the father during the play, and he is called Father as if it represents a

universal value. However, we can learn much information about Norman's father, such as his past, his job, his marriage, his affair, and his relation to his mates and his boss. He is a member of the working class, considering his clothes and Norman's speech, and he is unable to speak due to the traumatic event that he had experienced before. This past event dramatically affects the father-son relationship and makes it very problematic for them. They are not sincere and close enough in their relationship because they do not have anything to share with each other. For Norman, almost no information is given about this child. Norman does not remember his childhood clearly, and his father refuses to mention the past. Norman cannot get enough memories or information about his childhood experience. He is really "a living question" (Bond, 2014, p. 5) for Bond's audience.

The whole play takes place in an old, dirty, and secluded room, reflecting "a sense of neglect" (Bond, 2018, p. 159). This room is almost a burial place where the past is buried. In fact, it is a place where Norman and his father were buried alive. The door of the room opens for the audience to some problems of contemporary society, such as miscommunication, hiding to truth, loneliness, and problematic familial relationship. In the production, the audience meets an adult actor sorting toys on stage. In this representation, the actor achieves an alienation effect by putting a distance between the character and the audience. It serves "to contemplate the relationship between childhood and adulthood" (Chen, 2018, p. 189). While showing the transition from childhood to adulthood, this performance has an emphasis on the image of 'the inner child in an adult' as a reflection of Bond's concept of the palimpsest structure of the subject (Chen, 2018, p. 189).

The play begins with Norman's sorting his toys. Norman is alone in the room, occupied with the old toys. The only area where he can move is inside the room, and he is almost imprisoned in this room. His childhood is wasted in this tiny room. He is sorting his toys, which is like "a gesture that signifies his farewell to his childhood" (p. 188). On the one hand, he drops the damaged toys in a bin-liner; on the other hand, he chooses the best ones to have. As the cognitive philosopher John Sutton stresses, "physical objects carry part of the past with them" (as cited in Resnick, 2016, para. 5) because they have a memory and bring to mind all the past events. They also allow the memory to carry the past. They are like the testimony or witness of the past. It seems that all these toys are memories of Norman's childhood, traces of his past. While trying to get rid of them, Norman seems to be trying to get rid of his past that wears him out and hurts him. Even he expresses his regret and his desire to get rid of them by saying, "Don't know why I didn't do it ages ago" (Bond, 2018, p. 160).

Until the father comes, this small room is so quiet. The silence ends for Norman when his father, in his late forties or early fifties, comes from outside.

The interruption of silence is so important to "see just how impoverished is the relationship between father and son and how deep their emotional isolation" (Wooster, 2016, p. 238). With the arrival of the father, Norman begins to talk and overwhelms his father with his questions about where he is. However, the father is indifferent to Norman's existence; he is busy eating the food he brings. However, when the father comes with his arm bandaged in the Second Act, Norman takes care of him even though he is angry with his father. Roughly speaking, parents' interest in the child is a necessary element in developing social relationships. It creates a bond between parent and child and also strengthens this bond. The communication in parent-child relationships enhances family ties and forms the young personality. As in Norman's case, Norman feels isolated, unhappy, and lonely because of the lack of his parents' care and interest. Interestingly, Norman can talk to everything, including his toys, the wall, and the table, except his father: "Can you remember your voice? The sound you made? Sometimes the table creaks, and I think it's you. I start to answer. Start a conversation with a piece of wood. ... Least it says the truth" (Bond, 2018, pp. 163-164). These words are rather ironic in the face of the father's silence. According to Bond, "Children enter the real world through the monad's self-creativity, they anthropomorphize the world, create it in their own image. ... Trees speak, chairs are tired, storms angry, winds spiteful, plates hungry and demons wait in the dark" (Bond, 2000b, 119). In Norman's situation, everything is closer to him except his father, he can communicate with them. In addition to the lack of his interest, the father's actions cause the child to get angry. The father's act of brushing his toys on a table off without hesitation makes Norman annoyed, and immediately he reacts. When his father throws the toys, it is as if he was throwing the past. This initiates the first serious conflict or tension between Norman and his father. Norman begins to blame the father for the past through toys as follows:

> You think I'd bring out the toys to stir up the past? Bad enough without me adding to it. (...) Round there . . . (Going to table) – and my toys! (Suddenly angry. Snatches the tin puppet. Throws it at bin liner. Misses) Its got nothing to do with it! Toys! Toys! Toys! – anything! -- to make me feel guilty! Its you! You did it! I don't even know what Im supposed to be guilty of! If it was up to you I wouldn't --! You don't tell me. Nothing! It must've been in the papers. Where are they? Torn! You tore them up! Thrown away! (Father stirs his tea. Norman becomes quiet) Its not just tomorrow. Its every day. The whole year. When I was a kid I thought my toys were crying because of that. They didn't want to be in the house. Used to ask them what it was. When I was a kid. Really. Didn't expect an answer. Ask them for the sake of asking someone. -- Why cant you tell me? (Bond, 2018, pp. 161-162).

In this speech, Norman is an adolescent entering the adult world. Norman is furious with his family, especially his father, for keeping the truth hidden from him because this truth has affected his entire life. He questions his father over the past through toys. During his long speech, Norman states that he wants to know everything about the past that bothers him. In a sense, he questions why he is a victim of the past. But these efforts of Norman are unfortunately in vain, as the father, who lost his voice, is indifferent to his quest.

The main factor causing the troubled relationship between Norman and his father is an accident in the past. As his remarks suggest, his father had lost his voice due to that incident in the past. His mother left Norman and his husband after that incident because he could not carry this load. This incident has broken up the family. However, Norman is unaware of the details of the incident and is uncomfortable with this situation. Every time he asks his father to tell him the truth, as in the following speech:

> People shouldn't do things like that to a kid. You could make it right -- now -- before tomorrow --. (Imitates Father's rap on the table) You could tell me. In your way. … If Mother hadn't told me I wouldn't know anything. I dont know how you lost your voice. All I know you could've been born dumb. I want to go away. You could look after yourself. You communicate with your work mates. Get on with them. Write notes. Tell them things. In here in this house -- you don't write for me. You'd have to say too much. I have to work it out. Bang bang bang. You could've learnt a sign language. Something. You don't trust me. You don't trust yourself. I don't know if you even speak to yourself anymore. Perhaps there's just silence in your head. … One night I woke up. Nightmare. Heard my heart beating. Banging. I thought it was you saying something. Talking to me. Im haunted by sounds no one else notices. I ought to go away. While I can. When Im here on my own I dont feel lonely. When you come in I feel it – Im alone. Im sitting here on my own now. When you come in tomorrow I may be gone. D'you know I keep a case packed under my bed? The essentials. I ought to go. Mother did (pp. 163-164).

In his speech, Norman always accuses his father of hiding the truth and telling lies. He claims that it is his right to know the truth. He wants to break the silence in his father's mind. He searches for his father's lost voice. He emphasizes how lonely he is with his father's presence. Father does not tell Norman about the accident causing the death of two people and the breakup of a family in the past. This creates an emotional paucity in the child. As always, the father does not care about his son's righteous rebellion. In the process of the play, the audience begins to learn the truth step by step by witnessing Norman's frustration, his disappointment, his intellectual development and his maturity. Bond expects his audience to discover "the gradual extraction by the

son of the story behind this emotional paucity" (Wooster, 2016, p. 239). Father deprives Norman of having a warm family atmosphere, knowing the truth, and finding himself. He has to live separately from his mother after this accident. However, the exact blame for the incident belongs to the father, and Norman is subjected to live as if he was a prisoner.

According to the story, the father is in a relationship with another woman, although the father is married. Due to an argument, he killed the woman he had an affair with and his baby by driving his taxi over their bodies. Some details, such as the reason for the argument that gives rise to the accident and Norman's role in the accident, are not clear in the play. It can be understood that the argument begins, and then the accident occurs because of the pregnancy because it is possible that the woman does not want to end their affair, and the man deliberately kills them to turn the situation in his favor. The mother, who is aware of the forbidden relationship, leaves him and her home, partially informing Norman of her departure. Norman is only six years old. Norman, who more or less remembers what had happened despite his young age, now wants to hear all the truths from his father and presses his father with his questions by emphasizing that adultery is a bad thing as follows: "Dont go to another woman for the row you can have with your wife" (Bond, 2018, p. 164). Norman reminds his father of ethical values. While Norman is talking constantly and never keeping quiet, Father does not say a word because he always hides things from his son, and he is not open to his son.

During the play, Norman confronts us with a struggle at the point of learning the truth from his father. He is tired of his father's lies: "Your hands are lying! All of you's a lie! - Everything I've just said is true... You shouldn't lie to kids. Lie about Father Christmas. Not about what matters" (Bond, 2018, p. 167). Norman reminds us that adults should not tell lies to their children in any case because learning the truth, in a sense, means controlling his future for Norman. According to Chien-Cheng Chen (2018), "Norman's own story can never be complete if he fails to tell the insupportable story, nor can his future be possible without basing his self-knowledge on this truth" (p. 188), because there is a traumatic accident that turns the lives of Norman and his father into a nightmare. This accident caused by Father is the main reason for the problematic relationship between the father and the child. It is clear that the father–son relationship has an influential role in the development of the child. It has a major effect on forming the self-concept of the child. In Norman's case, his father is not the ideal model for the child. He doesn't communicate with his father on the basis of a real father-son relationship. On the one hand, there is a man who has lost the ability to speak and hidden the truth from his son, and on the other, a boy who is stubbornly seeking the truth about the past. As a result, a distorted father-son relationship ensues naturally. The secret tension

between Norman and his father causes insurmountable problems between them. In the play, Bond also embodies it in the symbol of the dead pigeon that the father brings home in his pocket. This is revealed in Norman's words as follows: "Life. Same out there as it is in here. That why you brought it? Tell me that?" (Bond, 2018, p. 165). In this sense, it is possible to say that it is as if the accident did not happen in the past but happened at home at that moment. In the words of Bond (2014), "the accident is already in the room because it's always there to be bumped into or tripped over" (p. 1), and it stands as a major obstacle in front of them to establish a new future for themselves.

The accident seems to have left a disaster behind. While the father cannot face reality, the child does not give up trying to learn the truth. In this relationship, the father experiences trauma within him, while the child bravely tries to face this traumatic event and build a future for himself. Norman is "constantly being burdened with the guilt for a world they have not created" (Wooster, 2016, p. 241). He revolts at his father by saying, "Tired of being blamed for what I haven't done" (Bond, 2018, p. 161). During the play, he always shares this feeling of guilt with the audience. Bond describes the play as one "about what we know, what we don't want to know and how we avoid knowing what we don't want to know" (as cited in Wooster, 2016, p. 241). Only Norman has sought the truth to establish his future and to form his own self. The father continues to live with the trauma of the past. In fact, he escapes from the burden of the past by losing his voice or refusing to talk about the past. Maybe his silence or mutism is because of his wish to forget this tragic accident. Probably he is afraid of the memories of the past and tries to stay away from them by not talking about them and by pretending it never happened.

Good communication between parent and child is the first and essential step toward building trust. It leads to developing a positive relationship between them. According to Kristen Zolten and Long (1997), effective communication helps the children to form their beliefs and ideas about themselves and the world, to show them respect, and to gain self-confidence (p. 1). On the contrary, miscommunication brings about a conflict between parent and child. In Norman's case, miscommunication alienates the father and his son from each other. In this respect, it is necessary to mention that asking the right questions is a significant part of a goodparent–child relationship. The parent should encourage their children to ask questions. Bond (2014) asserts that "the questions about the human situation must be addressed or life becomes a hobby or they become fanatics" (p. 5). Thusly, asking questions is a crucial step for Norman to find the truth. During the play, Norman returns to his childhood and tries to learn about the past by constantly asking her father all the questions on his mind. But the only thing Father does is to run directly from the room to the kitchen and reveal his feelings with the sounds he makes on the

table. The father is disturbed by the questions about the past that his son asks, and he shows his discomfort with the movements and sounds he makes. Bond actually serves a more important purpose here, as Chris Cooper (2014) tells in his notes on the rehearsal process:

> Edward Bond keeps asking the question: What is it to be human? The answers lie in the audience. He uses drama to open the door to this most profound, complex and meaningful question for young people and takes them by the hand as they cross the threshold (p. 4).

Bond expects his audience to ask the right questions because reaching the truth also requires asking the right questions. Norman's mind is full of questions about the past that need to be answered. His unanswered questions are indeed the answers about a dysfunctional family, a family with certain communication disorders. In the middle of unanswered questions, both Father and Norman carry a wreck within themselves, but Norman is the most crushed person under this wreckage.

The play invites its audience into the world of adult silence. In fact, the play is not interested in "what happened in the accident but what happens in us, and ... what happens in society" (Bond, 2014, p. 5). The accident time consists of some chaotic moments like Freud's slips. It reveals the dark side of the dark nature of unconsciousness. During the play, young Norman always talks, and his father is always silent. Father tries to communicate with his gestures and by rapping on a table. He uses table-tapping communication to express himself. The table-knocking is "just another language that is shared by him and Norman" (Chen, 2018, p. 188). It is rather functional in terms of revealing the violence of his feelings by hitting the table. In fact, this interesting communication process between the father and his son is very important in terms of revealing the problem between them. According to Chen (2018),

> His father's mutism, caused by the traumatic loss of his child, is an enigma for Norman, and it is this enigma that situates Norman within the structure of the familial tragedy even though he never experienced it in person. In spite of the fact that it is reasonable to suppose that Norman has communicated with his father through table-knocking for a long time, Norman's recollecting process still surpasses rational communication (p.188).

The father has lost the voice that will tell the truth. Nevertheless, Norman tries to find the truth with his imagination. He is in individual self-seeking, and in one sense, the play recounts Norman's inner journey to its audience. Richard Holmes (2015) asserts that it "tell[s] the story of a man and a son who spend all their time together. Actually, what we are exploring is a man that doesn't speak but says a lot, using his son's voice, and a son prevented from talking about his

own story" (p. 1). In one sense, Norman reveals the main task of the drama that Bond puts on to educate the young while making all his inquiries about the past. According to Bond (2014),

> Drama must now put its characters in extreme situations in which the self speaks to itself. S's words are simple – shout, kill, whisper, hiss, choking, oh, ugh – but the situation on the site of home and accident, and ultimately of the city's angry roads, is extreme and the extremity shuffles and shunts everything into a changed situation. That is drama's purpose and our purpose (p. 2).

The traumatic event Norman was involved in at a young age has matured him at an early age. At that point, the play highlights Norman's transition from childhood to adulthood by embarking on an inner journey toward finding his own self. Bond believes that children's journey is "like the map of ancient rite of passage the very ancient journey that all humans have had to go on since we first wanted to understand ourselves and take responsibility for our world" (Davis, 2005, p. 149). Norman's attempt to make sense of the world he inhabits both inside and outside the room pushes the limits.

Imagination emerges as one of the main themes of *The Angry Roads*. Bond (2000) sees imagination as a special power that "makes us human" (p. 57). Imagination, defined as "the desire - the need - to be at home in the world," is "our deepest need" (p. 57). As Bond suggests, living in an unjust society or in fear makes our imagination corrupted and makes us angry, violent, and destructive. At that point, Bond offers to follow the imagination because imagination is closely linked with consciousness. It always "seeks justice" and gives "the basis of our humanness" (p. 57). Norman searches for justice with his imagination in the unjust world in which he lives in. He does not lose the sense of justice and radical innocence. He questions the order that takes away a child's right to live and to know the truth.

The play shows us how strong the voice of young people who are trying to be silenced in the adult world can be. Norman is deprived of all realities that can enlighten his miserable life and help him cope with his solitude. The past created by his parent causes to keep him away from a happy family life and make him passive. On the contrary, Norman does not give up on learning what is bothering him, constantly asking questions and trying to reach the truth with his imagination and apprehension. According to Roger Wooster (2016),

> It is a play about disaffection and the dissociation of young people from a world over which they have been taught they have no control. It is a construct at the edges of naturalism and thus enables them to relate their own lives and their existential disengagement from the world to the theatrical metaphor presented. By considering the lives of the

characters in the play and their actions, they can safely unpick the dissociation that they observe in the world where 'reality has lost its voice (pp. 240-241).

The world presented by the rules and prejudices of adults is cruel, unimaginative, and ordinary for young people. The young carry a model of a world in their minds in which there are no boundaries, and imagination leads them to freedom. Whenever they enter into the adult world, they are disappointed. Even if Norman is forced to live his destiny in the adult world, he does not blindly accept his imposed fate and tries to reveal the secrets through his own imagination and his stories. To Chen (2018),

> Bond holds the relationship between information and stories in tension by turning information into stories. For Bond, the source of storytelling is not the past or foreign countries but the present and the local. Turning information into stories is to save from consumable news the inconsumable, that is, the ethical (p. 189).

As a storyteller, Norman attempts to discover the secret that makes his father silenced, his mother kidnapped, and him distanced from his parents. His storytelling enables him "to consider and critique [his] own subjective relationships to the community of which [he is] part" (Lane, 2010, p. 140). His greatest weapon on the way to discovering the secret is to construct scenarios and to ask questions with the help of his imagination and his apprehension.

Father and his son's reactions to the accident that ruins their lives are different from each other. While the guilty father is withdrawn, Norman seeks the truth to build a hopeful future for himself. Norman questions the right to death and life by asking his father why he killed the woman and her baby. According to Bond, Norman is in a total human situation. As a social being, he is subjected to the change and experiences a Freudian paradox. Bond implies the following points in his notes on Norman's interrogation:

> The explanation is the relationship between ideology, imagination and drama. N[orman] finds it difficult to say what he discovers in the accident. It is too shocking for him. If instead of being born (or here: once you have been born) you were forced back into the womb (the baby mashed up and forced back into the mother by the taxi – their double flesh becomes one) you have the perfect Thanatos, life wrapped up in death. Ultimately that is the ideal of ideology, the death wish of Fascism– but the paradox is that you have to stay alive to kill -- the Fascist has to stay alive to see he's dead and so his dead self stares at him and so the desired state can never be reached– so Fascist life is a sort of hallowed death with toys from the capitalist market (not rewards in heaven). That is our present culture. You could say that N[orman] had naively held

onto his toys before selling them so that they would have increased value as antiques. But that is interpretation. The play is enactment. Ideology uses the kinetic and the intellectual to repress, drama uses the same forces to release repression. It can do this because imagination can re-describe, recreate, the situation – and this isn't fiction because if the description is intellectually right it inevitably incites the kinetic involvement. This produces enactment. Ultimately what is repressed is radical innocence –human creativity (Bond, 2014, pp. 3-4).

For Norman, the experience he has is quite tiring and devastating. He attempts to question the past, to learn the truth, to get rid of the nightmare of the past, and to change the future. While questioning the existence of the baby killed by his father, he actually problematizes his own existence because his existence is somehow related to the death of this baby. Norman says that his father hit his mate and his baby with a taxi and that the baby is forced to die in the womb, which actually gave life, and that the mother and baby are identified with death again. It can be said that his father clings to life by killing or causing an accident between a Thanatos (the instinct of death) and Eros (the instinct of life) dilemma. In this regard, Norman's questions to his father require considering the relationship between Freud's concepts, Thanatos and Eros. In the ideological struggle, the act of killing for the sake of living is at the forefront. Norman's presence has also been linked to the infant's death. In the human situation, he can build his self by asking questions and reacting against the rules of the adult world.

Bond sees asking questions as an important step to finding the self. According to him, "we ask about the beginning and end of time, about our mortality and life after death, about good and bad, about creation. Really, in asking about these things, we are seeking to know who we are, to find ourselves" (Bond, 2000, p. 63). Norman needs to ask 'why' in order to have meaning and value in the world because "values come into the world only when we can ask why" (p. 63). Norman asks questions about the past, begins to understand more and more of the world, and forms his self. But in this sense, Norman is not stuck in the past. As he learns about his past, he becomes aware of his own existence and creates some values for himself. After the time of the accident, he is not mature enough to perceive the world. He does not make any distinction between himself and the world. As he grows older, he begins to become aware of the world outside himself and his relation with it. With the belief that he has the right to live, he seeks to be at home in the world and thus seeks justice, which means his mind is not autistic; on the contrary, it functions. Unlike Norman, Father remains stuck in the past. In a sense, he lives in the past by being silent. Here are Bond's notes on the father: "F[ather] remains imprisoned in the accident. N[orman] is freed from it by going to the accident. The oddity of his

home causes him to do this" (Bond, 2014, p. 4). The father remains passive by not speaking in this situation. The house in which they are imprisoned makes the father tense and irritable, prompting Norman to question the past.

Learning the truth is so important for Norman in forming his self. As Chen (2018) highlights, "Norman's quest for the truth is both a process of breaking the structure of egoism and a rite of passage toward maturation" (p. 185). However, his maturation requires facing a painful experience because Norman is busy with questioning why his brother was deprived of his right to life. In this sense, he cares about the other. This quest leads him to have an autonomous self. He appears as "a subject that is, … 'non-indifferent' to the other" (Chen, 2018, pp. 185-186). Actually, Norman's quest for the death of his brother stems from his desire to radical innocence. His radical innocence reveals the ideological presuppositions. Norman, rejecting the right to be at home in the world, quests the right of his brother to be at home in the world. He feels compelled to bear the burden of his brother's death. He cannot be indifferent to the unfortunate fate of his brother. As it is stressed, this conscience shows his human side that cares about other's life and struggles for them. In the circumstances, he has to cope with a trauma in the process of forming his self.

Bond has high expectations from his audience. He expects his audience to comprehend the conflict between the adult and the child. He invites them to be a part of the solution rather than the source of the problem by reminding them that "the power of theatre to humanise and in doing so become a force for change in the world" (Gillham, 2011, p. xi). He requests his audience to practically look at the people in the room and speculate on the lives of the people living there. He also encourages young people not to accept a frame and to strive to change. He allows his audience to explore the truth from Norman's words and to begin an inner journey through his imagination. Norman does not use pompous language in telling his story. He avoids poetic rhetoric and instead uses "a language close to the situation" and suitable to "raw, immediate human experience" (Bond, 2014, p. 3). Norman bravely confronts the problems of the adult world as a child and speaks with the language of the heart, which is the most natural language. He tries to reach the truth with scenarios he creates in his imagination and shows his anger through his simple rhetoric. He appears as an active knowledge seeker while reconstructing the truth of the murder through his imagination.

At the end of the play, Norman chooses to walk away with a suitcase as the only thing to do after asking all his questions left unanswered by his father and finding his answers by himself. To Roger Wooster (2016), his departure raises many questions:

When the son leaves with his suitcase at the end of the play, 'he's taking his experience with him out into the world and we don't know what he does do, where he's going to go or what he's going to become, but we do know what he is taking with him (p. 241).

Thusly, Norman creates hope for himself and the future. He shares the story he creates by means of his imagination with the audience, gets rid of the burden of the past he has been stuck in, and goes to his future. Now, the silence fills the room for the father. In Norman's last remarks, he says that "Is it possible? They didn't tell me I had a brother" (Bond, 2018, p. 174). As a matter of fact, it is his natural right to know the truth about Norman, who affects his whole life. Bond (2014) comments on Norman's last lines as follows:

It seems impossible because the accident was public knowledge. But it is possible -that and stranger things happen. In the play there is the ambiguous relationship between N[orman] and his mother. The point is not "can it happen?" but that it happens all the time. Ideology asks us to believe the impossible. Hitler said if you want the lie to be believed make it big (make it unbelievable so that it will be believed). Then the effort to believe it will guarantee its truth. And this isn't an abstract pattern -the proof of truth will be extracted from the confused ramifications caused by ideology and then the belief will not only be psychologically true but will also lead to action that will make it a social fact – so it's true. And in morality it isn't the flapping of the butterfly's wings that brings down skyscrapers – it's more insidious, it's the pattern on the butterfly's wings. In ideology the boundary between imagination and objective reality collapses. That's why it's the last line (p. 4).

Norman's final words claim that the baby has the right to live. Norman's reaction to the baby's killing represents a total human situation. According to Bond, in his total human situation, Norman identifies himself with the baby. In one sense, he thinks of himself as both the baby and not the baby. He has an experience that "goes further than being the baby- being the baby enables him to see the situation sub specie aeternitatis, to see the perspectives of nothingness" (p. 6). Consequently, he experiences the difficult situation by paining his self, and in the end, he succeeds in finding a way out for himself.

Conclusion

As a dramatist who is sensitive to the world and his society, Edward Bond prefers to use drama as an educational and transformative tool. He believes that drama can be used as a power to solve the problems of society. According to Bond, it is people who make the world beautiful or ugly. In this regard, it is necessary to raise children, who are the future of society, as an individual that

questions and criticizes the failing aspects of society and improves it. The playwright believes that drama will help educate children, prepare them for the future in the adult world and ignite the wick of social change. Accordingly, he produced and staged plays for children with the Big Brum Theatre Group he worked for. One of his Big Brum Theatre plays, *The Angry Roads* deals with a child's efforts to reveal the real face of life by questioning the past that destroys his future and building a new future for himself. This challenging piece, which problematizes the relationship between adult and child, shows us how the truths hidden from children can harm them and that like adults, children should have a say in forming their own future. By highlighting that asking questions has an important role in the total human situation, he creates Norman or a child that asks questions and seeks the truth. Putting the topics such as communication, silence, a familial bond, the effect of the past over the present and future, the power of imagination, and self-knowledge into the center of the play, Bond makes his audience engage in the uneasy problems of the cruel and unjust society. By inviting them to Norman's inner world, Bond shows how the adult world can limit the children's world or prevent them from making meaning. However, the message that Bond conveys throughout the play is that children can create a new future and find their own selves through their imagination, and at this point, adults also take their share.

References

Ada, U. & Parlak, E. (2020). Edward Bond'un *At the Inland Sea* oyununda zaman olgusunun kadın karakterler üzerinden temsili. *Ordu Üniversitesi Sosyal Bilimler Enstitüsü Sosyal Bilimler Araştırmaları Dergisi*, 10(1), pp. 34-47.

Ada, U. & Parlak, E. (2022). What Will It Be Next?": The process of 'dramatic child' in Edward Bond's *Eleven Vests*. *Söylem*, 7(1), pp. 97-109.

Allen, D. & Handley, A. (2017). "'Being human': Edward Bond's theories of drama." *Text Matters*, 7(7). pp. 307-329.

Biçer, A. G. (2008). *Edward Bond'un tarihsel oyunlarında diyalektik yaklaşım.* (Doktora Tezi). Erzurum: Atatürk Üniversitesi, Sosyal Bilimler Enstitüsü.

Big Brum Theatre in Education Company. https://media.bloomsbury.com/rep/files/Big%20Brum%20Theatre%20in%20Education%20Company%20overview.pdf Date accessed: 6.8.2021.

Big Brum Theatre in Education, Retrieved from http://www.bigbrum.plus.com/Resources/bboffer201314.pdf.

Billingham, P. (2007). "Drama and the human: Reflections at the start of a millennium Edward Bond: in conversation with Peter Billingham." *PAJ: A Journal of Performance and Art*, 29(3), pp. 1–14.

Bond, E. (1972). "Drama and the dialectics of violence." *Theatre Quarterly*, 2. 5, pp. 4-14.

Bond, E. (1996). *Human Cannon, The Bundle, Jackets, in The Company of Men.* London: Methuen Drama.

Bond, E. (1998). "Education, imagination and child." In E. Bond, *Letters 4* (pp. 1-104). Amsterdam: Harwood Academic Publishers.

Bond, E. (2000a). *Selections from the notebooks of Edward Bond*, volume one, (ed. Ian Stuart), London: Methuen.

Bond, E. (2000b). *The hidden plot: Notes on theatre and the state*, Bloomsbury Methuen Drama.

Bond, E. (2003). *The cap. In: Plays 7*. London: Methuen.

Bond, E. (2011). *Jesus and Hitler Swept*. In E. Bond, *Plays 9* (pp. ix-xxvi). London: Methuen Drama.

Bond, E. (2014). 'The Angry Roads writer's notes' in Teachers' Resource Notes, Birmingham, Big Brum.

Bond, E. (2018). *Plays 10*. Bloomsbury: Methuen Drama.

Bowen, Kirsten (2005), "Edward Bond and the morality of violence." *American Repertory Theatre*, 3(3), <http://www.amrep.org/articles/3_3a/morality.html>

Bryanston, C. (2001). The Children. *Drama Magazine*. Winter 2001, pp. 29-35.

Chen, C. (2018). *The later Edward Bond: Subjectivity, dramaturgy, and performance, dissertation*. London: Royal Holloway.

Cooper, C. (2014). "The Angry Roads" director's notes, Retrieved from https://media.bloomsbury.com/rep/files/The%20director%27s%20notes%20for%20the%20programme%20(Chris%20Cooper

Coult, T. (1977). *At the Inland Sea: Notes and commentary*. Bloomsbury: Methuen.

Coult, T. (1979). *The plays of Edward Bond*. London: Eyre Methuen.

Coult, T. (2005). "Building the common future: Edward Bond and the rhythms of learning." In D. Davis, *Edward Bond and the dramatic child* (pp. 9-22). Stoke on Trent, UK: Trentham Books.

Davis, D. (2005). *Edward Bond and the dramatic child: Edward Bond's plays for young people*. Stoke on Trent, UK: Trentham Books.

G. Gillham. (2011). *Six plays for Theatre in Education and youth theatre*. Trentham: Stoke on Trent.

Hall, J. (1971, September 29). "Edward Bond," *The Guardian*. Retrieved from www.guardian.com.

Hay, M. & Roberts, P. (1978). *Edward Bond: A companion to the plays*. New York: Theatre Quarterly Publications.

Hemley, M. (2014, July 4). *Edward Bond hit out at arts council's cuts*. Retrieved from www. thestage.co.uk.

Holmes, R. (2015, February). "The Angry Roads" interviewed by Roger Wooster. *The Journal for Drama in Education. 31*(1).

Lane, D. (2010). *Contemporary British drama*. Edinburgh: Edinburg University Press.

Resnick, B. (2016, December 23). *Why objects can be more meaningful gifts than experiences*. Retrieved from www.vox.com.

Takkaç, M., & A. G. Biçer, (2009). *Edward Bond's play for children: Education for sustainable development and the need for Theatre in Education*. Retrieved from https://www.researchgate.net/publication/277148686_Edward_Bond's_Play_for_Children_Education_for_Sustainable_Development_and_the_Need_for_Theatre_in_Education.

Villa Diez, J. C. (2016). *Rethinking aesthetics in the politics of theatre: A road to Edward Bond - the ethical* (Unpublished Doctoral Dissertation). UK: The University of Leeds.

Wooster, R. (2016). *Theatre in Education in Britain: origins, development and influence.* Bloomsbury: Methuen.

Zolten, K. & Long N., (1997). *Parent/child communication* (Unpublished Doctoral Dissertation). USA: University of Arkansas for Medical Sciences.

Chapter 4

Edward Bond's Theatre and His Educational Play, *A Window*

Kadriye Bozkurt

Manisa Celal Bayar University, Türkiye

Abstract

According to Bond, to create a better future, children should be awakened to the potential positive and negative developments around them. For that reason, their confrontation to difficult circumstances and their efforts to interpret and overcome these difficulties are vital. Social awakening and social understanding as the aim of Bond's in writing for his adult audiences are followed in his plays for young audiences even with highly serious and extreme events. For that reason, the disturbing stories, and violent happenings in these plays lead young audiences to think upon justice, moral and humanity. Staged firstly at Golden Hillock School, Birmingham, in 2009, *A Window* is one of Bond's plays written for young audiences. This play is striking in terms of its portrayal of real-life problems by putting the experiences of family members, unmarried couple, and their son into centre. In this play *A Window*, young audiences can easily realize the facts of real life, even they may find some resemblance with the experiences of the characters and sometimes they feel scared with the extremities of the incidents. They are not kept busy with a fictional pollyannaism with full optimism and amusement, on the contrary, they are confronted with any aspects of life. To Bond, drama engages in human reality, since anything performed on stage are strained through by the perceptions of young audiences. Through drama, they can produce their realities with their own moral judgements and innocent approaches without feeling the confinement of rules and ideologies. Young audiences should not evaluate incidents according to mechanics of law or moral system, on the contrary, they interpret the events according to their ideal system in their mind. This is one of the basic points of Bond's drama since he wants his young audience's imagination and conscious thinking for a better and ideal future.

Keywords: Edward Bond, Window, young audience, human reality, imagination

Introduction

It is beyond question that when talking about radicalism, extremity, social issues, daringness, and justice, Edward Bond (1934 –) is one of the first names coming to mind in Contemporary British Theatre. Bond has a rare talent in theatre with his courageously chosen themes, characters, aesthetics, and with his use of unconventional theatrical elements. Not all the time the world becomes a place of peace and trust for people. Under many different circumstances, people can find themselves in the middle of sad events, crises, wars, or unexpected violent actions. In British theatre, the works of many playwrights such as John Osborne, Arnold Wesker, Harold Pinter, and many others are highly noteworthy to show their responses to the ongoing events and also to activate their audiences for their surroundings. Edward Bond is one of those playwrights, maybe the most singular and radical one, who raise their voice against social incoherence, violence and cruelty, and any inhumane events and treatments. Bond has never been a pacifist playwright (Davis, 2005, p. xiii), and he created eminent yet much-debated plays for theatre. In his plays, Bond does not hold back from depicting the world as it is, so in his plays, the violent events and the unwanted experiences of people are depicted on stage with dramatic reality and artistic creation. Also, his collaboration with Big Brum Theatre in Education Company, which has undertaken an important task for the education of young people through theatrical works, has attracted attention and has been carried on till the year 2016.

Edward Bond's Theatre and His Educational Plays

Edward Bond is one of the most radical, controversial, and also prolific playwrights of contemporary British theatre. He explores uncomfortable issues in society and achieves to create awareness with his highly criticized social and political plays. Bond wrote more than fifty plays and some well-known plays of him are *Pope's Wedding* (1962), *Saved* (1965), *Lear* (1971), *The Sea* (1973), *The Fool* (1975) and *Restoration* (1981). It is hard to categorize his plays under certain movements and aesthetics since he has his own way and attitude. He generated his own vision in theatre, and his plays do not compromise either the rules of the theatres of Stanislavski and Brecht or the characteristics of the experimental theatres of the twenty-first century. He calls his plays as 'rational theatre' since his plays "creates the adequate conditions to bind reason and imagination as a means to understanding reality" (Nicolás, 2016, p. 258). The point he criticizes about a method of Stanislavski is its focus on the character's emotions that can prevent objective judgment; in a similar way, he does not agree with the use of the alienation effect in Brechtian theatre that puts the audience outside of the situation and creates escapism. As David Davis (2005) asserts,

He has faced the responsibilities which flow from his understanding of the world around him; responsibilities which each of us needs to face. His art is concerned with how this can be done without preaching at the audience, without using propaganda, without taking a 'holier than thou' stance. This has involved him in creating a new form of theatre and has led him to stringent criticism of Stanislavski and Brecht, whose approaches to theatre cannot do the job required of them today (or even yesterday) (p. xvi).

Bond cannot find his expected dramatic materials for social change in these two major theatre-acting theories. In the same vein, his theatrical attitude does not apparently correspond with that of many major British theatre groups. He has worked before well-known theatres in Britain like the Royal National Theatre, The Royal Shakespeare Company, and the Royal National Theatre. But contemporary theatre rarely fulfills Bond's expectation from drama since he seeks in the drama "the possibility, the stimulus, the provocation, for us all to uncover the hidden forces" (Davis, 2007, p. 82). Relatively, what disturbs mostly about contemporary theatre is the tendency of many theatre groups to engage in profit-oriented works and the priority given to the commercial and entertaining part of the theatre. For that reason, he criticizes British theatre for being "impoverished by the corrupting forces of the market economy" (Nicholson, 2003, p. 10). Bond concentrates on 'drama', which appeals to human sides and brings out conscious plays that provide social, political, and moral narratives for society's sake. Expressing his dissatisfaction with the current status of theatre in his country, he criticizes the theatres that turn into what Bond calls 'show shops', and then he reveals his decision to work for young people's theatre:

> What I find in this country is that the most useful theatre is theatre for young people, because young people are still not completely plugged into the social/cultural economy we have. 'Shop shows' are all about commercialism. Children and young people are continuously fed gadgetry. If you swim in the sea you get wet, so young people start trying out the culture they are part of (as cited in Grimley, 2013).

This very feeling of Bond becomes quite essential for his acceptance of Big Brum Theatre's request to write plays for children. Then a reciprocal process begins in which Bond writes many plays for young audiences for the projects of Big Brum Company. This company, a Theatre in Education (TIE), was founded in 1982, and it has gained worldwide popularity since that time. Big Brum Company covers the TIE programme in schools, and it addresses a wide range of children and young people. Supporting critical thinking and active learning with TIE programme, Big Brum Company aims to 'enrich children's

lives through the arts' (Big Brum Theatre in Education), and this attitude is noteworthy for the continuation of principles of TIE. As David Lane (2010) observes during his research, TIE is a very important programme that aims to encourage child/young audiences to "examine their place in the world in a way that neither the curriculum nor the mainstream theatre could offer" (pp. 133-134). Certain theatre groups, like Belgrade Theatre and Leeds Playhouse, show ultimate care to produce important theatrical works for children, and Big Brum Theatre comes into prominence as a part of this tradition in the last quarter of the twentieth century. The collaboration of Big Brum and Edward Bond since 1995 secures this theatre's place on the contemporary stage, and it becomes a powerful medium to convey Bond's plays to a young audience. As Tony Coult (2005) suggests, this is a mutual evolution in a "shared territory, artistically and politically" (p. 10) and Bond clearly explains their intentions with these words:

> So, what we try to do in Big Brum is to create drama. ... Drama is of course very important that is why in this country I concentrate on writing drama for young people because I feel they are not yet completely cemented into the necessities of our commercial culture. They still have freedom, they still have liberty. They often don't know it. They often can't articulate that adequately. But if they can be approached with drama at an early stage then I think drama can become part of their power (as cited in Amoiropoulos, 2013, pp. 233-237).

Criticizing the commercial and materialistic tendencies of theatre, Bond directs his attention to drama and stresses its possibility for imagination and creativity. His Big Brum plays, *At the Inland Land* (1995), *Eleven Vests* (1995–97), *Have I None* (2000), *The Balancing Act* (2003), *The Under Room* (2005), *Tune* (2006), *A Window* (2009), *The Edge* (2011), *The Broken Bowl* (2012) and *The Angry Roads* (2014) show the power of educational drama for young audiences. These audiences are called for a new experience to explore their future. As Lane (2010) indicates, "the power of the imagination is crucial to Bond's philosophies about drama and helps to explain his opposition to what he calls the 'lie-truth" (p. 142). The power of imagination will direct them to new possibilities and new realities about life. Ideologies force human beings to act in a certain way and to behave properly in a given system (p. 142): however, imagination cannot be restricted by ideologies. Bond trusts imaginative and young minds that can search and create, so he writes challenging plays without giving any ready answer and easy solution. In each play, audiences can find their own reality and their own inferences. The artistic director of Big Brum TIE Company, Chris Cooper, explains how Bond's plays operate:

> People object to Bond's plays, because they want to be told what's right and wrong, but the kids don't need to be told ... They need to know why,

and what does it mean, to commit that act? ... they're (adults) trying to identify a given answer, whereas kids experience it, and it's a very open and powerful tool, for the kids to fill it with meaning (as cited in Lane, 2010, p. 141).

Bondian drama for young audiences does not give a moral lesson or not preach for certain ideology but it reveals some instances of life and some of them are very cruel and tragic ones. Bond emphasises that drama uses extreme situations to force people to be creative, and they search for new alternative ways and make new decisions (as cited in Allfree, 2009). A world of violence in which terror, abuse, drug use or death are seemed to be non-depletable, Bondian drama puts aside romanticism, the illusion of fairy tales and lullaby for children. For instance, in his play *At the Inland Sea* (1995) children make a journey in the history of compelling times of Holocaust. Experiencing himself the hardships of life, Bond stresses the vitality of young people's confrontation with difficulties. Bond himself says, "I think the child has to do with tragedy as well as comedy or pleasure and pain. There are much more conflicts and [children are] much more interesting and much more potentially fruitful" (as cited in Amoiropoulos, 2013, p. 240). As Bond relays in his essay *Something of Myself* (2005), he was a little boy who experienced the World War II with his two sisters. They were evacuated from London to Cornwall by train. In the classical town hall, the evacuees were picked up and Bond recalled that like a 'slave market'. He witnessed children's funeral who were dead because of diphtheria. He caught scabies; he felt the sores of his skin when he was scratching. After some time, they were sent to home. During this time, he could hear the sounds of bombs and explosions (Bond, 2005). "Each time. It lifted up the top of your head as if it was a lid and jumped inside. In the morning, we collected shrapnel in the street. There was a lot. Heavy and jagged" (p. 2). In that age, Bond saw pilotless flying bombs, newspapers with pictures of concentration camps, news about two atom bombs. Children's efforts and ability to get to know this world with its all aspects help them to generate critical thinking about incidents and then they can create their own value judgment.

To create a better future, children should be awakened to the potential positive and negative developments around them. For that reason, their confrontation to difficult circumstances and their efforts to interpret and overcome these difficulties are vital. As Nicholson (2003) says, "particularly in the context of TIE, Bond's plays deliberately challenge young audiences to imagine how they would behave in difficult or extreme situations, ... young people are asked to re-think the future" (p. 12). Social awakening and social understanding as the aim of Bond's in writing for his adult audiences are followed in his plays for young audiences even with highly serious and extreme events. For that reason, the disturbing stories, and violent happenings in these

plays lead young audiences to think upon justice, moral and humanity. Depiction of violence, confusion, and injustices can create 'aggro effect' by "intensifying the sense of violation experienced by the audience" (Spencer & Spencer, 1992, p. 8). With aggro effect, the tension and violence and seriousness of plays produced shock effect and unsettling feelings. Aggro effect stands in contrast to Brechtian alienation effect (Nicholson, 2003) since it searches for an inner look, not sympathy but conscious thinking and feeling. Bond makes it clear that his plays intertwine reason and imagination, so neither alienation effect nor pure cathartic feeling is sought in his plays. Bond defines his drama as "the formal process of creating humanness" (as cited in Amoiropoulos, 2013, p. 39), and during this process, each person can think about and produce their own value system. Bond's Big Brum plays coincide imagination and creativity of young audiences with the chosen issues that are contextualized around lives and experiences of modern people. So, Big Brum plays meet the aesthetics expectations of young audiences, moreover darker sides of modern time are introduced to them. Many different stories that display the crises about family relationships, drug use, prostitution, violence, suicide, and these undesirable issues are explicitly performed with great seriousness. Bond's one of Big Brum plays *A Window* (2009), which is chosen as the focal point in this chapter, is written and performed with the same sensibility.

A Window (2009): For a Better World for the Young

Staged firstly at Golden Hillock School, Birmingham, in 2009, *A Window* (2009) is one of Bond's plays written for young audiences. This play is striking in terms of its portrayal of real-life problems by putting the experiences of family members, an unmarried couple and their son into centre. This three-act/panel play is about the chaotic relation of three people: a single mother Liz, an abandoner father Richard, and their son Dan. In the formation of this three-panel-play, Bond features 'the classical pattern' of Greek drama. This plot structure progresses from recognition to conclusion that starts with the first signs of disaster, then crisis increases in the second panel, and finally, the third panel gives resolution by freeing the characters from their responsibilities (as cited in Amoiropoulos, 2013, p. 231). Unlike the Greek drama, this play centres on domestic site; however, the incidents are larger than to be only domestic issues. The themes of the play are centralized around basic problems of the contemporary time, and these themes are staged as it should be without any reduction in terms of violence and cruelty. Considering Bond's vision and poetry in this play that is "sometimes gnomic, but seldom wrong," Lyn Gardner (2009) likens him to "a latter-day Tiresias" (para. 3). In Greek Mythology, Tiresias is known with his ability of clairvoyance. He was a blind prophet, and he had a great talent for gaining information and interpreting it with the help of his clear

vision. Gardner puts for this comparison to show the powerful writing insight of Bond which analyses its time properly and detects the essential points as necessary.

In this play *A Window* (2009), young audiences can easily realize the facts of real life, even they may find some resemblance with the experiences of the characters and sometimes they feel scared with the extremities of the incidents. They are not kept busy with a fictional pollyannaism with full optimism and amusement, on the contrary, they are confronted with any aspects of life. With the following words, Bond explains these stories are presented for the young audience:

> The young audiences were not seduced. The young audiences were not seduced. It was not a love or fairy story. They were just presented with the facts of their own lives. But what was strange is the extremeness of the danger and in conventional terms the wickedness that appears sometimes in these plays" (as cited in Nicolás, 2016, p. 262).

In his presentation of the facts of life, Bond intends to show "distinction between factual reality and human reality" (as cited in Amoiropoulos, 2013, p. 52), and witnessing the factual realities young audiences can reach the human reality by using their conscious and imagination. To Bond, drama engages in human reality, since anything performed on stage are strained through by the perceptions of young audiences. Through drama, they can produce their realities with their own moral judgements and innocent approaches without feeling the confinement of rules and ideologies. Young audiences should not evaluate incidents according to mechanics of law or moral system, on the contrary, they interpret the events according to their ideal system in their mind. This is one of the basic points of Bond's drama since he wants his young audience's imagination and conscious thinking for a better and ideal future.

This play depicts the domestic life with its crisis and the flat that is used as setting appears as a site of conflicts, despair, and loneliness. As Director Cooper says, "the room is bare. Nothing is extraneous but everything is extreme" (as cited in Amoiropoulos, 2013, p. 23). The play sets in a bare room decorated with the chaise-longue with a sheet on it and a dining table with chairs. This room does not reflect the warmness of a family, it gives the impression that it is a place for provisional stay or for single seater. As it is insighted, this small place is the setting of dysfunctional relation of Liz and Richard, and moreover, it hosts the incidents and discourses on economic struggles, harmful habits, smuggle, drug use, suicide, and many others. Rather than creating dreamlike fictional world for younger audiences in this play, the grim truths of real world are depicted. As important failures in contemporary life, the devaluation of communication and the infrequency of healthy relationship are unfolded in

this play through these three characters: abandoner father, suicidal drug addict mother, and smugger son. The first panel of play opens with the conversation in which Liz calls for peace and space:

Richard: Seen this comin. Yer bin actin up for days.

Liz: Want a bit a' quiet. Not a crime.

Richard: Quiet!

Liz. Please. I juss need a bit a' space for meself (Bond, 2011, p. 181).

Richard is a broken person, and in the first scene, he comes back home after his struggles for finding a job. He gets angry when he sees Liz, mother, has slept on the chaise lounge. They have not seen each other for weeks and Richard feels suspicious about her coldness. Even he asks about if she sees someone. Wishing peace and silence, Liz only wants Richard to settle down. Then she talks about a news on the newspaper about a mother who blinds her child because of her extreme love. It is like that this woman is haunted by this story and she cannot erase this tragic subject in her mind. He understands that she only feels herself unwell and she is also under the effect of the story about the mother who blinds her child.

Liz: She blinded 'er kid.
… So it'd 'ave t' stay with her. Always be with 'er. When it grew up. Never 'ave t' go out – mix with – never 'ave t' fight its way in the – grovel t' survive – tear itself t' bits. She did it 'cause she loved it. She'd always care for it – look after it – it'd grow up as if 'er 'ouse was its playpen. Be buried in its playpen!
… It was both eyes.
… She did it with some scissors – (Bond, 2011, p. 184).

Richard knows her obsession to this story. He is tired of listening this story again and again, moreover, Liz is getting upset while thinking on this story. These certain instants are also important for the play to create aggro effect for the audience since this story conveys two powerful feelings together, love and violence. While Liz is feeling sympathy for the mother thinking her deep love, Richard finds it quite extreme and violent for mother and son relation. Alongside this emotionally unbalanced environment, the news about baby alerts Richard. He wants to dissuade Liz to have the baby when she gives the news about her pregnancy. He reminds their financial condition by saying "we cant afford it!" (p. 187). As it is plotted in the very beginning of the play, Richard struggles with financial difficulties and his days pass while looking for job. He defines himself as broke, so he is discontent with this idea of having a child. Additionally, he describes having a child as a kind of burden for him with these trenchant words,

What use is a kid? Mess 'n noise. Snot one end, crap the other end 'n piss all over. Clean up after 'em, break yer back, sacrifice yer life – so they can grow up 'n blame yer for bringin 'em in t' the world. ... That kid's a curse on me. Get rid a' it or I'm out (Bond, 2011, p. 187).

Here, Richard's detection about having a child indeed reveals an important fact about parenthood. It requires sacrifice, willingness, responsibility, and unconditional love. It does not seem that Richard feels himself ready for a baby. And the loose bond between this couple that is set around is broken totally after the baby news, and their relation comes to end.

In the second panel, the audience see the baby as a teenage boy, Dan, and now Liz is older and high on drugs. The second panel reveals another problematic relation that occurs between Liz and Dan as problematic mother-son relation. Although he is so young, Dan shoulders all responsibilities for his mother. He smuggles to provide drug for her mother. They reverse their roles; Dan here acts like a compassionate mother who takes care of his daughter. Realizing this truth, Liz says, "(*hurt*) Dont treat me like a child dear. I worry when yer out" (p. 188). Liz's serious drug addict damages her son, and they find themselves in an inextricable circulation that goes between drug supply, drug use, smuggling, fighting, injury, depletion of drug and then drug supply and so on. Even in this circulation, as Richard will reveal to his son later, Liz commodifies her body to get money to buy drug. Considering the capitalist world and the struggles of the characters, Bond stresses that "the corrupt the universe has shrunk to their own little corner in it. ... Where there is trade there is politics and money turns everything into commodities" (as cited in Amoiropoulos, 2013, p. 227). Liz sees everything sellable for the sake of drug because of her addiction. As it is remembered in the first panel, Richard is tested by the lack of money and it is pathetic that he gives up on his baby because of financial difficulty. For sure this is not the only reason but a powerful one for him. And in this panel, the audience witness a drug addict mother who prostitutes and a teenage boy who does drug dealing and fights for money. There are exchanging their bodies and life for money.

Liz is a drug addict, and she is not behaving proper way, however her bad habit does not lessen her love to her son. While Richard prefers to run away leaving behind all his responsibilities, Liz brings up her child. Moreover, her final decision about suicide is the extreme sample for her love and compassion to her son. This decision is difficult but closely related to the toxic relation of mother and son. After fifteen years Liz turns into a drug addict whose bad habit forces her son to involve in illegal activities. At this point, Liz's decision is very touching since she gives up her life for her son's future. Bond clarifies some points about her suicide,

because she is weak and she is corrupted and, as you say, she is literally injecting poison into herself that she asked her son to provide her with. … You can't get more corrupted than that really. And this is from the person who is being feeding you milk, you know, who's being giving you blood. She is actually asking you [Dan] to poison her (as cited in Amoiropoulos, 2013, p. 76).

Liz is a dependent to drugs and by observing her mother's physical need for drug, Dan smuggles even risking his life. Like the mother who blinds her child in her story, Liz feels herself guilty towards her son. He is like an innocent child who wishes to delight her mother by bringing drug to her. The term 'radical innocence' used by Bond to define the innocence and purity of child world and "responsibility for other people's lives" (as cited in Amoiropoulos, 2013, p. 8) is hidden in these two characters' decisions in this play. They give their decisions for the sake of one another. Liz is a compassionate mother who worries about her son and she finds the solution in suicide. As Bond (2011) refers, "to remain innocent she must destroy Dan's innocence" (p. 76). She assumes that this mutual contribution for their destruction can be finalised after her death. Liz knows about her addiction and sees that her son sacrifices himself to get drug for her. In this way, his son will stop smuggling and has a chance to build a better future for himself.

> Liz: I seen enough – got the right t' die. … Death's the best drug. (*Looks down.*) The world's under the chair. Fall into that."
> … (*Tries to attach rope. Lets it fall. Silence.*) Cant – not in front of 'im. Be ashamed. 'E woke up 'n saw – 'e 'd close 'is eyes – never open 'em again. (*She steps down from the chair. Goes to* Dan. *Uncovers his head. Looks at him.*) I'm at peace now. Like looking down at a pool a' water. (*She covers his head. Goes to the table. Takes a music player from the drawer. Turns it on. Dance music.*) Got nothing t' leave yer. – (*Takes the packet from her pocket.*) Give yer the drugs. Yer wont take em. But yer'll know I thought a' yer. Mustnt linger 'ere. Go t' me room. (Bond, 2011, pp. 194-198).

Even while plotting her suicide, Liz is very compassionate and caring for her son. She changes her spot of suicide in case his son will see her dead body in the room when he wakes up. She goes another room and turns on the music. She tries to find ways to lessen the effects of this suicide on her child. For audience, second panel mixes the aggro effect and radical innocence in the deeds of Liz and Dan. Tension, compassion, sorrow, and violence come to climax when this suicide act is presented with music as if it was a ritual with best wishes for future.

Panel three presents another unconventional relation that goes between father and son, Richard and Dan. This relation holds no emotional bond and

sympathetic feelings. This panel includes highly traumatic incidents for Dan and even for Richard. After fifteen years father and son meet each other for the first time in the beginning of the panel. When Dan sees his father first-time, he thinks that he is one of the officials from social service. Dan says, "(*off*) Wasnt expectin yer yet. Yer office said they'd fix a time. ... They said they'd send a woman" (Bond, 2011, p. 196). With his words, it is clear that Dan has no idea about his father and does not know what he looks like. The condition is not different for Richard, either. After the suicide of Liz, Richard comes back to this flat with a thought of finding something at home that can bring money. After a long time, he comes across his son; however, he is not enthusiastic to have a pleasant conversation with his son. During their conversation, Richard cannot develop any healthy relation, in this encounter his revelation of ugly truths takes attention more than his effort to know his son. There may be different reasons and excuses of Richard for this attitude: maybe he is inexperienced to talk to his own son, maybe he does not want to take his responsibility or maybe he does not make any emotional bond. Whatever the reason is, when he uncloses all details about her mother's bad habits that even goes to her prostitution, he gets out of line for Dan. Firstly, he makes fun of Liz's story saying "Did she tell yer about the kid with the eyes? No? Funny. 'Er big story" (p. 201), and then confesses his opposition about Liz's pregnancy, her prostitution and more with these harsh words:

> Richard: I'm goin. Seen enough 'ere. I tol' 'er t' get rid 'a yer. Flush yer down the toilet. 201 She done that she couldnt a' turned yer in t' 'er druggie pimp and she'd still be alive. (*Stops.*)Yer said I 'ad worms on me face. She 'ad snakes inside 'er. Thass 'ow druggies end up, feedin their snakes t' get a bit 'a quiet. (*Starts to go to the door again.*) Things I could tell yer. Yer think yer money kep 'er 'abit goin. What yer petty crime brought in werent 'arf enough t' feed 'er snakes. When yer was out muggin she was out sellin herself on the streets. Plyin 'er trade as they say. Thass the sort a' mother yer 'ad (Bond, 2011, p. 201).

The audience can see how sensitive Dan is about her mother and the memories they lived together. Richard acts mean and insensible about their past. He uncloses the realities about Liz that are very tough for his son to bear. Bond stresses the undemocratic status of the dead who lived in the past and who cannot be fitted into today. Here the warnings of Bond are crucial to understand why Dan fells so angry to her father, he says, "you have to be very careful because the past is very fragile and we have to live with it." (as cited in Amoiropoulos, 2013, p. 47). So, people should be careful about delicate matters about the dead. And here, after the bold and injurious words of Richard, Dan turns into a troubled person for Richard. Relatively he fits Nicholson's description about Bond's characters, he observes that "Bond's young characters are often

both troubled themselves and cause difficulties for others" (Nicholson, 2003, pp. 13-14). Here, the evolution of Dan can be apparently seen after his encounter with his father. Losing his temper, Dan attacks his father. Inspiring from her mother's story, he throws Richard, ties him with sheet and attempts to blind his eyes as the mother has done to her child. In the course of the play, this radically innocent boy is replaced by an aggressive teenage because of his father's insensitive words about his mother.

> Dan: Look at 'er! – 'cause yer goin t' lose yer eyes! Thass why yer come 'ere! Why yer come in this room! So I can put the room right! Yer goin t' lose yer eyes!
> Richard: No no son – please please – (Bond, 2011, pp. 206-207).

Richard is able to escape from getting blinded, and while he is leaving, Dan looks out the street and shouts "For the kid. For the kid" (Bond, 2011, p. 208). As Bond stresses, "His power to destroy becomes the power to create, and that always means in part self-creation" (as cited in Amoiropoulos, 2013, p. 231). Dan strips from any parental bond and responsibilities, he turns his face to other kids for the same freedom. This is the first time he looks out the window. Now he can be free from the domestic relations with the help of this window that opens to outer world. Before that he has been outside of this house, but it was for his mother. Life has brought unexpected sorrowful experiences for Dan and he wonders about other people's life. Here, Bond does not depict an idealised world for children, on the other hand, children should move on in given circumstances with their realities, innocence, and imaginations. After all these traumatic incidents, now it is time for him to start to live his own life. Now he witnesses the rush of people in the street and says, "they spend their life walking to each blind corner. They don't know what's behind it" (Bond, 2011, p. 198). This act of looking out brings an insight for Dan, he can understand the struggles of people. There may be 'blinds corners' in each person's life; however, people keep on walking towards these corners.

Conclusion

A Window here as Sarah Hemming (2009) claims might be the reflection of deserted, lonely and ruinous facade of contemporary life as it is presented with the experiences of three different characters. Moreover, as Liz utters before her suicide, "Yer see it every day. Famine. Kids' bones wrap up in old skin. War. Fightin. Tanks bouncin in the dust – clouds a' it. A piece a' bread in the street. The long streets with a piece a' bread drop in 'em for the fillin. The city's a stone sandwich" (p. 194). Big Brum actors interpret of these lines related with consumerism, coldness of city life, materialism, survival, the blindness to outer world, poverty. (as cited in Amoiropoulos, 2013, p. 58). Obviously, there is not a

glamourous world in front of Liz's son in play, unfortunately many unpleasant incidents are still going and will go on. Here the key moment is about young audiences' motivation to explore, to ask and to experience in their own world for a better future. This is why final word of the play "for the kids" (Bond, 2011, p. 208) is so vital.

References

Allfree, C. (2009, November 11). *Edward Bond not bound by theatrical tradition.* Metro. Retrieved August 20, 2021, https://metro.co.uk/2009/11/11/edward-bond-not-bound-by-theatrical-tradition-539613/

Amoiropoulos, K. (2013, May). *Balancing gaps: An investigation of Edward Bond's theory and practice for drama.* (Unpublished Doctoral Dissertation) UK: Birmingham City University.

Big Brum Theatre in Education: Imagination in action, Retrieved August 20, 2021, https://www.bigbrum.org.uk

Bond, E. (2005). The Children. In. D. Davis, *Edward Bond and the dramatic child: Edward Bond's plays for young people* (pp. 1-9). UK: Trentham Books.

Bond, E. (2011). *Plays: 9.* London: Methuen Drama.

Coult, T. (2005). Building the common future: Edward Bond and the rhythms of learning. In. D. Davis (ed.), *Edward Bond and the dramatic child: Edward Bond's plays for young people* (pp. 9-22). UK: Trentham Books.

Davis, D. (2005). *Edward Bond and the dramatic child: Edward Bond's plays for young people.* UK: Trentham Books.

Davis, D. (2007). Edward Bond and drama in education. *Yaratıcı Drama Dergisi, 1*(3/4). https://doi.org/10.21612/yader.2007.005

Gardner, L. (2009, October 22). *A Window.* The Guardian. Retrieved August 10, 2021, from https://www.theguardian.com/stage/2009/oct/22/a-window-review

Grimley, T. (2013, May 31). *Dramatist Edward Bond is still going to extremes.* Business Live. Retrieved from https://www.business-live.co.uk/retail-consumer/dramatist-edward-bond-still-going-3938648

Hemming, S. (2009, October 26). *A Window, Birmingham Rep, Birmingham, UK* Financial Times. Retrieved from https://www.ft.com/content/d20c2214-bff0-11de-aed2-00144feab49a

Lane, D. (2010). *Contemporary British drama (Edinburgh Critical Guides to Literature)* (1st ed.). UK: Edinburgh University Press.

Nicholson, H. (2003). Acting, creativity and social justice: Edward Bond's The Children. *Research in Drama Education: The Journal of Applied Theatre and Performance, 8*(1), pp. 9–23. https://doi.org/10.1080/13569780308325

Nicolás, S. (2016). The trigger of truth is in your hands: Conversations with Edward Bond. *Contemporary Theatre Review, 26*(2), pp. 258–266. https://doi.org/10.1080/10486801.2016.1144184

Spencer, J., & Spencer, J. (1992). *Dramatic strategies in the plays of Edward Bond.* UK: Cambridge University Press.

Chapter 5

Edward Bond's Theatre of Desire: *Dea,* A New Madhouse Tragedy

Kağan Kaya

Sivas Cumhuriyet University, Türkiye

Abstract

As a larger than life play, *Dea* should be regarded as the freshest one of the results of Edward Bond's theatral desire and extremity. *Dea* which premiered at Sutton Theatre on 24 May 2016 and was directed by Edward Bond thoroughly demonstrates his shift through its show of Dionysian extremity in the human mind employing the thought behind his theory of 'radical innocence' against the 'material reality' within the Postmodern concern. That does not mean that *Dea* is a complete and profound break between early Bond and later Bond. The philosophy of Aristoteles and Hegel indicates that the thought/mind could not surface regardless of history/memory. *Dea* designs a relation between the mind of the subject and the mind of the society. In addition to the negative effects of modernism upon mind, the play lights on some social, historical, ethical and political questions as well. Through three subtitles as 'War Inside', 'War Outside' and 'War Everywhere', the primary purpose of this work is to unearth how Bond's own philosophy was improved and how his philosophy constructed a new form of traditional/contemporary 'Madhouse' play arising from a micro-cosmic madhouse plan to a macro-cosmic madhouse idea. It is the claim of this analysis that 'wars' in *Dea* build the main concern of the playwright in order to reveal the argument of Bondian 'drauma' or 'trauma-tragedy': They reveal the condition of both modern troubled/mad man/woman and the insane society. This analysis suggests not to limit Bond's own theories; but instead, to provide a detailed account of Bondian Drama by propping it through its hermeneutical depth. It suggests that the play is related to understanding the nature of human being and the society in which man lives.

Keywords: Edward Bond, Dea, War, trauma, Bondian Drama

Introduction: MADea

Michel Foucault, in *Folie et Déraison: Histoire de la folie à l'âge classique* (*History of Madness*), claims that in the serene world of mental illness, modern man no longer communicates with the madman: "The man of reason delegates the physician to madness, thereby authorizing a relation only through the abstract universality of disease. Doctors have authority not because they have the knowledge to cure but because they represent the moral demands of society" (Foucault, 2006, pp. 28-110). Except for modern man's clinical madness, his 'self' in crisis is always under discussion by both modern philosophers and dramatists. As a promethean playwright, Edward Bond establishes a relation between the modern madman and his society on the stage, and thus he is dramaturgically assigned the responsibility for the human mind. In this regard, Bond's theory on the nature of the human mind is significant not only because it demonstrates how he characterizes humanity but also because it regulates his dramaturgy.

There is a swift shift from the state of the nation to the state of mind in Bond's Drama. He evidently seems to search for human's mind on the stage. This shift occurs maybe because of the fading power of Marxist theatre and British mainstream theatre or Fukuyama's famous 'the end of History'. Perhaps it is just because of the fact that the playwright has rejected the accusation of being a "savonarola" (Bond, 2016b, p. viii) or that he has dismissed a sort of theatre that is part of the entertainment industry now as he claims. Whatever it is, Edward Bond thinks that drama's function is "to push the present to extremes so that we may see what we are doing and where we are going" (p. viii).

Edward Bond always "radicalized and revitalized the British stage with some 60 works based on an exceptionally confrontational aesthetic; one that combines provocative issues and highly unsettling scenes ... His drama is essentially built upon the idea that in a world operating on irrational terms," (Vangölü, 2017, p. 173) as "art expresses the need for the rational" (Bond, 1978, p. xvi). This is also a reaction against Dürrenmatt's notion that there is no longer probable tragedy. For Bond's 'Mind Plays' or 'Madhouse Tragedies' behind rationality, David Hirst (1985) epitomizes the theatrical power of the playwright, exclaiming that:

> Bond is an iconoclast: for him the writer's task is to destroy an ideology which society mistakenly reverences. Yet he is equally concerned to replace this with a rationally organised ethical and political structure. His plays have been concerned with attacking or demystifying figures as different as Queen Victoria and Shakespeare in order to expose the inheritance of moral guilt and hypocrisy associated with the former and to question the role of the artist in society through his dramatisation of the latter. (p. 160)

As a larger-than-life play, *Dea* (2016) should be regarded as the freshest one of the results of Edward Bond's theatrical desire and extremity. The play in three acts begins with Dea's slaughtering her twins before being raped by her husband, Johnson. It suddenly advances sixteen years or so. Dea now turns up at her ex-husband's house, where she meets her son Oliver who is the product of rape. She kills Johnson before he intends to rape her once more, and then she kills Oliver by accusing him of her murder. Act two takes place in an army tent in an unknown desert war zone where Dea's other son John is in command of a group of fighters who are questioning a woman. At the end of this act, there is another attempted rape. Dea arrives and causes a calamity before she is raped by John, who is then blown to pieces by a suicide bomber. Then Dea leaves the battle ground with his head. The third act takes place somewhere near the war zone where now completely insane Dea appears in a caravan in an austere and virtually post-apocalyptic setting. Cliff, who is one of the fighters from John's regiment, appears. He suffers from post-traumatic stress, but he still seems to take orders from the head that Dea has kept. He finally ends the tragedy of Dea by killing her. *Dea*, which premiered at Sutton Theatre on 24 May 2016 and was directed by Edward Bond, thoroughly demonstrates his shift through its show of Dionysian extremity in the human mind employing the thought behind his theory of 'radical innocence' against the 'material reality' within the Postmodern concern. That does not mean that *Dea* is a complete and profound break between early Bond and later Bond. The philosophy of Aristoteles and Hegel indicates that the thought/mind could not surface regardless of history/memory. *Dea* designs a relation between the mind of the subject and the mind of the society. In addition to the negative effects of modernism upon the mind, the play lights on some social, historical, ethical, and political questions as well.

Through three subtitles as, 'War Inside', 'War Outside' and 'War Everywhere', the primary purpose of this work is to unearth how Bond's own philosophy was improved and how his philosophy constructed a new form of traditional/ contemporary 'Madhouse' play arising from a micro-cosmic madhouse plan to a macro-cosmic madhouse idea. The plot that Bond deals with in a house, asylum, tent, and caravan showcases the inside-outside dynamics of this micro and macro-world. It is the claim of this analysis that the inside and outside 'wars' in *Dea* build the main concern of the playwright in order to reveal the argument of Bondian 'drama' or 'trauma-tragedy': They reveal the condition of both modern troubled/mad man/woman and the insane society.

This analysis suggests not to limit Bond's own theories; but instead to provide a detailed account of Bondian Drama by propping it through its philosophical depth. It suggests that the play is related to understanding the nature of human beings and the society in which man lives. While making its analysis, this work

respects Bond's thought that "drama isn't directly philosophical but enactment" (Edward Bond, personal communication, September 2, 2021), but it still asks philosophical questions and responds to those questions so as to understand Bondian philosophy behind *Dea*. In this respect, the basic philosophical remark of the play is argumentatively asserted by one of the soldiers of the play; Cliff rewords Hamlet's remarkable aphorism: "To be sane or not to be sane, that's the question. And if not, then be mad and everything that follows" (Bond, 2016a, p. 78). Sanity/insanity exactly corresponds to the phenomenological, philosophical and social background of *Dea*. In that sense, in order to solve the problem of the mad man and society, Edward Bond (2000) suggests that "theatre is the madhouse where the audience go to find their sanity, just as madmen go mad in reality to find theirs" (p. 95). It is this analysis which seeks the rational or irrational traces behind sanity/insanity both in modern man and society through Bond's theatrical ingenuity in *Dea*.

War Inside

Edward Bond's suggestion for British drama is related to the direction of drama Antonin Artaud (1958), in his *The Theatre and Its Double*, offers for the role of drama which "wakes us up: nerves and heart" (p. 84). The playwright's dramaturgy, in this sense, is deeply indebted to the tradition of Greek Tragedy. British theatregoers have been acquainted with the plays of the Greek tragedians since the last years of the sixteenth century. However, the adaptations of great Greek tragedies such as *Oedipus Tyrannus*, *Antigone* and *Medea* particularly became popular on the British stage after World War I though they have been watched in Britain for four centuries. Bond's *Dea* (2016) gets its motivation first from Euripides's and then Seneca's notorious *Medea*, but it is hardly a variation of the original ones. Bond intends to reconfigure the original play with its archetypal characters. Besides that, Euripides's ends with the agonistic character of Medea's (431 BCE) massacre of her children, and Bond's launches with filicides of precarious Dea. This reveals how Dea, whose deeds shake the audience in their seats, is in the middle of a war inside.

Dea's opening scene, which presents an inner war, is based on Bond's former twenty-minute play called *There Will Be More* (2010). However, *Dea* (2016) includes some contradictory elements as its title suggests. There is a great contrast that elucidates the whole play as in the word play of 'Dea': D(n)a, MaDea and dea(th). The play notably follows some elements; life versus 'dea(th)', silence versus noise, inner war versus outer war. These contradictions are true for the major characters, as well. Dea, who is a lonely mother of two babies, is physically and mentally far from her husband, Johnson. In contrast, Johnson is quite a busy and alienated commander in a politically noisy environment outside, and he has military ambitions. Johnson, as master, does

not hear Dea. Dea, with her twin babies, has no one except for a babysitter to hear her cry of violent or monstrous loneliness, and she seems to be in extreme unhappiness at a silent house or a 'Madhouse' of Bond. Her silence, like tongueless Lavinia's in Shakespeare's *Titus Andronicus*, both symbolizes and realizes a semotic crisis. Her silent outcry also echoes Medea's in *There Will Be More*: "No, I've had quite enough" (Gardner, 2010). It is a fact that there is no healthy communication between Dea and Johnson at home, either until Dea, in the absence of Johnson, asphyxiates her babies with her dress and shoes. Horrified by the death scene of his babies, Johnson helplessly asks why Dea slaughtered them, and she speechlessly replies: "You wanted me to do it" (Bond, 2016a, p. 11) though Johnson never ordered her to do so. In fact, he solely demanded Dea to get dressed for a party so as to celebrate a current victory he took on the battlefield.

There seems no noticeable war at home at first sight, yet it is a fact that home is not a comfortable place for Dea for a long time. Dea's frightening silence at home/inside and her inner-self constructs a parallel/paradoxical dramatic structure with Johnson's war outside. Dea's ontological inner war is in contrast to Johnson's victorious life outside. This war transforms into another complex clash and becomes more visible after Johnson rapes Dea as though to retrieve his lost children – this can be described as a violent action from inside to outside.

Dea tolerably shows no reaction to her husband's violent action at first. However, it is possible to make some philosophical or even psychological links with her attitude. Her meaningless silence reminds Lacan's *jouissance* since her condition could include both pain and pleasure – though Dea does not experience any orgasms – or Freud's *das Ding* which is the lack that gains a positive existence in the form of the impossible – inaccessible pleasure. It also corresponds to Bond's "theory of subjectivity" (Chen, 2018, p. 33), which is behind the idea that Dea is pictured as a precarious subject with her self/soul. Bond's theory of subjectivity, then, is partly in consistent with the philosophy of Theodor Adorno, too. For instance, Adorno (2003) states that "once subjectivity as an independent identity disintegrates, the elements of nonidentity emerge to participate in the reconstruction of a post-psychological subjectivity: these elements are the negative images of an instrumental and psychological reality" (p. 271). This is reminiscent of Dea's rejection of being an object or the Other. But instead, she admits to being the subject or human being within Bondian aestheticism.

Bond's tragic-heroine is precisely in-between dialectical inside and outside wars in which Bond's major ontological views manifest themselves as the concept of 'radical innocence' – it is a way of understanding human nature and the moral psychology of 'the subject'. Bond (1998) proposes that "[w]e are born radically innocent, and neither animal nor human; we create our humanness

as our minds begin to think our instincts" (p. 251); this is the evolutionary transformation of the subject's mind not from organic to mechanic, but from mechanic to organic so as to form humanness. In this regard, Dea thought of Johnson as if he were a totalitarian commander before her instinctive action. She even acts as if she were sleeping before her crime. The problem here is whether Dea slaughtered her babies consciously or unconsciously/by using her mechanic mind or organic mind. This is similar to her ontological description. Bond deconstructs the idea that Dea is definitely mad, and he creates a new condition in which she is a new-born baby – a neonatal creature. He suggests that 'radical innocence' is the state of the purest form of the human soul, and this makes it possible to understand the reality of human beings as in Dea's crime scene in which Dea's purest self/soul precisely emerges when she becomes a liberated subject released to the nature.

In order to delve into the condition of the human being in the state of nature, Bond benefits from some dramaturgical images and 'the Palermo paradox'. *Dea*'s first but not the last infamous scene reveals how Bond constructs and contextualizes the stage images in his dramaturgy around liberated subjects. When performed, such scenes, which include Brechtian 'gestures' serve as critical apparatus of drama for contributing to the issue of humanizing the subjects within dehumanizing circumstances. Bond also uses 'the Palermo paradox', which he improves with the students at Palermo University. "The paradox is never absent from our mind. It is the crux on which humanness is poised, an expression of the radical innocence which makes us human" (Bond, 1998, p. 251), he suggests. According to Bondian terms, it corresponds to "the 'fictions-within-the-fiction'. Because for Bond (2012), the use of ghosts is another dramaturgical device of fictions-within-the-fiction:

> In drama fiction is the first layer of psychosis. But there are fictions-within-the-fiction: God, ghosts, witches, phantoms. ... Then the fictions-in the-fiction undo, decathex, the fictions of ideology, because the audience know they in fact are not the dead who came to the theatre as ghosts. ... It is a matter of the relation between fictions (p. xxxvii).

The audience also has contact with the drama and dramatist through fictions-within-the-fiction. Bond's dramatic tools determine the combination between the real and fictitious, and so the audience directly focus on the meaning of life of real/haunted Dea.

To figure out Dea's ontological existence, it is also necessary to enter her haunted world. It is likely to create a metaphorical connection between her house and Plato's famous 'cave', which includes both the interior and the exterior world of the man. Gritzner (2015) indicates that

Theatre, Bond would argue, presents us with the opportunity to create imaginary places where reality can be mediated and made sense of in a confrontational, even aggressive manner, which brings into sharp focus the aggressions and violence of human behaviour in reality (p. 48).

A cave, for instance, is regarded as an uncivilized place in ancient Greek tragedies – even in the tragedies of Euripides. Similarly, Dea's house must be considered as an uncivilized one with hardly any precise dialogues or social interactions. That is, in her house, there appears no truth or reason. It is an irrational environment like Plato's cave. When Dea's criminal action is taken into consideration, it is also realized that Dea does not live in the world of truth, but she lives in the world of frightening shadows of Plato.

Dea transforms into a subject who acknowledges her captivity in her own cave before her crime. In Kantian words, this is her aufgang/weggang, which means rise/leaving in English. Dea's crime indicates her sophistication/ enlightenment – it is a kind of rising ontologically. Luce Irigaray, in her psychoanalytic reading of Plato's cave, suggests that Ideas outside the world do not belong "in the realm of pure unchanging Being" (Whitford, 1991, p.105). Dea goes out of her own metaphorical cave – the womb. Her true 'being' emerges outside the womb – the walls of the cavern. In a sense, she also represents all the women who are outside the cavern. It is the result of the fact that Bond cannot bear for people to lose awareness of their captivity; he cannot stand that they fail to be members of the proper society. Dea, by killing her babies, brakes her chains and manages to become a liberated subject/woman out of her haunted cave.

If the Madhouse/haunted cave of Dea is significant for indicating her ontological and feminine condition, some details about Senecan tragedies must also be highlighted in order to indicate the similarities and differences between Senecan and Bondian ideas behind the madhouse. Dea has not got a good life as Senecan Medea has not got. Although Seneca embraced Stoic philosophy, his tragedies differed from Stoic principles. Seneca constructed his madhouses in the tragedies. His plays are not representations of a Stoic ideal of a good life. Contrary, they distort the ideal. For instance, "There are no gods' are the final, despairing words with which Medea closes" (Young, 2013, p. 52). Besides this, his tragedies do not reflect Plato's major theoretical principle of art; the imitation of brutal emotions onstage supports the augmentation of those passions in the audience though Seneca was possibly unaware of Aristotle's Poetics. Bond, similarly, plays with emotions and desires, still, Dea does not reject reason. On the other hand, Seneca's tragedies usually begin with 'a sense of impending doom' pursued by a conflict between logic and emotion that logic loses. Such a defeat causes psychopathic actions, as in Medea:

[I]t is good to know the truth about our inner demons. Seneca's aim, his conception of the purpose of tragedy, is to look these demons square in the face and thereby provide a picture of the 'monsters' dwelling in the 'underworld' of the human psyche (Staley, 2010, p. 101).

Dea, on the other hand, is a play in which the heroine commits a crime not only because of her desires but also because of her mind/reason.

The question here is whether Dea's action arising from her desires and reason makes her a 'proto-totalitarian figure' like Sophocles's Antigone or a victim of 'ethical violence' according to Žižek's philosophy. Moreover, she, like Antigone, may be regarded as, in a Hegelian perspective, "a character has her stand for the transition from matriarchal to patriarchal rule" (Butler, 2000, p. 1). It is also unclear why Dea's action is unethical. It is then required "to re-evaluate the fundamental nature of issues" (Takkaç, 2001, p. 84) behind the actions of that Bondian character. According to Greek tragedy scholar Edith Hall (2010),

Euripides's Medea is aware of the fact that she committed crime, and this is morally wrong, her filicide is framed in a terrain of moral ambiguity since we cannot be sure whether her acts are completely intentional or they are driven by uncontrollable rage (p. 189).

But Dea does not reveal any clues about the extent to which her wrongdoing is unethical. Because while Medea jealously kills her children and takes her revenge on her husband, Dea does not have any egocentric motivation before her crime. She does not plan to kill her babies. Maybe her crime reminds the Socratic intellectualism around "no one errs willingly" (Plato, 1990, 345 C 4–E 6; cf. 352 A 1–358 D 4). Because it is almost impossible to accuse Dea of being isolated/alienated at her home. Her destiny conjures up what happened to Medea, who is not from Corinth and who is ostracized and despised. Dea, like Medea, is an ordinary and discarded woman by her husband. According to Aristotelian Ethos, Dea rejects to regard happiness as a 'contemplation' on which all virtues depend. She ethically thinks that happiness does not correspond to the supreme good. But she is never virtuous. She is mentally poisoned as being the Other, and she commits a crime for the sake of saving the honor of all humanity by killing her babies intentionally.

War Outside

Dea is sent to a madhouse after her terribly inhuman crime. She gives birth to twin babies again, and those babies are named Oliver and John. She is kept in the asylum, but her babies are given to Johnson. After eighteen years, another war shatters the hospital, and she comes back home to maintain her right to be a family member with her sons, Oliver and John, and her husband as well, but she still claims that she is neither mad nor wicked:

Johnson: ... Why did you ruin my life?

Dea: I don't know. ... Every day I was with the mad my sanity was clawing at my brain. When the bombs fell they opened the roof. Suddenly there was sky everywhere – I was free – and I ran out into a bigger madhouse. Help me. ... I have a right to live here.

Johnson: A right! ... (Bond, 2016a, pp. 19-20).

Bond's description of the outer world as 'a bigger madhouse', is ingeniously connected to the playwright's philosophical and theatrical realm, and it is a vivid description of the war outside, as well. It is obvious that Edward Bond is one of the most negatively affected playwrights by World War II and The Holocaust. This reality greatly affects his career. War, in Bond's plays, is one of the basic circumstances which deconstructs the idea behind the dehumanised environment outside. This is not surprising because Bond achieved a great deal of foresight and experience in shaping war in his drama; he always wrote about war as in *Saved* (1965) and *War Plays* (1985). They all contribute to Bond's philosophy and aesthetic understanding, and thus, *Dea* (2016) is not an exception.

After Dea's return, it is also understood that Johnson lost his position in the army and that he became a commander of his own house. It is visible that Johnson has a strong authority over his sons at home. This disturbs Dea for the reason that she probably killed her twin sons in order to guard them against the battlefield to which their father always tries to send his children. Johnson's behaviour, though he is an old warrior, also shapes a controversial phenomenon for the understanding of the sexual relationship between Dea and Johnson. While Dea behaves as if she were a fertile goddess who gives birth to only soldier boys – it is a fact that she never gives birth to any daughters – Johnson, on the other hand, is a soldier who leads them and causes them to be killed at wars outside. When Johnson realized his children were killed by his wife, he also, for the first time, learned how wars outside – or the holocausts – collapse the children of others. Bond aesthetically depicts such theatrical empathy through the words of Johnson's anti-militarist son, Oliver, during his quarrel with his father:

I know why she killed them. Bits of me are killed every day since I can remember ... You put on a uniform to kill. Where you kill and she killed are the same place – it's where my dead brothers are kept and because they were killed when they were little they ride round and round on a merry-go-round and wave at us and cheer. (Bond, 2016a, p.32)

Oliver thinks that after his brothers are massacred, they begin to be seen as subjects that do not go beyond numbers. His exclamation furthers the negative criticism of the political and ideological perspective that reduces deaths/

massacres to numbers or statistical details. Bond here revives the memory behind the innocent people murdered in Auschwitz. This idea is shared by Bond in a similar way to Emmanuel Levinas and Theodor Adorno because in drama, "[m]orality combines imagination and reason" (Bond, 2019, p. 6). Thus, Bond's point of view while disclosing his ideas on war and The Holocaust is similar to Levinas's and Adorno's. Both philosophers' thoughts are accumulated in Bond's theory called 'Aggro-effect', which is "a more efficient device to commit the audience" (Bond, 1972, p. 34); it is Bond's eclectic method to emphasize ethical concern in his plays like *Dea*. This method is partly linked with Levinas's ideas. Levinas (1999) clarifies his main concern in his philosophy, saying that "[T]he Holocaust is an event of still inexhaustible" (p. 161). For Levinas, philosophical concepts such as reason, freedom, autonomy, and consciousness all entail the logic of identity thinking that reduces the otherness of the other for the ego to subsume. He asserts that humanity is defined by how one can remain open to the death of the other since the death of the other awakens one to the other (Levinas, 1999, p. 157-161). In this regard, Levinas does not define man as a supreme ruler of consciousness. He establishes his ideology on ethics dependent on his phenomenological examination of the reality of the subject rather than his/her egology. His basic effort is two-way: One is to break up the ego-centered subjectivity, in which the self just authorizes the other at his or her disposal; the other is to explore an optional subjectivity which gives supremacy to the other even at the cost of the self. Levinas (1969), for his analysis of the 'I', states that "[t]he 'I' is not a being that always remains the same, but is the being whose existing consists in identifying itself" (p. 36). Adorno also examines the The Holocaust distinctly; he connects a relationship between the numbers and the humane; this is about rationality, or *ratio*, which is not intrinsically instrumental. As Adorno (1999) explicates in *Negative Dialectics*, "while ratio in Plato still implicates qualitative differentiation, it is that ratio works as scientific eradication of qualitative differences, which are converted into quantifiable units" (p. 43) particularly after Descartes's bracketing 'the object'.

Dea, like a serial killer or a vicious warrior or 'the object', later indifferently kills Johnson because he wants to rape her – this raises the idea that she does not want to give birth to any more soldiers for Johnson, instead to eradicate them all. Then she fellates drowsy Oliver beside Johnson's corpse. She, furthermore, accuses Oliver of killing his father and blindly kills him. Despite these barbaric actions, Dea still professes that she is not insane and wicked. Later, she starts to pursue her other son, John, who is sent to the battlefield by his father. Part One of *Dea*, though Dea rejects her symptoms of madness, shows the violence behind the military madness. It is a fact that there is no on-stage military madness of Johnson, but Dea is the real mad of the family.

Part Two of *Dea* (2016), which is dramaturgically more ambiguous than the first one is almost entirely set inside an army tent where a few soldiers led by John are about to attack against their enemy. It is this part in which Bond actually tells a war crime. He describes the terror on the border. This must be regarded as Bond's serious dramatic reaction to some negative examples behind the real war scenes after the idea of the 'War on Terror' at the beginning of this century. In fact, this reaction is not new for Bond. In his '*Author's Note: On Violence*', Bond (1977) proposes that '[v]iolence is not a function of human nature but of human societies' (p. 17) of our time.

Dea (2016) designedly reminds what also happened in Iraq, Abu Ghraib, or Guantánamo. Bond establishes an unlawful and totalitarian war prison for a woman on the stage. The captured woman, like the prisoners in those jails, is seen as "the improper/unclean" (1982, p. 2) according to Julia Kristeva's 'theory of abjection'. First, Dea finds herself in the middle of a war in the pursuit of John. Then she takes part in that prison-like circumstances. In this atmosphere, a captive woman with a sack over her head is killed, and later her corpse is raped with a beer bottle by the soldiers to whom John commands. Bond (2016b) shakingly describes the scene: "I write of the rape of a corpse with a beer bottle to bring back some dignity to [the British Theatre]" (p. viii).

It is this atmosphere that bonds the dramatic aim and philosophy of the playwright and the thinkers' thoughts in terms of power, ethics, and totalitarianism. Initially, it is better to remind that the soldiers depicted on the battlefield do not act according to the universal ethical norms that can protect human dignity. In an epistemological sense, they do not have the knowledge to act according to moral values. From this perspective, Bond's idea is "Kantian in the sense that he refuses to explain the imperative through psychological motives; nevertheless, he acknowledges the discrepancy between practical reason and empirical actions" (Chen, 2018, p. 148). For Kant (1997), "the sole principle of morality consists in independence from all matter of law (namely, from a desired object) and at the same time in the determination of choice through the mere form of giving universal law" (p. 30). Kant believes that to be rational is the same thing as being free, and a human is free only when he acts on the basis of reason as opposed to his passions and desires. Moral actions can not be driven by feelings or emotions. Kant's practical reason is not determined by any 'matter', any specific desire or object, but by a mere 'form' of universal law. In this, Bond's soldiers are expected to decide what is good/evil in the frame of the universal rules of the war; nevertheless, they cannot do that. Although they have a chance to change their minds, they do not manage to act without the desires of the authority. They obey the orders of John and the voice heard from a transceiver.

It is known that Bond's 'radical innocence' does not mean that man will act without thinking or judging the circumstances he meets. Bond's heroes/ soldiers have the chance to judge the order coming from the authority; however, they are not capable of considering/judging the orders according to the universal moral norms and laws. It is reasonable because man can not easily resist the power. Bond builds the prison-like condition around the idea of power. He creates "an Orwellian dystopic atmosphere on the stage, presents different societies and character types in order to reveal the scale of the negative effects" (Özata & Biçer, 2021, p. 230) of power. Thus, power dominates the Bondian prison-like stage. Under the pressure of political power, John crazily orders one of the sergeants: "Order the men to shoot the hill! Massacre it! Massacre the earth!" (Bond, 2016a, p. 62). John's command reveals that they all gradually transform into Harold Pinter's infamous killers, Ben and Gus, in *The Dumb Waiter*. Ben and Gus do not realize and question what is right, but they just kill people whom they do not know because Wilson always orders them to do their job. Similarly, the soldiers under the control of political/ military power seem to be ready to open fire on the unknown enemy on the other side of the border. It is even unclear whether the troops of the enemy consist of children or not. The soldiers never question what happens there. It is a fact that the self, which completely succumbs to reason, renounces any resource to the imagination and acts strictly in accordance with the operation of the authority. This recalls what Hannah Arendt's remark in *The Origins of Totalitarianism* (1951): "Totalitarian government can be safe only to the extent that it can mobilize man's own will power in order to force him into that gigantic movement of History or Nature which supposedly uses mankind as its material" (Arendt, 1973, p. 473). The action of the soldiers reminds the famous words of the nineteenth-century politician Lord Acton: "Power tends to corrupt and absolute power corrupts absolutely" (Lazarski & Allshouse, 2012, n.p.) because the soldiers act in accordance with the authority independent from their reason and 'self' though they have chance to act independently. They never manage to be a human.

In order to understand Bond's aim at using poisonous power on the stage, it is also better to analyze the ideas of two western intellectual minds; Friedrich Nietzche and Martin Heidegger. Their ideas focus on 'being' and power. Both Nietzsche and Heidegger regard to reason and truth as the absolute source behind the violence. According to many postmodernists, power is the most common irrational prerequisite for logic. For example, Nietzsche claimed that the will to power was behind reason's will to truth. Heidegger, as an ontologist and an existentialist, on the other hand, took a more nuanced approach, arguing that while the history of Western metaphysics begins with Plato and ends with Nietzschean will to power, such will to power as the operative understanding of being in modern science and technology nihilistically

reduces the meaning of being to a single meaning in order to control and manipulate it. Heidegger, on the other hand, believes that there is a will to the power behind Western metaphysics and reason, and he believes that there is a deeper, more fundamental reality underneath and beneath the notion of being as power, which he refers to as '*beyng*/*das Seyn*. Heidegger thinks that before bothering the trivialities like this or that particular entity or being, it should be learned what it is 'to be' or what 'being' tells about itself: "Being cannot be equated with the highest being, or God, who creates, causes or grounds the world. Yet, without Being, nothing at all could 'be'" (Stambaugh, 1991, p.10). *Das Seyn*, then, is finite, and it is a collection of psychic states such as *angst*/anxiety or violent which projects being, and they correspond to the facts of the horizon of human existence apart from the theological aspect – the existence of God.

Bond's understanding of being, however, is related to hallucinations, unlike Heidegger's. Still, both, in search for the purest being – maybe Heidegger's is also about 'Being' in a theological sense, it is in capital B – turn their faces to pre-Socratic ideology. This makes clear that in its purest form, one can feel violence behind authority on Bond's stage because he deeply unearths what being is while it acts violently – this is again similar to his philosophy of 'radical innocence' or the understanding of 'to be'; it is to understand the authentic human being.

Edward Bond, who aims to reveal the destruction of 'being' caused by globalizing power, further establishes a relationship between space and power in his violent war scene. Italian philosopher Giorgio Agamben (1998) describes such a relationship by claiming that "the camp is the space that is opened when the state of exception begins to become the rule" (pp. 168–169); it is no longer possible for the state to mention a real democratic understanding. Power decides fate and death in the life of the subject because biopower dominates the biopolitical spaces. Bond's camp, which is similar to the description of Agamben's Nazi camp prepared for Jewish people, seems to be built for performing violence. It is the territory where Agamben's biopolitical distinction between *zoē* as the simple fact of living and *bios* as the political form of living (Agamben, 1998, p. 1) are observed. For Agamben, the spirit of modern biopolitics exits in how the division of border between *bios* and *zoē* is featured – the time of judgment when a subject equipped with political power may give up his or her rights and get the status of *homo sacer* in Agamben's words. It is "the production of a biopolitical body is the original activity of sovereign power" (Agamben, 1998, p. 6) seen as a part of trivialities within such spaces as in *Dea*. Bond, like Agamben, seems to describe such spaces as trivial and ordinary. This is his intentional theatrical method to emphasize the condition of the subject exposed to violence.

In such an ordinary environment, Bond asks a moral question that must be answered by the soldiers under the command of John, who a constituent representative of power is. It is the question of whether they are going to act regardless of political power in this camp. However, it is understood that they do not manage to act without state-authorized violence or, in Nietzschean terms, without master's morality, as they are warrior-type inhuman creatures or barbarians. Because they dominate the Other, take advantage of the Other, and pain to the Other without any noble actions arising from their moral judgment. On the battlefield, for instance, John seems determined to treat the prisoner according to the orders which are heard from the transceiver; yet, in the final decision, the act of rape as a punishment given by reminds him that the woman prisoner is thought as the oppressed inferior or 'the peasant' in Nietzschean words. She is now someone who can be killed. She is a figure reduced to physical existence – a 'homo sacer' in front of the soldiers, and since there is no law of war anymore, guilt enters the stage Bond. The tent just turns in to a space where "materialization of the state of exception" (Agamben, 1998, p. 174) is distinctly viewed.

The state-authorized violence in the play could be dealt with by Michel Foucault's ideas on 'biopolitics', too. Foucault's major philosophical message is that the only way to extend the domain of human freedom is a ruthless analysis of power that seeks out all coercion imposed by one person on another and tries to eliminate that. In some ways, it is claimed that it is a sort of nihilistic philosophy of resistance. Another way of describing it would be a Postmodern articulation between power and knowledge. In his notion of 'biopolitics', Foucault also makes a connection between the holocausts and politics. He says that "wars were never as bloody as they have been since the nineteenth century, and … never before did the regimes visit such holocausts on their own populations" (Foucault, 1980, pp. 136–137), and he views the reason for this in modern racism, which guarantees the "death-function in the economy of biopower" (Foucault, 2003, p. 258); it is a way of oppression of power over the human being. Bond's philosophy/aestheticism on the stage is then to undermine and interrogate all prevailing moral and political codes which abuse power.

Apart from this perspective, Bond consciously dramatizes the soldiers in their tent as having visual hallucinations of seeing children across the border. Sean Carney (2013) states that Bond's tragedy "replicates the childhood encounter with nothingness and dramatizes the radical innocent's tragic interrogation of the boundary" (p. 158). It is obscure whether these children are real – it is probably another Brechtian 'gesture' because the children are ghost-like figures. Bond intends to reveal that adults who are soldiers in wars are also the mothers' innocent children and that just because they are adults on the battlefield does not mean that they are not children. They are the representative

of all children sent to the wars by any political power. In light of such an idea, Bond also plays with the level of reality. It is really invaluable since Bond reminds real violence performed in World War II by Nazi power, similar to the unlawful or inhuman deeds performed by the soldiers under the control of John.

In the final part of the war scene under a tent, the Interpreter, who mostly maintains to be wordless, and only helps John translate 'rape' into the incomprehensible language of the captive woman, wears her suicide jacket and explodes it – this action mirrors the method of terrorist attacks in our century. John and his soldiers die in front of the very eyes of Dea. Dea, later in paranoia, appears carrying John's head behind the tent. This is a Bondian leap from reality to unreality or from sanity to insanity. It is decisive that Bond, through the image of decapitation, makes an invitation to establish a relationship between Dea and John and Agave and Pentheus after that torturous scene. It is a beheading image having some theatrical traces of Agave's grasping his son's head in *The Bacchae* (405 BCE) by Euripides: "In *The Bacchae*, both Agave and Pentheus are in a Dionysiac trance, and Pentheus is decapitated by Agave due to her delirium. Only when Agave comes to normal consciousness does she realize her violent deed" (Chen, 2018, p. 166). Similarly, Dea realizes what happened to John after the burst of the explosives. That is, it is a realistic war scene that vividly reveals what happens to the innocent children of innocent mothers in real wars outside.

War Everywhere

The destruction caused by violence on the border profoundly affects the last part of the play. Dea's war is everywhere, even in the other world. First, Bond underscores the condition that people who experience wars are no longer themselves. Dea distinctly begins to behave as if she is mentally ill after the death of her child. That is, 'Posttraumatic stress disorder (PTSD)' or 'post-war syndrome' becomes the main concern of the argument in the play on the surface, henceforward. It is astonishing that although Dea is a murderer of her babies in the opening scene, she seems more traumatized by the death of John in the war. She even starts talking to her son's head, which she takes with her wherever she goes. Because she does not have any family anymore, it is realistic that Dea lives in a wreck, in a shabby caravan in the jungle. John's head is treated as a lost child and a commander without any parts of his body except for his head in this wild world. One of John's soldiers, Cliff, who is the only survivor after the explosion, accompanies Dea in her paranoid jungle. The jungle absolutely becomes the new 'Madhouse' of Dea.

In this madhouse, Cliff, who just obeys Dea's rules, realizes that he is going mad like Dea. He says in fear, "I'm afraid of things in my head. If I go mad, I'll turn into an animal. They'll hunt me for my skin. My pelt. It's all I have" (Bond, 2016a, p. 72). Although Cliff, as a veteran, initially thinks that "People talk to themselves – it doesn't mean they're…" (Bond, 2016a, p. 72), he later feels that he has to contradict Dea's imagined world/Madhouse. He sanely/insanely informs Dea that John's head is just a head and that John is not alive:

Dea: … He ordered you to go!

Cliff: Who ordered me?

Dea: My son! …

Cliff: (*stares at* Dea) That? (*Turns to look at the head.*) That's real? A – (*Shocked.*) When I was here before I thought it was a toy. Kid's party mask.

Dea: He's my son.

Cliff: Your son … ? (*Turns to look at the head. Turns back to* Dea) It's a head. (Bond, 2016a, p. 75)

Unfortunately, Cliff also begins to consider John's head as his authority, and similar to Dea, he obtains the ability to talk to John in time, and at last, he obeys John's command and shoots at the mother three times at intervals. In physical and mental pain, Dea later appears while struggling to relieve her soul in-between this world and the other world. She emerges not with John but with her dead son, Oliver. The mother even urges Oliver to revenge from her soul/self: "Take this knife. Do it now. Before it's too late for ever! The madhouse was worse than dying! Give her more death! Death's nothing for the mad! …" (Bond, 2016a, p. 85). Unlike Oliver, Cliff, on the other hand, cannot resist the ongoing orders of John and kills the mother: "When an order's given it can't be –" (Bond, 2016a, p. 89). Dea's last moments reflect Bond's other theatrical world in which the playwright replays with the reality is the space of 'fictions-within-the fiction'. Because she is an example of one of the lost subjects of the modern world. Dea does not belong to this world, nor does she belong to the other world. It is obscure that Dea is in the real/unreal world.

The in-between space of Dea becomes one of the dramatic apparatus of the playwright when he conceives madness clinically and socially on the stage. It is, therefore, important to make an analysis of the concept of madness and the use of madness in *Dea* in a broader sense. Bond (2000) asks his questions for such an analysis: "Why can't madness be perfect? Why can't madmen live benignly in their fantasies and society in its injustice?" and says that "The answer defines our humanity. It is in two parts, one structural and one existential. Together they show that the real world requires us to be sane" (p. 88). The playwright in *Social Madness* (1997) categorizes madness as 'clinical

madness' or 'psychosis', and 'social madness'. Bond's idea of clinical madness is prominently related to that of the core self/soul. Bond thinks that people become clinically mad when they become unsuccessful in building a practical relationship with their environment properly, and their madness is flourished as an alternative reality/world that challenges the legitimacy of what is regarded as the real.

Social madness, in contrast to clinical madness, is that "people who seek the rational logic of society are mad since society itself, due to its structural injustice, becomes intrinsically 'mad'" (Chen, 2018, p. 89). For Bond, when a clinically mad subject undergoes the process of socialization improperly or when the subject cannot contact the world outside accurately, the subject constructs an alternative reality. Bond (2000) thinks that "Most of us are clinically sane but socially mad" (p. 93). It is that reality echoes from *Dea* – it reveals the social psychosis of Dea. For instance, one of the last insane cries of Dea is: "It's better to die than kill" (Bond, 2016a, p. 88). Dea cannot communicate with the real world correctly even after she takes deadly wounds.

In a pathological sense, there are similarities between some contemporary philosophers' and Bond's ideas, too. For Jacques Derrida, for instance, the exemplary spectre that demands justice is Hamlet's father, whose ghostly appearance endows Hamlet with the responsibility to adjust injustice and restore order. In Derrida's discourse on spectrality, the spectre is always connected to the problem of justice: "If I am getting ready to speak at length about ghosts, it is in the name of justice, of justice where it is not yet, not yet there, where it is no longer" (Derrida, 1994, p. xviii). It is a fact that nobody can say that haunted Dea is not a woman of justice. Because she just tries to find out justice for her children.

According to Slavoj Žižek, the condition of the postmodern subject can be understood through the 'Symbolic Order' he theorized. It is the 'Symbolic Order' in which the man hides his 'self'. He proposes a Lacanian hauntology: symbolization ultimately always fails, and it never succeeds in fully covering the real. "This real, the part of reality that maintains non-symbolized, returns in the guise of spectral apparitions" (Žižek, 1995, pp. 13-21). Žižek asserts that the spectre is a residue that symbolization fails to incorporate into the symbolic order; therefore, the spectre demands that we should take a transgressive action of freedom to establish a new reality. Dea creates one for her 'self' because she always escapes from the real world. Žižek's theory relies on our understanding of the distinction between reality and the real. We have no access to the real because our world is always mediated by the Symbolic. Reality, therefore, is always Symbolic. Dea, who is a part of 'Symbolic Order' is even sent out of that symbolic world by Oliver and John. Dea's sons cannot stand seeing their mother in that symbolic world.

In the Lacanian perspective, on the other hand, Dea's world is partly equal to the world of 'the Other of the Other'. The name Lacanian psychoanalysis gives to an Other in the real is 'the Other of the Other'. "A belief in an Other of the Other, that is in someone or something who is really pulling the strings of society and organizing everything, is one of the signs of paranoia. Following Jameson's influential analysis of postmodernity, it is now commonplace to argue that the dominant pathology of today is paranoia" (Myers, 2003, p. 53). In that sense, Dea seems to become part of the Other. For Bond, the subject is structurally mad. "Whether the subject is dominated by pure reason, pure imagination, or by any harmonious, yet corrupted, interactions between reason and imagination, the subject is anchored in different forms of madness. Bond's idea of 'psychosis' transcends the enclosed structure of madness" (Chen, 2018, pp. 91-92). While the act of authority that fills the gap with the law is an act of necessary violence, the self, in certain circumstances, may not be able to accept the established order and seeks to create 'unreal-reality' (Bond, 2012, p. xxxii) through imagination. Dea creates her 'unreal-reality' or her Madhouse everywhere. It is significant to indicate that, for Bond, "the only way to transcend the structural madness is to keep psychotically questioning and self-questioning – this is 'radical innocence' in its purest form as well as a process of deconstructive self-dramatizing" (Chen, 2018, p. 92). It is possible to come across such similar "traumatic self-interrogation" (Billingham, 2013, p. 49) in the condition of Bond's Lear. In explanation of clinical madness, Bond clearly concludes that "[t]he mad go mad in order to seek the truth of their situation, and in drama the fictions-in-the-fiction are the means by which our madness heals itself" (Bond, 2012, p. xxxviii).

Bond's 'social madness', on the other hand, can be analysed through the politics of society. For example, Michel Foucault (2006) attributes the starting point of the conflict of man with his society to 'modernity', including the modern thought of the Middle Age, Renaissance and the Enlightenment. That is, for Foucault, man becomes socially mad after Renaissance (p. 35). However, Bond, like Giorgio Agamben, considers that the concept of social madness originates from the advent of democracy in Ancient Greece and reemerges after Renaissance and Reformation as the second crisis. It is worth taking the playwright's comment in length since it evaluates the results of such crises in the history of human beings by revealing the negative impacts of those, including the third crisis in society:

> We now live in the Third Crisis of the human species since it became aware that it was the cause of its own worst problems. That it was responsible to itself and not to some distant cosmic authority. So these problems relate to us to society. There is no direct solution available to the individual. We must solve the problems as a species and that means

in society and through politics … [The first two] crises created radical forms of drama that were in fact the formula of how to be human in the new society that the crises created. To illustrate this by means of an ancient language, the new dramas reconstructed the human 'soul', or as we would now say the human 'self' … The Second Crisis forced people to abandon their age-old peasant ways of living, move into insanitary slum-towns and become factory slaves … [the] colonial wars finally led … to the Second World War. We live in the Third Crisis and we have yet to see if it will end in the Third World War. (Bond, 2016a, pp. v-vi)

Edward Bond's analysis seems pessimistic because, for Bond, it is not easy to acquire the canon of how to be human in society today. The conflict between "the socialized self and ideology compels the subject to question the social order and to seek justice, but those who disobey and transgress the law are usually regarded as mad and abnormal" (Chen, 2018, p. 92) in society. Dea as the representative of the modern 'every-mad', questions the authority of her husband for the sake of justice, and justice for her babies and sons. Cliff, as another every-mad, also tries to disobey the orders coming from John and his seniors. Nevertheless, both Dea and Cliff are overwhelmed by the authority. Instead of a life imposed by the global world or the rules of life imposed by the sovereign power, the life Dea dreams of is another life: a life that is just and that the rules are not determined by the authority. It is a life socially safe and independent – a bare life – for the subject. Then Dea and Cliff, as losers, are as mad as we are in today's world.

Conclusion: Bondian Drama is Always Ready for a War

Due to the negative effects of the happenings experienced in the modern world, Bond's theatrical vision has gradually transformed from the interaction between drama and society into the interaction between drama and the human mind. This does not mean that he no longer dramatizes the state of society/the world. This work lights on the understanding of Bond's exclusive philosophy on the stage through *Dea* (2016). It claims that the play reveals how likely to establish a link between the mind of the subject and the mind of society through Bondian philosophy/drama and how Philosophy itself helps establish Bondian aestheticism. It is hard to accomplish to be a perfect human being today, according to Edward Bond. However, for Bond, theatre today is the only holy place where the audience regains and maintains their sanity or their humanness. It is the only means to remind us how to be human. In this regard, "while exploring the oppressive systems of postmodern societies, Bond's rational theatre always gives hope and optimism for the salvation of the human being" (Biçer, 2017, p. 479-480). The attempt to create a perfect political order or to create a perfect individual human being is bound to result in a worse

condition morally, for Edward Bond. However, theatre always needs a radical change to tell the condition of humans and society for all humanity. That is why the playwright anxiously exclaims:

> No child born since the Thatcherite putsch has lived for one second in a democracy. That is sad and shameful. Instead of a democracy we live in a market ... We no longer go to theatres to understand ourselves and create our humanness ... It is an escape from reality. Drama is not an imitation of reality. Its characters, events and plots must be integrated into drama became drama itself is the form of reality ... I have spent years honing the skills of my craft. Perhaps I can do something to change drama... We are the drama species. We need a new epoch drama to live through the Third Crisis (Bond, 2016b, pp. vii-viii).

Edward Bond feels that while describing trauma experienced by humanity in crisis, he needs to attempt to reestablish man's bond with his 'self' or his geography of mind and society – this constructs a critique of the identity of the man and the identity of society today. In view of this assertion, he asks, "How is it that most of us appear to be sane, but we live in societies that are mad?" and responds, "We live rational daily lives, but our societies make grotesque weapons, economically destroy their environment" (Bond, 2000, p. 87). It is a fact that most popular drama can not be regarded as a means to understand the condition of human beings and society today. Nonetheless, Edward Bond is aware of the fact that he needs to distance human beings from the opaque elements that commodify him. Because the dramatist should always reject the man's seen as an object of the consumer society by neoliberal politics or simply the authority itself. It is that Bond, as being more humane, will use his new theories and methods; he will maintain to use his unique philosophical and theatrical ideas so as to construct awareness for the realization of the 'mad man' and 'mad society' on the stage. As a result, according to the later but the younger Bond as a more humanistic intellectual/playwright, both the man and society should be ready for that war in the world –in the bigger madhouse. Drama must always be ready for the purpose of awakening both the man and society for him. Bondian drama, as in *Dea*, is always ready for such a holy purpose through his unique philosophy of enlightenment because the playwright, on his stage, resists being fragments or being fragmented as either a human being or society.

References

Adorno, T. W. (1999). *Negative dialectics*. (E. B. Ashton, Trans.) New York: Continuum.

Adorno, T. W. (2003). *Can one live after Auschwitz?: A philosophical reader*. (R. Tiedemann, Ed., & R. Livingstone et al, Trans.) California: Stanford.

Agamben, G. (1998). *Homo sacer: Sovereign power and bare life.* (D. Heller-Roazen, Trans.) Stanford: Stanford University Press.

Arendt, H. (1973). *The origins of totalitarianism.* San Diego: Harcourt.

Artaud, A. (1958). *The theatre and its double.* (Mary Caroline Richards Trans.), New York: Grove Press.

Biçer, A. G. (2017). Shakespeare ile hesaplaşma: Edward Bond'un Lear adlı oyunu. *MCBÜ Sosyal Bilimler Dergisi, 15*(1), pp. 479-495.

Billingham, P. (2013). *Edward Bond: A critical study.* Basingstoke: Palgrave Macmillan.

Bond, E. (1972). On Brecht: a letter to Peter Holland. *Theatre Quarterly 8*(30), pp. 34-35.

Bond, E. (1977). Author's note: On violence. In E. Bond, *Plays: 1.* London: Methuen.

Bond, E. (1978). The rational theatre. In E. Bond, *Plays: 2* (pp. ix-xviii). London: Bloomsbury.

Bond, E. (1998). Commentary on The War Plays. In E. Bond, *Plays: 6.* London: Methuen.

Bond, E. (2000). The hidden plot: Notes on theatre and the state. London: Methuen.

Bond, E. (2012). The third crisis. In E. Bond, *The Chair Plays* (pp. xxi-xlii). London: Methuen.

Bond, E. (2016a). *Dea.* London: Bloomsbury Methuen Drama.

Bond, E. (2016b). Introduction to Dea. In E. Bond, *Dea* (pp. v-viii). London: Bloomsbury Methuen Drama.

Bond, E. (2019, June 15). *Drama Theory.* Retrieved from https://edwardbond drama.org/s/Tragedy-and-Politcs-15-6-19-revised.pdf

Bond, E. (2021, September 2). *Notification for Authors* (Bondian Drama and Young Audience). Email.

Butler, J. (2000). *Antigone's claim.* New York: Columbia University Press.

Carney, S. (2013). *The Politics and poetics of contemporary English tragedy.* Toronto, Buffalo: University of Toronto.

Chen, C.-C. (2018). *The later Edward Bond: Subjectivity, dramaturgy, and performance.* (Unpublished Doctoral Dissetation). Royal Holloway, University of London.

Derrida, J. (1994). Spe*cters of Marx: The state of the debt, the work of mourning and the new international.* (K. Peggy, Trans.) New York: Routledge.

Foucault, M. (1980). *The history of sexuality, Vol. 1: An introduction.* New York: Vintage Books.

Foucault, M. (2003). *Society must be defended: Lectures at the collège.* New York: Picador.

Foucault, M. (2006). *History of madness.* (J. Khalfa, Ed.) London: Routledge.

Gardner, L. (2010, November 07). There Will Be More – Review. *The Guardian.* Retrieved from https://www.theguardian.com/stage/2010/nov/07/there-will-be-more-review

Gritzner, K. (2015). Edward Bond and the aesthetics of resistance. (2015). In K. Gritzner, Adorno and modern theatre: *The drama of the damaged self in Bond, Rudkin, Barker and Kane* (pp. 46-85). Basingstoke, Hampshire: Palgrave Macmillan.

Hall, E. (2010). *Greek tragedy: Suffering under the sun.* Oxford: Oxford University Press.

Hirst, D. L. (1985). *The hidden plot.* London: Macmillan.

Kant, I. (1997). *Groundwork of the metaphysics of morals.* (M. Gregor, Trans.) Cambridge: Cambridge University Press.

Kristeva, J. (1982). *Powers of horror: An essay on abjection.* (Leon S. Roudiez Trans.), New York: Columbia University Press.

Lazarski, C., & Allshouse, S. (2012). *Power tends to corrupt: Lord Acton's study of liberty.* Illinois: NIU.

Levinas, E. (1969). *Totality and infinity.* (A. Lingis, Trans.) Pennsylvania: Duquesne.

Levinas, E. (1999). *Alterity and transcendence.* (M. B. Smith, Trans.) London: Athlone.

Myers, T. (2003). *Slavoj Žižek.* London: Routledge.

Özata, C., & Biçer, A. G. (2021). Edward Bond'un sandalye oyunlarında iktidar. *Litera: Journal of Language, Literature and Culture Studies, 31*(1), pp. 229-254.

Plato. (1990). *Protagoras.* New York: C. Scribner's Sons.

Staley, G. (2010). *Seneca and the idea of tragedy.* Oxford: Oxford University Press.

Stambaugh, J. (1991). *Thoughts on Heidegger.* USA: University Press of America.

Takkaç, M. (2001). Reflections of new naturalism in Edward Bond's Summer. *Hacettepe Üniversitesi Edebiyat Fakültesi Dergisi, 18*(1), pp. 83-93.

Vangölü, Y. B. (2017). Still expressing the need for the rational: Edward Bond's Dea. *TDR/The Drama Review, 61*(3), pp. 173-177. doi:10.1162/dram_a_00680

Whitford, M. (1991). *Luce Irigaray: Philosophy in the feminine.* London and New York: Routledge.

Young, J. (2013). *The philosophy of tragedy.* Cambridge: Cambridge University Press.

Žižek, S. (1995). *Mapping ideology.* London; New York: Verso.

Chapter 6

Embracing Strangeness: Edward Bond's 'Triple Brain' of Drama

Kate Katafiasz

Independent Scholar

Abstract

This chapter attempts to integrate my personal experience of the Bond/ Big Brum project, with a Lacanian reading of excerpts from two of Bond's theoretical essays. The chapter formulates a decentred approach to identity and staging which locates the strangeness of the other at the heart of stage and subjectivity alike. This helps us to grasp the intense intersubjective experiences that drama can create, and offers practical rehearsal strategies to help achieve these ends.

Keywords: Edward Bond, Bondian Drama, Lacan, Sites of Drama

Introduction

Between 1997 and 2016, dramatist Edward Bond wrote a series of ten one-act dramas for Big Brum Theatre in Education Company: *At the Inland Sea* (1995), *Eleven Vests* (1995-97), *Have I None* (2000), *The Balancing Act* (2003), *The Under Room* (2005), *Tune* (2006), *A Window* (2009), *The Edge* (2011), *The Broken Bowl* (2012), *The Angry Roads* (2014). The first three of these plays brought the gas chamber, a school stabbing, and cultural amnesia into school classrooms, but they did this without the sentimentality and sensationalism of the media culture in which we were becoming saturated in the 1990s. The next two plays brought things that at the time seemed far off, like climate catastrophe and the traumatic effects of child soldiering, to play out in the here-and-now of condemned flats, gentrified urban apartments, and a claustrophobic cellar. As the play-cycle develops, the ancient Oedipal figure of jealous patriarch looms repeatedly, threatening the sanity and autonomy of the youth.

Not only were these plays highly unusual, they were also performatively challenging. People as yet unborn appeared dreams were made visible, hallucinations walked through walls and asserted their presence onstage. States of traumatic disassociation, delusion, drug-addiction, depression, and mutism were subtly opened up for their young audiences. At the beginning of their collaboration, Big Brum, like many other theatre companies, saw political theatre practice and Brechtian theatre practice as one and the same thing; and so under Geoff Gillham's direction, they began rehearsals using the *gestic* methods that were so fashionable at the time (Finney, 1996). But when they invited Bond to rehearse with them, the company was shocked to discover he was developing a new theory of drama in opposition to Brecht (B. Colvill, personal communication, September 22, 2011). In 2000, Bond formalised this thinking in a book on theatre theory, *The Hidden Plot*, in which he expressed a violent disagreement with Brechtism, declaring: 'Alienation is the theatre of Auschwitz' (p. 187). It's worth stopping to think about that statement for a moment: humanity is at stake.

There could be no doubt that these plays demanded a new working method, and in the early days of their collaboration with Bond, the company was absolutely up for experimentation. Actor-teacher Bobby Colvill, who instigated Big Brum's initial connexion with Bond, remembers:

> Bond was a total surprise for us, his reputation and his detailed stage directions, led us to expect him to tell us what to do, instead he asked us, and the play questions, my experience was that he was in a dialogue with his plays (B. Colvill personal communication, January 11, 2023).

This un-authoritarian, creative approach excited the small group of academics and practitioners who met regularly to try to process the new ideas that poured out of Big Brum's open rehearsals with Bond. The group comprised Chris Cooper, who became artistic director of Big Brum when Geoff Gillham became ill; David Davis and Bill Roper, drama educators at Birmingham City University; and me – their erstwhile student. I had just set up a new drama degree at Newman University in Birmingham and was starting to work on my doctoral thesis on drama and desire with Graham Saunders, who was then at Reading. Some useful early thinking came out of this group, and the actors responded well to the dramatic vitality of the plays; but they needed help to develop a new working method that could take the place of the Brechtian strategies on which they had become so dependent. Without a coherent fresh approach to rehearsal, it is fair to say some members of the company struggled. The difficulty seemed to be most acutely felt by the actors, several of whom felt the need to move on after a period of time with Big Brum. Bond recently characterised the problem: 'Big Brum wasn't dealing with young people's problems but giving them political lessons' (E. Bond, personal communication, December 13, 2022). The

research group also struggled with this paradigm-shift and soon disintegrated. However, Bill Roper and I continued to meet up until he died in 2021 to exchange our developing ideas around a Lacanian understanding of drama.

In spite of these issues, Bond and Big Brum collaborated productively for nearly twenty years. Together they created a drama that went far beyond the health and well-being clichés, to which funding regimes had reduced many other TIE companies during this period. Chris Cooper generously allowed me to continue watching rehearsals with Bond and sometimes to share my thinking with the company, but there never seemed to be time to engage practically with them. Instead, I built on Bond's ongoing work with Big Brum with my students, workshopping and staging several productions of Bond's post-millennial work in Birmingham, as well as a British Council-funded TIE project in Jordan. I was lucky enough to work with some amazing classical scholars at Newman[1], and when my doctorate was completed, I developed a broader fascination with the art form of drama itself. Much of this stemmed from co-teaching ancient Greek drama and theatre history with my undergraduates – in connection with a continuing engagement with the plays and ideas of this extraordinary living dramatist.

Thinking through the Theatre of Dionysus

The thinking behind this chapter began in response to Andreja Kargačin, a young Serbian director. Andreja wrote to several 'Bond experts' in the Autumn of 2022, asking for advice as she approached her production of At *The Inland Sea* in Belgrade. The chapter expands on the advice I sent Andreja and draws on my work of two decades or more. It explores two short excerpts of Bond's theoretical writing to open up new ways of rehearsing and staging these plays and perhaps even instigate a new way of thinking about drama altogether.

The first piece is from an essay in *The Hidden Plot* (Bond, 2000), entitled 'Modern Drama', in which Bond categorises the four 'sites' of drama. A is the 'city era culture' in which the production takes place; B 'conveys the audience to the play's specific sites'; C 'conveys the play to the audience'; and D is 'the audience as a site of imagination' (Bond, 2000, p. 10). Chris Cooper had initially alerted me to this essay, but it was not until October 2014, watching rehearsals for *The Angry Roads*, that I realised its significance.

This was the last play Bond wrote for Big Brum; he felt his plays were not well enough understood by the company to develop drama for young people with them any further. In spite of this, feeling incredibly fortunate to have been even tangentially involved in this exciting, dramatic project, I watched and took

[1] My thanks to Chris Upton, Esther Eidenow, and Juliette Harrisson.

notes as usual. Bond spoke about the strange set. It had a double window stage left; a blank wall where he said the Ancient Greeks would have set their Palace Door in the centre; "in the back wall right a wooden door ... leads to a short passage and an unseen outer door ... In the right wall an open doorway to the kitchen and other rooms" (Bond, 2018, p. 159). Bond said the blank wall at the centre housed 'secrets' that the father, mute following trauma from long ago, wanted to hide from his son. At one point, the son knocks on this blank wall as he tries to work out his father's involvement in a woman's death on a nearby city street years before. Bond observed that the Theatre of Dionysus had two side entrances and exits; one to the sea and the countryside on the left; and the other to the city on the right. He said that the window and front door in Big Brum's set echoed this ancient set-up and that the two streams of energy or roads met on the stage: the site of Laius's mortal encounter with his son Oedipus at a crossroads. The comment seems to posit Oedipus as a structural arrangement, suggesting that all drama sends the habits formed by civilization into creative flux. It also seemed clear that *The Angry Roads* was an explicit enactment of the original Oedipal drama for the twenty-first Century. But what was obvious above all was that the Theatre of Dionysus was actively present in Bond's mind when writing and thinking about staging his plays. If we map the Theatre of Dionysus onto Bond's 'sites' of drama, something important concerning the structure of drama emerges. According to this schema, A is the city outside the theatre; B the auditorium; C, the stage; and D, the obscene backstage space.

If we think about Bond's 'sites of drama' A, B, C, and D in connection with theatre history, we can appreciate how the ancient structure of the Theatre of Dionysus had carried through into Early Modern theatres in London, such as the Globe and Rose; and even onto Restoration and Proscenium stages. It was not until the twentieth century that Modernists Brecht and Artaud dismantled these ancient structures, taking apart boundaries between stage and auditorium (B and C) and between visible and invisible aspects of the stage (C and D). In doing so, it seems they may have destroyed the physical spaces that drama needed to function politically, inaugurating the solipsistic post-dramatic landscape so usefully theorised by Hans-Thies Lehmann (2006). This may be one reason why Bond, avowedly a dramatist, distances himself from Brechtian practices.

Bond's comments at the *Angry Roads* rehearsal (K. Katafiasz, personal communication, October 01, 2014) suggest that he continually reworks the spatial structures so carefully instituted at the Theatre of Dionysus – but without rupturing their boundaries as the Modernists did. In this play, for instance, he erases the central door in the back wall (the Greek *skene*). So, although the visible and invisible aspects of the stage (C and D) exist, they cannot articulate with each other. This means there can be no ancient Greek

Messenger Speeches, where a character who has witnessed obscenities offstage (in D) can make an entrance and put their singular experience into words that can be understood socially by stage (C) and auditorium (B). For the boy, the past is blank because his father cannot – will not – tell him what happened. So there is no way he can grasp how the obscenities his father perpetrated have impacted his own life. Instead, like anthropologists, the boy and his audience have to piece this personal history together – using the little information his departing mother gave him as a six-year-old and his father's wordless sounds and gestures.

Stage and Psyche

Two years later, in 2016 (at Jérôme Hankins' symposium in Amiens, which Tony Coult refers to in the Foreword of this book), Bond began to speak of a phenomenon he called drama's 'triple brain'. He refined and published it on his website during the pandemic in 2020. If we populate the four 'sites of drama' at the Theatre of Dionysus with the minds of actors and audience members, a dynamic palimpsest of stage and psyche begins to emerge.

> The triple brain is created by drama and its performance. The actor is the first brain. The audience singly and collectively are the second brain. The third brain is not the play but the stage. The Greeks created the stage as the public space on which to recreate their humanness in the face of dilemmas and disasters. Separately and jointly the three brains revert to the neonate self and its creation of morality. The triple brain is social. It is not just thought but also the way that thought, social morality, is made. The stage is the site of neonate consciousness. (E. Bond, personal communication, June 9, 2020).

The first thing to note is drama's differentiated, yet unifying function – it operates 'separately and jointly'. The three 'brains' occupy the theatre's three spaces: the actor occupies the visible stage (C), the audience occupies the auditorium (B), and their collective imagination occupies the invisible backstage space carved out by the *skene* (D). (But as we shall see, the audience can only imagine D, the fictional world of the play beyond the *mise-en-scene*, if the actors inhabit it in performance; crudely, if their characters know where they are going when they make their entrances and exits).

In this excerpt, Bond seems to suggest that during the performance of the drama, as well as operating separately, these brain/spaces articulate with each other to form an active, intersubjective social consciousness. This dramatic collective operates in a state of intimate relationality, much like Leibnitz's monad. Each member of the audience maintains their individual identity, but the collective operate jointly in the sense that "when a change occurs in one,

there follows some corresponding change in all the others" (as cited in Strickland, 2006, p. 7). It is as if the theatre's 'sites' correspond with 'sites' in the minds of the participants, with the drama actively reconfiguring the way these 'sites' relate to each other[2]. So that, although each person responds to the dramatic events in their own way, everybody comes out of the theatre with their consciousness having been 'reshuffled'. It begins to look as if Freud, whose psychoanalysis always leaned heavily on drama, may have taken his topology of the psyche (*super-ego*, *ego*, and *id*) from the Theatre of Dionysus; from its stage, auditorium and obscene backstage spaces; so carefully differentiated in their topology by the ancients.

To understand this fascinating proposition, we need to consider the system that the ancients put in place to ensure that the bodies of actors and audience members, in their separate spaces, operate in different but complimentary, ways. In the city outside the theatre (site A), people look and are looked-at, speak and are spoken-to. But once the performance begins inside the theatre, the active and receptive functions of gaze and voice are carefully choreographed. The stage (C) actively speaks and receives the audience's gaze, while the auditorium (B) actively gazes and receives the staged voice. The boundary between 'B' and 'C' is not physical but conventional. These conventions are crucial to drama's function: the stage may not directly address the audience with its gaze, nor may the audience address the stage with its voice. If either side breaks these rules, the world in which the play is set beyond the *skene* (D), imagined by both 'B' and 'C', is compromised.

Deconstructing Patriarchy

But much more is at stake in the way we manage the boundary between stage and auditorium. If its ancient conventions are observed, the communal eye belongs to the auditorium, the communal voice, to the stage. This leads me to make the exciting suggestion that patriarchal power, which subjugates bodies with its gaze *and* voice, is split apart in dramatic performance. The arrangement certainly seems to endorse Bond's view of Oedipus as a structural phenomenon integral to all dramatic performances, as well as the man who literally kills the patriarch. By splitting audio-visual synchrony in this way, dramatic performance can trigger what Bond terms 'neonate consciousness'. We can grasp this concept most easily perhaps if we think of the infant who follows the sound of a rattle with their eye, as adults do when we wake in the night to a sound and cannot

[2] For a more detailed account of drama's changing relationality, see this work which uses Borromean knots to model both stage and psyche: Katafiasz 2022, "Drama and Desire: Theorising Entangled Performance Practice." *Performance Philosophy* 7 (2):68-88. https://doi.org/10.21476/PP.2022.72359.

rest until we have identified its cause. Neonate consciousness is an anxious state and activates us to use our body to make meaningful connexions (as we would if we could hear a hidden rattlesnake), instead of relying on the ready-made structures (and culturally-laden expectations) of language. Drama's collective split conjoins all the bodies onstage and in the auditorium in an ungendered (mutually penetrative, mutually receptive) Queer embrace: much like the androgynous, 'spherical' archaic humans that Aristophanes jokes about at Plato's Symposium (2008).

We can also consider drama's permeable boundaries in light of Donna Haraway's (2003) work on postcolonial complexity. Haraway (2003) asks:

> How can people rooted in different knowledge practices "get on together," especially when an all-too-easy cultural relativism is not an option, either politically, epistemologically, or morally? How can general knowledge be nurtured in postcolonial worlds committed to taking difference seriously? Answers to these questions can only be put together in emergent practices; i.e., in vulnerable, on-the-ground work that cobbles together non-harmonious agencies and ways of living that are accountable both to their disparate inherited histories and to their barely possible but absolutely necessary joint futures. For me, that is what significant otherness signifies (p. 7).

Drama may not involve the microbiological exchange of body fluids in the manner of Haraway's 'companion species'; but the physical entanglement activated by drama's 'triple brain' can certainly be viewed as a form of *xenopraxis*: the practice of taking difference – the significance of otherness – seriously.

Taking Difference Seriously

So, how does this theoretical thinking help actors and directors with the practicalities of performing Bond's work? If we want to evolve a usefully *xenopractic* performance practice, whereby splitting the modalities of eye, ear, and voice activates the entangled complexity of Bond's 'triple brain' – we clearly need to pay attention to drama's boundaries. It seems counterintuitive, but there can be no unity without differentiation. Neither alienating nor immersive strategies, which dismantle, or ignore boundaries altogether, can deliver on this score. Looking back, this was obvious from the very first Bond-Big Brum collaboration: their production of *At The Inland Sea*. When Bond started working with Big Brum, as we have already noted, he found a company with very sparse resources, immersed in Brechtian practices. This combination of factors meant they operated without a designer, using minimal sets without a *skene*, sometimes with a little low rope to indicate the presence of a wall. Bobby

Colvill remembers Bond in rehearsal 'using a chair as the entrance to the gas chamber and getting Mandy (Finney) to say which was inside and which was outside until she understood the difference – at the time, we were all a little non-plussed.' (B. Colvill, personal communication, September 22, 2011).

The plays that were to come would challenge the company even more. When Bond sent Chris Cooper his manuscript for *Have I None*, Cooper told him he "read it, groaned, and then put it under the bed" (E. Bond, personal communication, October 22, 2022). It seemed to me at the time that the company was unsure how to handle the way the plays staged the reality of psychological trauma, but that this was precisely what their young audiences responded to so readily[3]. *Have I None* (2000) stages a lucid dream in which Grit intuits his sister's plan to poison him; *The Under Room* (2005) stages a disassociated child soldier; *The Tune* (2006) and *Broken Bowl* (2012) are both plays that, like *Born* (2002-03), take hallucinatory states very seriously; while *The Angry Roads* (2014) as we have seen, sealed up the father's atrocity behind its muted skene.

It soon became clear that Bond's plays needed three-dimensional stages (Bond's all-important third brain), and Ceri Townsend began designing ingenious wooden sets that the company could assemble and take apart on tour. Bobby Colvill remembers discussions around the set design for *Have I None*:

> Ceri was an inexperienced designer, Bond insisted the room be socially realistic, it be a room in a house, bare walls, with a door, but he suggested we do something that was out of kilter, but not obviously so, such as the skirting board being slightly too big. I'm still not quite sure what he meant by that except to give it that vivid dream like quality, lodging a problem in our minds that we couldn't quite rationalise (B. Colvill, personal communication, January 11, 2023).

The danger of a set hidebound by too much realism is the creation of what Bond terms 'lounge plays':

> Most plays now take place in what I call the "theatre room" – the stage space functions as a lounge, or some other domestic space. There you can row and shout as if you are an exploding H bomb but it remains domestic, comic or sad. My stuff is set in a world space and so the connections between things are more dynamic. They aren't concerned with the lounge but with the destructive world condition (E. Bond, personal communication, November 8, 2022).

[3] See an account of a schoolchild's response to *The Under Room* in Birmingham; Kate Katafiasz (2023) Beyond Post-drama, in Mosse and Street (Eds.), *Genre Transgressions: Dialogues on Tragedy and Comedy*. London: Routledge.

But actors and directors can easily avoid this trap if we view the third 'stage-brain' not only as a realistic social mirror but through the lens of the three-dimensional spatial arrangement at the Theatre of Dionysus. Then the focus can fluctuate between the visible and invisible sides of the *skene*, sites 'C' and 'D', to orchestrate and 'shuffle' the consciousness of actors and audiences alike. Perhaps these fluctuations help to break the stranglehold of destructive orthodoxies in the culture – the 'world condition': site of young people's problems in 'A'.

The set for *Tune* usefully shows the different 'sites' which, when activated in performance, can produce dynamic new connections.

> *A room.* The back wall appears to be solid but is made of malleable material such as cloth. Behind it is another wall that exactly resembles the first wall but is solid. A kitchen table and chair, both wood.
> Later, *a city street.* (Bond, 2011, p. 154)

The audience at B gaze at what appears to be a traditional if spare 'lounge' scenario. The visible part of the stage (site C) presents them with a table and chair, representing a recognisably domestic space. To the audience, the *skene* boundary between C and D, visible and invisible aspects of the stage, looks normal enough. Its strangeness only comes into play in Scene 4 when teenager Robert confronts his mother's lying boyfriend, Vernon. We hear Robert's voice for the first time, from behind the wall, telling Vernon he is a liar. Then the actor playing Robert enters the room through the wall, pushing against its malleable surface layer from behind. As he steps forward onto the stage, the solid wall closes behind him, and covered by the cloth, he is visible only in outline like an apparition. Vernon behaves as if nothing unusual has happened and continues with his plan to incriminate Robert as a vandal so that his mother will throw him out of the house. The audience is faced with what Bond terms a 'wall figure' (p. 163); something which has entered the visible part of the stage but which retains the integrity of the obscene space D in that it cannot be identified. We simply do not know what we are looking at, just as when we hear a hidden rattle, we do not know what we are listening to. Later in the play, when he is living on the streets, the boy explains the moment as a sensation of strength: he felt strong enough to come through the wall.

While 'lounge plays' focus on the painted visible side of the *skene* at C, Bond's plays take us into the 'beyond' at D, into a state of not knowing. As Bond (2020) says in his piece on the Triple Brain: 'No one can enter another's consciousness. The nearest we can do that is in the triple brain of drama'. Perhaps this happens when, like one of the characters, we have to put things together imaginatively for ourselves as they do, in this way entering their subjective space. In *At the Inland Sea,* we go beyond the schoolboy's bedroom when we hear the man

climbing onto the roof of the gas chamber with his can of poisonous gas. In *Eleven Vests* (1995-97), the *skene* operates as a shredded school blazer and vest, beyond which lies in the mind of a disturbed child and the body of a murdered soldier. In *Have I None* (2000), the *skene* reverses itself in Grit's dream to reveal bones beneath the spoons. In *The Balancing Act* (2003), the obscene backstage space relocates underfoot to the floorboards of a condemned flat, where Viv goes to protect the world and ultimately dies. In *The Under Room* (2005), the voice and body of the protagonist are dislocated from each other, using a dummy and a dummy actor who speaks on the dummy's behalf. The strategy puts its audience halfway between C and D as they switch their gaze between the Dummy in the lounge and the dummy actor speaking from the world beyond. *A Window* (2009) is described as a tryptich, which we can understand as a play with three *skenes*. The first conceals an early pregnancy; the second *skene* conceals the streets beyond the lounge where criminality and sex work sustain a hidden addiction; the third *skene* reveals the absent father and ends as his son looks out of the window contemplating the future. In *The Edge* (2011), the mother in the lounge gives credence to a stranger's delusions while the son wrestles with the 'beyond' of his past that will shape who he becomes. In *The Broken Bowl* (2012) the father continually tries to keep the 'beyond' at bay. But although he nails up the windows, its amorphous influence seeps into the domestic space when the family dismantles their furniture, swathe themselves in blankets, and his daughter saves food for her imaginary friend. The father in *The Angry Roads* (2014) has turned his body into a *skene* and refuses to reveal himself to his son. However, his body leaks information against his will, and even though he cannot speak, his son pieces the past together.

Into the Real

These are plays that continually take us beyond the lounge into a space where things are less easily recognised. This ontological state of unknowing seems to define the 'neonate consciousness' that Bond refers to. Neonates do not yet have the experience to recognise things, an innocence that can be triggered when we perceive something we cannot easily identify – when what we see and hear, fail to coalesce into a definable image or sound.

As the rattlesnake knows, when sounds and images do not ground and locate each other, it becomes difficult to locate our own bodies in relation to them – even though when we are watching a play, we know perfectly well that we are sitting in a theatre. The subsequent dislocation makes noises off, shadows, and movement difficult to ignore; their 'otherness' becomes significant to us personally: a definition of xenopraxis. This is because our visual, vocal, and auditory faculties, which usually work in synchrony in each individual body, have had their configuration changed or 'shuffled'. Partly by the split between

gaze and voice instigated by the ancients, whereby the auditorium looks, and the stage speaks, and partly by this dramatist who seems to strategically interrupt the auditorial gaze or the staged voice.

When an image is not iconic (resembling something) and a sound is not a word (symbolically referring us to something else), the drama has taken us beyond its mimetic lounge. We are left with an auditory or visual index: an indication that we are in the presence of something real. Charles Pierce defines the index as an indication of something 'necessarily existent'; 'anything which focuses the attention is an index. Anything which startles us is an index'; indices 'direct attention to their objects by blind compulsion' (as cited in Chandler, 2000, p. 41). This is when the world of the play beyond the *skene* at 'D' affects us physically –even though actors and audiences alike know they are in a theatre and the play is made-up.

Theorists have given this phenomenon different names: educationalist Jerome Bruner (1966) calls it the 'enactive' mode because it engages our muscles; for psychoanalyst, Freud (2006), such embodied states are led by the libidinous *id*; while psycholinguist Lacan (1981) characterises this intense corporeal engagement the 'Real'. While they may use different terms to describe it, all three theorists seem to describe the effect of Pierce's index. Indices engage us bodily or metonymically. Like the rattlesnake, they collapse space to bind each of us into their monadic structure, making our contiguity to them irresistible: separation takes effort. When they are used as part of dramatic performance indices, involve audiences at 'B' physically in the fictional events that pass before us. They make 'acting' at 'C' unnecessary; if we have understood our character's relationship to the imagined 'site' at 'D', all we have to do is enact their situation. If the *Verfremdung* aims to distance us from what is familiar, *xenopraxis*, it's structural opposite, attracts us to this indexical 'other'.

Rehearsing the Real

So how does all of this work in performance? During the Covid pandemic, my students and I staged *The Under Room* – Bond's play set in a cellar. Rehearsals began during one of the lockdowns over zoom, and we began by reading 'Modern Drama' from *The Hidden Plot* (Bond, 2000, pp. 10-19). Thinking about the stage in relation to the Greek Drama module everyone had taken in the previous semester was incredibly useful. We could see Bond's 'sites' in action. 'A' was the city of Birmingham in lockdown; my students were all zooming in from their bedrooms and living rooms. Because of the pandemic, we had cast each of the three characters six times so that we could rehearse and film each scene separately in very small groups in an effort to stop the virus from spreading. We were all feeling isolated and claustrophobic and worried about how the state was handling the pandemic: had anyone seen police or soldiers

on the streets? Was their absence even more concerning? So the play, about an illegal immigrant hiding in Joan's cellar in 2077 (by which time these Millennial students would be elderly), spoke to us in very interesting ways. 'B' was going to be those same living and bedrooms; we were going to experience the strangeness of being our own audience because it was too risky to stage a live performance. We would stream our work to an invited audience, which included the dramatist, on a certain date and time. (We wanted to make this more than a 'lounge play' production, even though we would all receive it quite literally in our lounges). 'C' was the sparse cellar of what felt like a nineteenth or early twentieth-century British terraced house. We knew this because it had a cellar; and because the immigrant tells Joan he has left the money for his break-in under a little blue pot 'on the shelf over the fireplace' (p. 173). The temporal reach of the play was clearly a wide one.

What was particularly interesting was the fact that 'D' – what we might consider to be the most amorphous and intangible of Bond's 'sites' – asserted its importance the minute Covid numbers dropped, allowing us to hit the ground working face-to-face and with the set. Chris Cuthbert, our set designer, had provided us with a set of metal steps, like the ones you use on board a ship to go from one deck to another, with integral hand rails to hang onto when the sea is rough. They made a metallic noise and seemed incredibly steep; it was a huge physical effort to haul our bodies up and down them – the actors had to use their arms as much as their legs, and the exertion made them out of breath. As the only way in and out of the cellar, these steps drew our attention to the entrances and exits in a very physical way. Far more demanding than opening and closing the palace doors at the Theatre of Dionysus would have been, these stairs changed the dramatic configuration of space from the horizontal to the vertical plane. But they still honoured its *skene* – *the* boundary between C and D – absolutely. In doing this, the stairs gave us a corporeal hotline to the imaginary social world upstairs, beyond the lounge-cellar in which the play is set. They put society where earlier dramatists traditionally put heavenly beings – up on the balcony or the roof of the *skene*.

We became very interested in D, the society of 2077 upstairs. The play tells us important and vivid details. There are soldiers on the streets searching for illegal immigrants and shoplifters; the authorities have changed the word for shoplifting to 'shoplooting' – because this makes it easier to shoot them without offending people's sensibilities. Joan's blue pot is a 'nice pot' – she has good taste. She locks the front door at night, but this does not stop people trafficker Jack from getting in to steal the immigrant's money. The immigrant brings a wider global reach to what we know about 'D' when, in what Bond terms the play's 'central speech', he tells Joan about being taken as a child soldier in his own country. This takes us to the heart of the play, occurring far away and long

ago cause of the consequences playing out in front of us. The immigrant brings the obscenities of being forced by the army to kill one of his parents to the stage. Like the Messengers in ancient Greek tragedies, Bond's immigrant uses *ekphrasis*, a trope that deploys words to conjure images and sensations, shuffling our faculties so we see with our ears as it were. Just as the second messenger in Oedipus Rex tells us how gory tears of black blood hail down Oedipus' face, Bond's immigrant tells us:

> There is the knife. In. I start to pull it out. Soldier grab my wrist. He holds the knife in. The *knife* throb because the heart is beating. You see? It is like the body sobbing inside. (Bond, 2006, p. 177).

In spite of their temporal and spatial distance from the visible part of the stage, these obscene events are far from amorphous or indistinct. Even though they are conveyed verbally, their effect can be visceral. Tragedy seems to happen when the visible part of the stage at 'C' finds a way (*ekphrasis* is one of them), to get beyond the *skene* into 'D', so that the 'lounge' imaginatively accommodates catastrophes that occur in the world outside it.

What emerges from this exploration of the world outside the cellar at 'D', is a set of seemingly intransigent social rules that govern every move and charge every object inside the cellar with their logic. Understanding these rules would seem to be a key component of the rehearsal process; once the actors have worked out how their particular character understands and experiences the play's political 'site', they can play the play and not the character; that is - forget about psychological quirks and characteristics, and inhabit and enact their particular situation. The process becomes very strategic.

Finding an Ex-centric Locus

In Scene One of *The Under Room* (2005), Joan starts by manhandling the immigrant, who she thinks is burgling her, giving him the unrealistic injunction to 'wait here' while she notifies the authorities. In our production, the logic of the situation put her between the chair where she had placed the immigrant and the foot of the stairs – the only exit from the cellar – because she thought he might try and make a run for it. Occupying this strategic space enabled the actress to activate the immigrant; it helped her establish that although the audience is looking at a dummy, Joan sees a lithe young man.

During the scene, Joan goes from wanting to hand the immigrant over to the authorities to insisting on protecting him from those same authorities: "If the soldiers catch you, you will be shot. I do not want you to walk out of *my* house into that" (Bond, 2006, p. 175). We noticed that in spite of completely changing her mind about the immigrant during the course of this scene, by the end of it Joan still wanted to stop him leaving her cellar. Even when she knew the

immigrant had a knife, Joan continued to 'police' the foot of the stairs as she had at the start; the immigrant was clearly – kindly – humouring her. Her expectation that she should command respect in such a life-and-death situation exposed her naivety; we could see how poorly she grasped the social realities of civilian life under martial law. But it also demonstrated to my student actors how the play's central 'site' at 'D' has its locus beyond the *skene*; its logic radiating down the stairs, dictating the possibilities available to the characters; each relating to the world of 2077 in their different ways. Some characters understand their world and the consequences of their actions better than others. In our production, the strange metal staircase helped us grasp the situational logic of the play; when these invisible power relations were activated, it was no longer about looking for political lessons or about acting but about enacting – and so understanding – the grim social possibilities of a play set just 56 years ahead of our production of it. Whether she imagined the army to be friendly to her or not, Joan literally looked up the stairs to its authority. People trafficker Jack, on the other hand, sat and picked his teeth while he made rational financial calculations on the stairs. He sent Joan up ahead of him so that he could watch her from behind and assess her worth to him as her pimp.

Finding this ex-centric focus at 'D', which locates the centre of the drama outside itself, could have helped Big Brum. They often had to ask Bond if things were true or if the characters imagined them: did Robert really smash the car windscreen in *Tune* (2006)? Was Liz really a sex worker in *A Window* (2009)? It seemed they did not want to accept this reality for her. When things happen beyond the *skene* it can be difficult to pin them down; and because Bond's characters often tell each other lies we cannot rely on what they say. Indeed Vernon does lie about Robert breaking the car windscreen in *Tune* (2006); whereas in *A Window* (2009), Richard is telling the truth about Liz's sex work, although it looks as if he might be trying to demean Liz in the eyes of their son. One thing is for sure if the actors haven't established their characters' relationship to the play's external centre at 'D' in rehearsal, the audience do not have a hope. If for instance, the logic of the nonverbal or metonymic communication in *The Angry Roads* (2014) is not understood by the actors before it is performed, the audience has to accept Norman's interpretation of his father's actions without question. Then they are shut out of the meaning-making process and the parts of drama's triple brain cannot articulate with each other. Under such circumstances watching Norman and his father communicate is as about as interesting as watching Dr Dolittle pretending to talk to the animals.

Ex-centric Topology

Site 'D' offers us fascinating and sometimes horrifying little glimpses of the imagined world beyond the *skene*. The actors need to use these glimpses to establish how their character lives in this society – and crucially, how this society lives in them. When this work is done in rehearsal the triple brain can be activated in performance so that site 'D' exists both beyond the *skene* and inside people's heads at 'C' and 'B'. When subjective states are shared in this way we enter an intersubjective space to experience what Lacan (1992) terms 'extimacy' (p. 139). The neologism neatly problematizes the binary opposition between what is internal and what is external. Euclydian representations of space figure inside and outside as separate and discrete spaces. But the topology of the Moëbius strip demonstrates how a surface can seemingly have two sides, but in fact have only one, taking us from one side to the other (from subject to object), without crossing any boundary (nosubject.com, n.d.). The model locates the subject outside itself as we have seen; but it also puts the strangeness of the other at the heart of our subjectivity. This may offer insight to Stanislavski trained actors who struggle when their characters do things that seem inconsistent with their identity. For instance Jack, who happily identifies himself as a double double-crosser, decides to drop his corrupt money-making activities in the military and go on the run with the immigrant. On the other hand Joan wants to protect the immigrant, but in the end, eviscerates him hoping the army will reward and not punish her.

So although the social injunctions radiating down the stairs from 'D' seem intractable, and actors need to spend time and effort understanding how their character is affected by them, dramatic structure renders them mutable. Oedipus kills his father; creativity overcomes tradition; the eyes, ears, voices, and limbs of all the people participating in the drama challenge and inform what is said. When we view the split between gaze and voice instituted at the Theatre of Dionysus through a Lacanian lens, we can see how the ancients set up what Leibnitz (2005) later termed 'monadic' relationality. The stage 'C' projects its voice and introjects the auditorial gaze, while the auditorium 'B' projects its gaze and introjects the staged voice. The resulting state of irreducible inseparability seems to define Donna Haraway's notion of entanglement, Aristophanes' archaic humans, and Leibnitz' monad. As Leibnitz notes, a change in one monad necessitates a change in all the others, perhaps because their internality and externality are inextricably connected. When we take Bond's novel step of the reading stage and psyche together as a 'triple brain' as we have here, we can begin to grasp more precisely how participating in dramatic performance can actually change who we are.

Making sense in space

Since this chapter began life as a paragraph or two of rehearsal advice to Andreja Kargačin in Belgrade, I want to end on a practical note. Focussing on the world of the drama beyond the lounge in rehearsal makes staging these plays very logical, even straightforward. It means that the play's rationale is not located in what its characters have to say but in what they do. It shifts the focus in performance from individual quirk to social predicament to generate a compelling metonymic subtext that takes performance beyond the mimetic lounge into the Lacanian Real. Andreja has been kind enough to feed back her findings a few weeks into the rehearsal process, which suggests that she has found the approach useful.

> We are now working in the space (and have finished the reading rehearsals). It is completely amazing what the actors are able to produce by focusing on the situation and site rather than the character, the amount of material that comes out of them is great and it naturally recontextualises every object that is used and the space the actors occupy. (A. Kargačin, personal communication, December 16, 2022).

As she so eloquently puts it: everything makes sense in space.

References

Bond, E. (2000). *The Children & Have I None*. London: Bloomsbury Methuen.

Bond, E. (2000). *The hidden plot*. London: Bloomsbury Methuen.

Bond, E. (2006). *Bond: Plays: 8*. London: Bloomsbury Methuen.

Bond, E. (2011). *Bond: Plays 9*. London: Bloomsbury Methuen.

Bond, E. (2018). *Bond: Plays 10*. London: Bloomsbury Methuen.

Bond, E. (Jun 9, 2020). 'Drama, theatre, and the triple brain'. Retrieved from https://edwardbonddrama.org/drama-theory (accessed Jan 01, 2023)

Bond, E. (Dec 13, 2022). Personal communication - Email to Kate Katafiasz, Tony Coult and Imogen Sarre

Bond, E. (Oct 22, 2022). Personal communication - Email to Tony Coult.

Bond, E. (Nov 8, 2022). Personal communication - Email to Tony Coult.

Bruner, J. (1966). *Towards a theory of instruction*. Cambridge MA: Harvard UP

Chandler, D. (2000). *Semiotics: the basics*. London: Routledge.

Colvill, B. (Sep 22, 2011). Personal communication - Email to K. Katafiasz.

Colvill, B. (Jan 11, 2023). Personal communication - Email to K. Katafiasz.

Encyclopaedia of psychoanalysis. (n.d.). Retrieved from https://nosubject.com/Extimacy (accessed Jan 17, 2023).

Finney, M. (1996). Creating theatre for knowing. In *SCYPT Journal 31*.

Freud, S. (2006). Beyond the pleasure principle. In A. Philips (Ed.), *The Penguin Freud Reader*. London: Penguin.

Haraway, D. (2003). *The Companion species manifesto: Dogs, people, and significant otherness.* Prickly Paradigm Press: University of Chicago.

Kargačin, A. (Dec 16, 2022). Personal communication - Email to Susana Roman, Kate Katafiasz, Adam Bethenfalvy, and Cesar Villa.

Katafiasz, K. (Oct 01, 2014). Unpublished notes taken at Big Brum's rehearsal that day.

Lacan, J. (1981). *The four fundamental concepts of psychoanalysis seminar XI.* London: Norton.

Lacan, J. (1992). *The seminar book vii. The ethics of psychoanalysis, 1959-60.* London: Routledge.

Leibnitz, G. W. (2005). Discourse on metaphysics and the monadology. (Trans. G. R. Montgomery). New York: Dover Publications.

Lehmann, H. T. (2006). *Postdramatic theatre.* London: Routledge.

Plato, (2008). *The symposium.* London: Penguin.

Strickland, L. (2006). *The shorter Leibniz texts: A collection of new translations.* London: Continuum.

Further Reading

Bond, E. (1997). *At the Inland Sea.* London: Bloomsbury Methuen.

Bond, E. (1997). *Eleven Vests & Tuesday.* London: Bloomsbury Methuen.

Katafiasz, K. (2022). Drama and desire: Theorising entangled performance practice. *Performance Philosophy 7(2):* pp. 68-88. https://doi.org/10.21476/PP.2022.72359

Katafiasz, K. (2023). Beyond post-drama. In R. Mosse & A. Street (Eds.) *Genre transgressions: Dialogues on tragedy and comedy.* London: Routledge.

Chapter 7

Exploring Space and Education in Edward Bond's *Lear* and *At The Inland Sea*

Nevin Gürbüz-Blaich

Heidelberg University, Germany

Abir Al-Laham

Heidelberg University, Germany

Abstract

Edward Bond contributes significantly to contemporary British drama, focusing his attention on the issues of dialectics of violence, politics, and justice. Proceeding from his theatre, the playwright has continuously redefined his realm of interest ranging from ideas of the post-war British left to the collapse of socialism, to addressing the individual's responsibility in a world he perceives as penetrated with violence, to the role of children and youth in inciting change for the future. When asked about the purpose of writing his plays, Bond has frequently expressed his intention to create stories that "tell the truth" (Spencer, 1992, p. 2) about the state of the world. Particularly young people are in the foreground of his concerns as he warns of conveying capitalist values, which he claims prohibit youth to 'learn about themselves' and lead to structures that emphasize economic growth at the expense of those who are vulnerable. If art asked the right questions and avoided laying out ready-made answers hindering young people's imagination, the theatre could provide the tools to help young audiences explore both their individuality as well as their place in society. this context, he penned *At the Inland Sea* (1995), in which a schoolboy confronts the legacy of the holocaust, an act that marks his transition from childhood to adulthood. As the play proposes, this shift is linked to the boy realizing the importance of history and, as this chapter will argue, of those sites and spaces that have found their way into society's collective consciousness and are therefore crucial for learning about the world. Comparing *At The Inland Sea* to Bond's older play *Lear* (1972), which is based on Shakespeare's *King Lear* and depicts the fall of an ageing king and his destructive relationship with his two daughters, this chapter illuminates how the author's texts, written for and

about youth, negotiate young people's role in society through highlighting spaces that shape and reflect how young audiences perceive the status quo and how they envision the future. In analyzing these plays, this chapter will use Foucault's idea of 'heterotopia' to interpret Bond's portrayal of public and private spaces as educational tools in the representation of adolescent and parental roles.

Keywords: Edward Bond, At the Inland Sea, Lear, space, education, children

<div align="center">***</div>

Introduction

Edward Bond contributes significantly to contemporary British drama, focusing his attention on the issues of dialectics of violence, politics, and justice. Proceeding from his *Rational Theatre*, the playwright has continuously redefined his realm of interest ranging from ideas of the post-war British left to the collapse of socialism to addressing the individual's responsibility in a world he perceives as penetrated with violence to the role of children and youth in inciting change for the future. Born in Holloway, London, he grew up in a working-class family in north London during World War II. As a child, Bond experienced the bombing of London, which created a profound impact on him, and later as a playwright, he intended to write with "honesty" about "the problems of being a human being" (library.leeds.ac.uk, n.d.). In five decades, he has written more than fifty plays, most of which have been controversial because of the violence shown in his plays, his views on the state of society, and the radicalism of his statements about modern theatre and drama.

When asked about the purpose of writing his plays, Bond has frequently expressed his intention to create stories that "tell the truth" (Spencer, 1992, p. 2) about the state of the world. As the playwright states in his prefaces, essays, and interviews explaining his works, he aims to address the inequalities in an unjust system leading to disadvantages for some groups more than others. Particularly young people are in the foreground of his concerns as he warns of conveying capitalist values, which he claims prohibit youth from 'learn about themselves' and lead to structures that emphasize economic growth at the expense of those who are vulnerable. Theatre's responsibility, he believes, is to open up spaces where "the processes in human society that slowly, painfully, and with great difficulty create democracy" (Klein, 1995, p. 411) should be revealed and where questions surrounding personal growth, social (in)justice, and "method[s] of change" (Bond, 1972a, p. xiii) can be explored. Theatre could provide the tools to help young audiences explore their individuality as well as their role within society if it asked the right questions and avoided offering ready-made answers that hindered their imagination.

When he turns towards young audiences and debates what theatre can offer to them, he reveals his disdain for the productions at the time: "I don't think it's possible for young people at the moment to learn how to use theatre" (Klein, 1995, p. 410). His criticism refers to works by directors that he claims to conceal social questions via the overuse of stage effects, and he concludes that "a proper approach to my plays isn't understood" (p. 410). This factor may have contributed to him teaming up with two partners who would maintain his writing momentum in the mid-1990s, allowing him to focus on young audiences: One is the Birmingham-based educational theatre company Big Brum, of which he remains an associate artist and for whom he has written seven pieces dedicated to young people. In this context, he penned *At the Inland Sea* (1995), in which a schoolboy confronts the legacy of the holocaust, an act that marks his transition from childhood to adulthood. As the play proposes, this shift is linked to the boy realising the importance of history and, as this chapter will argue, of those sites and spaces that have found their way into society's collective consciousness and are, therefore, crucial for learning about the world. Comparing *At The Inland Sea* (1995) to Bond's older play *Lear* (1972), which is based on Shakespeare's *King Lear* and depicts the fall of an ageing king and his destructive relationship with his two daughters, this chapter illuminates how the author's texts written for and about youth, negotiate young people's role in society through highlighting spaces that shape and reflect how young audiences perceive the status quo and how they envision the future. In analysing these plays, this chapter will use Foucault's idea of 'heterotopia' to interpret Bond's portrayal of public and private spaces as educational tools in the representation of adolescent and parental roles.

In his plays for young audiences, Bond has embedded the process of learning about the (young) self in the context of being aware of the history and spaces that have shaped society in the past and that continue to affect our present. To know yourself, these works suggest, you must understand that society will create conditions with severe consequences for succeeding generations; past, present, and future are interdependent factors. Both *Lear* (1972) and *At the Inland Sea* (1995) are situated not only in one time but in several: While set in the year 3100, *Lear* simultaneously has a 'historical atmosphere', constructing an ambivalence that aims to expose the connection between time passed and yet to come (Klein, 1995, p. 409). As an alienation technique, the different stages in time are designed to encourage audiences to "interpret our past rationally in order to *use* the experiences in our present and not to repeat the mistakes committed" (p. 409), thus suggesting that what had happened before we were born will inevitably become part of ourselves and influence our decisions. In *At the Inland Sea* (1995), the same idea is introduced: The boy keeps revisiting the past through his imagination, prompted by the events described in the history books he reads to prepare for his upcoming exams. Learning about the

Holocaust triggers imaginations in which past and present are blurred; the atrocities of this event are personified by a woman and her baby from the past who materialise in the boy's bedroom. Begging him to tell a story to distract the soldiers from killing her child, the woman insists that the boy has agency in dealing with the past - which, in the beginning, he refuses to believe: "They won't listen to you here! It's going to die! You're all going to die! You're dead already! I can't save you!" (Bond, 1997, p. 18). His perspective changes in the course of the play as the past no longer remains a series of abstract events to him, but they turn into stories that he understands need to be told. To put it in Bond's words: "Imagination is essentially storyable. Imagination needs to relate experience as story or as potentially storyable. When experience becomes overwhelming or chaotic, radical stories are told" (Bond, 1997, p. 38). The boy learns that these narratives must be preserved and passed on among families, generations, and communities to perpetuate the memory of the cruelty of this war and to uphold a resistance against those acting inhumanely. Instead of continuing to ask his mother to tell 'the story', he finally finds the words to tell it himself, thereby manifesting his transition from a child into adulthood (p. 34).

Crucial for his development is not only his ability to understand the importance of time, however: Equally significant, the play suggests, is the question of space. His visits are not limited to accessing different times. However, he is also transported to a space - a concentration camp - that, like others, has become part of our collective memory and has thus found its way into the consciousness of a global society. These 'fixations' (to borrow a term proposed in Assmann's (2018) discussion of cultural memory) serve to provoke communication that spans generations and centuries (Assmann, 2018, p. 36f.). In comparison, the conflicts in *Lear* arise from building the wall, a reference to the Berlin Wall and therefore a site whose symbolism resonates with contemporary societies. Confronting these 'crystallization points' is necessary as they provide orientation for a culture (p. 38); communication that is based on the memory of these spaces – reading about them in a history book, for example – preserves them in our cultural memory, allowing them to become part of our national, social, and individual identity.

These considerations have been heightened with the advent of the spatial turn, which has occurred over approximately the last 50 years and through which the concept of space has undergone a substantive philosophical evaluation by way of the writings of a range of scholars. There were a number of prominent thinkers who led this movement, including Foucault, Lefebvre, Certeau, and Bachelard. In a wider sense, their work suggests that space does not exist impartially; rather, it is built by its users and is an asocial, cultural, and subjective construct whose forms unveil insights into a distinct society at any certain time. Thereby, as Dustagheer (2013) argues, "the spatial turn alerts us to the importance of space in our existence and histories" (p. 570). As can be seen,

understanding the way humans use space allows us an alternative pattern within which to evaluate practices. Considering the heterotopias of Foucault, Rober Tally (2011) suggests that "in order to understand the spaces that gnaw and claw at us, we must also attempt to articulate a cartographic practice that can do justice to the heterotopias or "other spaces" as well" (p. 10).

Michel Foucault (1992) defined 'heterotopias' as real places that are different from their surroundings and somehow create their own alternative reality (p. 34). For Foucault, the criteria of policy are shifted in heterotopias. Furthermore, they signify places of 'crisis and deviation'; they hold an entrance and an exit and act, respectively, as places that one runs into, where one becomes attached, or that one does not get into above all (p. 34). Though heterotopia is initially a spatial concept, heterotopias also have their own time and temporality. Many of the spaces that Foucault identifies as heterotopias are institutional spaces: prisons, cemeteries, hospitals, brothels, and theatres (pab-research.de, n.d.). As it is in Foucault's heterotopia, de Certeau's (2007) notion of everyday life practices has in common the analysis of creative uses and imaginative configurations of space for human practices. Certeau (2007) takes up the study of the practice of everyday life by showing how the local practices of time and space can sometimes take prescribed time-space-practice configurations and result in dramatic improvisations. Societies may organise spaces in which behaviour unfolds, but everyone performs space in idiosyncratic ways. He distinguishes between strategies and tactics: Strategies describe ideological blueprints for daily conduct and use of space; tactics are the practices that insert themselves within strategies that result in a contest for cultural meaning and definition.

In this sense, in Bond's plays *Lear* (1972) and *At the Inland Sea* (1995), the wall, the prison, and the concentration camp are designed as heterotopic places as they embody sites of 'crisis and deviation' while also containing an entrance and an exit. Both of Bond's plays experiment with the repercussions of granting and denying entrance, making the point that access and mobility nurture young people's minds, whereas stasis stifles their imagination. Lear's declaration, "[m]y wall will make you free" (Bond, 1972a, p.4), is therefore presented as a severe misjudgement, a logical error, and an irrational approach to raising children. The plays suggest that knowledge, education, and personal development must be considered interconnected with the spaces young people are confronted with. Heterotopias represent deviating spaces that intensify this process as they negotiate notions of being other and comment on what is perceived as ordinary, thereby opening up areas that invite young people to explore their own identity. Taking into account that theatres as physical spaces are likewise deemed heterotopias, theatrical spaces thus turn into sites of learning where young audiences are encouraged to ask questions. The meaning of space in theatre is, therefore, twofold: While its representation

on stage serves to advance the character development and/or the story, on the one hand, it also provides insight into the behaviours of the characters for the audience. Spatial elements such as the wall, the bedroom, and the prison hence carry different meanings depending on whether the information is "evaluated within the framework of the internal or the external communication system" (Pfister, 1988, p. 40). Specifically, the wall in *Lear* symbolises safety and protection to the protagonist, but to his daughters, it denotes isolation and confinement within the internal communication system. Externally, the representation of the wall on stage communicates to the audience that Lear is trapped in the binaries he has divided the world into good and bad, friend and enemy, inside and outside. Similarly, the boy's bedroom in *At the Inland Sea* (1995) enables the mother to have control of her child while also signifying solitude and detachment to the boy; at the same time, it reveals to the audience that his upbringing is complicated as it is burdened by the expectations of his mother who orders him to study to avoid "ending up in a dead-end job" like herself (Bond, 1997, p. 3). Consequently, alterations to the spaces imply shifts in the lives of the characters and their behaviours and are designed to transport the idea of change to the audience. As for Lear, questioning and finally dismantling his wall is a manifestation of the insight he has gained along the way:

Lear: Don't build the wall.

Cordelia: We must.

Lear: Then nothing's changed! A revolution must at least reform!

Cordelia: Everything *else* is changed!

Lear: Not if you keep the wall! Pull it down!

Cordelia: We'd be attacked by our enemies!

Lear: The wall will destroy you. It's already doing it. How can I make you see? (Bond, 1972a, p. 84).

In *At the Inland Sea* (1995), stasis and mobility equally symbolise a halt of development and a change of perspective, respectively. Only after the boy encounters images of victims of the holocaust does he begin to leave his room for extended periods, as a mysterious older woman stepping into the familial home explains to his mother:

Old Woman: Your son's all right. He'll be here soon. Don't be angry with him. All young people want to change the world. Get an idea and can't let it go. He went for a walk.

Mother: He's all right?

Old Woman Yes. He's growing up. You must let him be (Bond, 1997, p. 22).

Growing up, this scene reveals, entails a negotiation of closeness and distance, with the latter providing the space for young people to emancipate themselves. What begins as a small act, such as escaping into different realms mentally - then the mother talks to her son, the audience realises that he has entered a dreamlike state, in which the boy can no longer hear her (Bond, 1997, p. 8) - culminates in him physically leaving the domestic space towards the end of the play. "Home is not only where many people form their earliest interpersonal attachments, but it is also often the locale of our deepest secrets, most treasured loves, and indelible memories; it is where identity is formed, and the self begins. As Gaston Bachelard wrote in *The Poetics of Space*, "the house shelters day-dreaming, the house protects the dreamer, the house allows one to dream in peace" (Klein et al. 2019, p. 8).

Although not a domestic space per se, Lear's wall represents walls behind which his daughters are kept and so goes Lear's superficial argument, brought up to shield them from potential harm. While laying out the consequences that this wall will have on the future generation, he declares to have built this space as another crystallisation point that is intended to provoke memory and communication about him:

> Lear: Bodice, you are right to be kind and merciful, and when I'm dead you *can* be – because you will have my wall. You'll live inside a fortress. Only I'm not free to be kind or merciful. I must build the fortress (Bond, 1972a, p. 4f.).

The wall is therefore turned into a representation of his relationship with his daughters, a remaining part of his in the kingdom he has created and that he will pass on to them. In Bond's writing, the meaning of the wall is multiplied and ranges from a public spatial monument to a political statement to an essential component in a private, familial matter. Seemingly, the plays insist that what appears to be theatre about political issues is just as much a question about the exchanges between parents and children.

Public and Private Spaces

Playing on the idea of walls and confinements arguably reflects events in the twentieth century, which was marked not only by the two world wars but also by principles of protection of an enclosed settlement or prevention of people crossing borders between two countries/cities. The Iron Curtain was a legislative barrier splitting Europe into two separate blocks from World War II in 1945 to the end of the Cold War in 1991. The Berlin Wall was a secured wall that physically and ideologically separated Berlin from 1961 to 1989. In this sense, separation, division, isolation, and protection have become associative terms, which are bound to resonate with contemporary audiences who have

witnessed the rhetoric of the Trump presidency and walls being erected in response to increasing migration into Europe.

Michel Foucault's notion of heterotopias delineates spaces of otherness beyond those representing the dominant classes and their ideology, in which all the other real sites that can be found within the culture are simultaneously represented, contested, and inverted (Foucault, 1986, p. 753). An example is the heterotopia of deviation, such as the prisons, where human behaviour is deviant from the norms of society. Walls that are built to protect the countries could be another example of heterotopia as they separate the communities from each other and create an isolated area. Foucault (1986) uses the term *heterotopia* (French: hétérotopie) to define spaces that have more layers of meaning or relationships to other places than immediately meet the eye. In general, a heterotopia is a physical representation or approximation of a utopia or a parallel space (such as a prison) that contains undesirable bodies to make a real utopian space possible. Apart from Foucault, David Harvey and Hethrigton define heterotopia as "spaces of alternative order" and underline the sociocultural context of this concept. Harvey emphasises that heterotopia does not merely indicate the existence of "other worlds" (as cited in Tompkins, 2014, p. 22); because it indicates that space and space will have a political function and that heterotopic spaces have a potential structure for social change (as cited in Tompkins, 2014, p. 22). Moreover, Boyer argues that "a city of split realities separated into two ideology camps compelled those on each side to gaze over the wall at each other yet remain a captive of their own imaginary beliefs and ideals" (Boyer, 2007, p. 65).

In light of these definitions, it can be seen that the context of heterotopia leads to creating/producing an alternative space/space, overcoming social norms and borders. Therefore, heterotopia can be defined as "a bridge between cultural politics and practice" (Tompkins, 2014, p. 11). Heterotopia offers a functional and reflective tool/tool for transforming or interpreting contemporary society. Moreover, it retains the quality of difference. This moves into the movement of an alternative order by looking at how society will develop in the future. Also, heterotopia is the inner vehicle of society within the present and the future and exists through functional relations of time and space.

At the time the Berlin wall fell down in 1989, the belief that a different historical epoch was beginning, that in some deep mind, we were at the origin of a new stage in the human narrative, was heavily assumed and severely canvassed - not only in the domain of worldwide politics but in the creativity, thoughts and the compass of society. As Bond (2000) notifies that "post-modernism is a turning point not yet an end. It is as if human life were the last dream flickering in the minds of the dead. Soon they will fall asleep forever" (p. 9). He also maintains that "we can still hear the echo of human language for a

while. r. It is not spoken in our courts, legislatures, factories, and seldom in our schools and theatres. Nevertheless, we still hear its echoes on the walls of our prisons, madhouses, children's playgrounds, the derelict ghettos of our cities" (p. 9).

As Henri Lefebvre suggests in *The Production of Space*,

> theatrical space, with its interplay between fictitious and real counterparts and its interaction between gazes and mirages in which actor, audience, 'characters', text, and author all come together but never become one. By means of such theatrical interplay bodies are able to pass from a 'real', immediately experienced space (the pit, the stage) to a perceived space - a third space which is no longer either scenic or public. At once fictitious and real, this third space is classical theatrical space (Lefebvre, 1991, p. 188).

With this in mind, it will be necessary to evaluate how the theatre, which Foucault refers to in his definitions of heterotopia, creates an 'other space' and an 'alternative order' in the context of the theatre's tools and method. The function of the theatre as a heterotopic space begins to operate in many spaces, side by side or on top of each other, or when it creates a kind of break from the current perception of time. Time and space are abstracted from their existing system. In other words, the time and place determined in daily life experience a deviation from the theatre and, therefore, the place-time of the screening.

As Kerstin Schmidt argues,

> Theatre on location, in general, represents the attempt to reach the public, to lend a new air to the site where theatrical performance takes place, and to attribute new aspects to everyday spaces otherwise alien to the usage as a stage - ideas mainly propagated by performance art and The Happening. The locus of theatre is thus reconceptualized and is turned into an important topic itself, a fact that also corroborates the metadramatic thrust of postmodern drama (Schmidt, 2005, p. 73).

Specifically, *Lear* (1972) and *At The Inland Sea* (1995) reveal how these spaces serve to educate and change both the audience and characters. Through the use of heterotopias, or "other" spaces, Bond can challenge traditional notions of space and force the audience to consider how space shapes our understanding of the world.

In *Lear* (1972), Bond presents the audience with a reinterpretation of Shakespeare's classic play. By using Brechtian techniques such as alienation, Bond forces the audience to question their preconceptions of the play and consider how it reflects contemporary society. The use of these techniques serves to educate the audience about how theatre can be used to comment on society.

Similarly, in *At The Inland Sea* (1995), Bond uses the concept of heterotopias to challenge the audience's understanding of space. The play explores the idea of "other" spaces, such as the *Inland Sea*, and how these spaces shape the characters' understanding of the world. The use of these dynamic spaces serves to change and mature the characters as they are forced to confront their prejudices and biases. As a result, through dynamic spaces such as heterotopias and Brechtian stagecraft, Edward Bond's plays *Lear* (1972) and *At The Inland Sea* (1995) educate and change both the audience and characters. These spaces challenge traditional notions of space and force the audience to consider how space shapes our understanding of the world.

In this sense, in Bond's plays *Lear* (1972) and *At the Inland Sea* (1995), theatrical space is presented as the endeavour to reach the public; the walls in Lear could stand for the real or imaginary barriers that every man builds around themselves. "I built my wall against you as well as my other enemies!" (Bond, 1972a, p. 7). The mother in *At the Inland Sea* also draws a kind of boundary for the boy, who can be considered as the child who is always expected to behave according to his parents' wishes.

> Mother: Where's you walk in the dark?
>
> Boy: I'm not a child.
>
> Mother: While you're under my roof you live by the rules. You tell me what you get up to (Bond, 1997, p. 34).

Bond's theatre frequently pursues Brecht's more urgent assault on the practices of the stage, particularly the rhetoric implicit in and its construction of a 'realistic' social audience. Bond's theatre generally avoids the scenic integration characteristic of realism; the space of a Bond play is usually open and spare, like the unlocalised space of Brecht's theatre, but without Brecht's theatricalising technology, the placards, film screens, and turntables.

In *Hidden Plot*, Bond (2000) states that,

> A play has to be in two places. Firstly, in the psychology of the characters - they speak from their psyches. Secondly, in the world in which the characters are. That world is divided into the natural world, the social world and the particular place (such as the army or school) in which the characters are. The psyche itself has a different aspect in each of these worlds - and together these may be called its first world (the world of social realism, primarily) (p. 27).

As Gourg (2008) points out, "Bond, whose primary concerns are political and ontological, has also challenged the limits of mimesis in a way evocative of Lojkine's *fabrique du sens* (Lojkine 2005, p. 31), especially by turning the stage into the locus of a spatial riddle" (p. 2). Re-examining Brook's image of the

'empty space', he redefines it 'a social gap', inviting out the description Lojkine calls the 'scopic dimension', named as the overwhelming urge to remove the interval between the sight and the recipient. "The empty stage invokes social meaning, it is a blank page that is to be read, it is the Sphinx's eye" (p. 2), hence suggesting by the trope of intruding ideas the ubiquity of a 'gap' bringing recognition to something hiding behind (p. 2).

Bond wrote *Lear* (1972) as a Brechtian version of Shakespeare's play, which underlines the brutality and cruelty in the pattern. Bond's Lear illustrates a disintegrated family, employing Brechtian stagecraft, a world where "violence shapes and obsesses ... society" (Bond, 1988, p. 3). "At the end of Bond's play, the old man, who has brought unremitting violence into the world, is pitifully trying to dig up his great wall, the symbol of the failed social order he tried to create" (Sternlicht, 2004 p. 174). The action of the play takes place in a multitude of locations. Although the audience does not see Lear's wall until the final scene, the play opens near the wall, which becomes a pervasive symbolic presence throughout the play. Constant references to the wall let the audience have an insight of enclosure and claustrophobia, which is the agent of the force created by various aspects throughout the play. The Gravedigger's Boy's house is also a critical location in this more pastoral setting where Lear encounters the opportunity of self-development and the extent of human sympathy.

Throughout the first scenes of the play, Lear insists on building a wall and keeps on mentioning how it is useful to build this wall for his daughters' future. He truly believed in the necessity of the wall so that his daughters and people would be safe from the war and the enemies outside. As can be seen in the play:

> Lear: I started this wall when I was young. I stopped my enemies in the field, but there were always more of them. How could we ever be free? So I built this wall to keep our enemies out. My people will live behind this wall when I'm dead. You may be governed by fools but you'll always live in peace. My wall will make you free. That's why the enemies on our borders - the Duke of Cornwall and the Duke of North - try to stop us building it. I won't ask him which he works for - they're both hand in glove. Have him shot. (Bond, 1972a, pp. 3-4).

As Lear is depicted as guilty for the misery of others, he comes to grieving himself, in need of his thoughts' security, whom he once forced to work to construct his wall. Bond reveals the causes for this significant adjustment in his play as such: "I wanted to explain that Lear was responsible, but that it was crucial that he could not get out of his problems simply by suffering the consequences, or by endurance and resignation" (Bond, 1972b, p. 29). In the play, it is emphasised that Lear requires to be mentally developed and have experienced certain things. Therefore, "he had to live through the consequences

and struggle with them" (p. 29). It is obvious that Lear suffers at the end of the play because of the walls he has built around himself because of the isolated world he has built for himself. While the wall creates a world far from reality, prison can be interpreted as a place of enlightenment and seeing the truth. While trying to protect himself from his enemies, the dark world brought by the wall, the prison, which is known as a dungeon, and a closed place, where he stayed between four walls, made him realise to realise the meaningful things in his life.

> Bodice: Yes, you'll ruin yourself. Our husbands can't let you terrorize these people - they'll be their people soon. They must protect them from your madness.
> Lear: Work! Get your men to work! Get them on the wall!
> Workers, Soldiers and Foreman go out. They take the two bodies with them.
> I knew it would come to this! I knew you were malicious! I built my wall against you as well as my other enemies! You talk of marriage? You have murdered your family. There will be no more children. Your husbands are impotent. That's not an empty insult. You wrote? My spies know more than that! You'll get nothing from this crime (Bond, 1972a, p. 7).

> Warrington: No, sir. They ask me to betray you and then each other. They'll both make me head of the army and let me share their bed.
> Lear: They live in their own fantasies! They chose their husbands well, they should be married to my enemies! Have the ceremonies taken place? It doesn't matter. (He takes the letters from WARRINGTON. He reads part one.) 'He is mad. If he won what security would you have?' (He reads from the other.) 'He would turn on you as he turned on us.' (Salutes as before.) Greetings to my friends the ninth! (Still saluting.) Warringtoon, if I'm killed or fail into their hands you must take my place and build the wall.
> Warrington: Sir. This fry won't take you. Your army is paraded! (Bond, 1972a, p. 9).

On the other hand, we come across a contradiction in Lear's objectives of thoughts and actions. Although he claims to design it to protect his people, as the wall is created, Lear surrenders the lives of his workers for his protection, much like a capitalist leader exploiting his workers. The wall turns out to be more like prison, isolation, and division instead of symbolising a promising future, peace, and protection. However, Lear does not recognise his fault until the end, after suffering and staying in prison, in other words spending his days isolated from the main society. He says: "[h]ow many lives have I ended here?" (Bond, 1972a, p. 80). Finally, Lear confesses that his desire to build a wall has

destroyed the lives of his nation. As Özmen (2018) points out, "this obsession turns into one of his biggest regrets at the end of the play as is illustrated in his following poetic speech about a life wasted in ignorance" (p. 80):

> There's a wall everywhere. I'm buried alive in a wall. Does this suffering and misery last for ever? Do we work to build ruins, waste all these lives to make a desert no one could live in? There's no one to explain it to me, no one I can go for justice. I'm old, I should know how to live by now, but I know nothing, I can do nothing, I am nothing (Bond, 1972a, p. 94).

As seen in the play's last act in which Lear tries to destroy the wall, he makes one last attempt in his late fight against the 'new' order of tyranny, oppression, and inequality. With such instances, Bond demonstrates the painful process of a political figure to learn from his mistakes and express his regret deeply.

Lear's relationship with his daughters emphasises the concept of family and the importance of education in the family. In the name of protecting his children by providing a bordered space, closing them to the outside world, the fatherblunted the girls' ability to distinguish between good and evil. The fact that their father put him in prison for his own good shows how much their perceptions of good and bad have changed.

As Nodelman (1980) suggests,

> Inside the wall, Lear's daughters Bodice and Fontanelle have grown up insulated from evil. So they cannot distinguish between evil and good, and are governed only by their whims. Lear's wall has made them, not good, but incapable of not being bad. Furthermore, in arrogantly assuming he has a right to protect others from ugliness and pain by keeping them inside a prison, Lear has created their understandable desire to be prison guards themselves (p. 269).

As Nodelman states, although Lear's wall was started to be built with good intentions, in the future, his inability to see the truth and shut himself off to the outside world instilled such a way of thinking in his children. However, because this form of education destroyed free thought, it prevented Lear's daughters from distinguishing between truth and falsehood, truth and falsehood, and good and evil.

> Lear: O my poor children, you're too good for this world. (To the others) You see how well they'll govern when I'm dead. Bodice, you're right to be kind and merciful, and when I'm dead and you can be - because you will have my wall. You'll live inside a fortress. Only I'm not free to be kind or merciful. I must build the fortress.
>
> Bodice: How petty it is to be obstinate over nothing.
>
> Lear: I have explained and now you must understand (Bond, 1972a, pp. 4-5).

In Act III, when Lear is living at the boy's house with Thomas and Susan, a young couple who become the ones who influence Lear's ideas about social problems with their charitable attitude to Lear when he falls from power and needs shelter. Also, when Lear is deposed, he first finds shelter in Gravedigger's Boy's place, and at the end of the play, he is protected in Thomas and Susan's place. Lear learns the values of compassion and pity from the hospitality and welcoming of these lower-class characters.

Moreover, Gravedigger's Boy's place as a setting represents a second home, shelter or an immigration camp as it brings a peaceful living place after his suffering in prison times. In addition to this, the first place in which Lear is protected becomes such a welfare territory for Lear that also, after his blinding, he envisions the spirit of the Gravedigger's Boy encouraging him with a commitment to take him to this house where, as he thinks, he will live in a quiet world. "He asked me to stay! No, I won't go! ... He said I could stay. He won't break his word. I'm too old to look after myself. I can't live in ditches and barns and beg for scraps and hire myself to peasants! No, I won't be at everyone's call! ..." (Bond, 1972a, p. 27).

This house, in a sense, pictures a distant period in which, according to Bond, ethical senses were not yet attained over by financial benefits. Recognising that Lear's wall is a representation of exploitation, and Gravedigger's Boy avoids being a role of it, he continues to ignore Lear's ideas, so he embodies the simple history when one used to have empathy for each other. Symbolically, Lear already places base in this comfortable home; he brings forth military brutality as the officers attack the place and wreck their order.

Concentration Camp & Room in *At The Inland Sea* (1995)

Edward Bond frequently combines two different fictional worlds in the same or different periods of time (Ada & Parlak, 2020; 2022; Bond, 1997, p.104) in the plays he wrote for young people, revealing their individual narratives or gaining various experiences by providing a different space for the main characters. In *At the Inland Sea* (1995), the boy, who is habitually silent to his mother's discredits, involuntarily generates a different imaginary world that performs an exit point in the bedroom. He prefers to spend time with his books and his library in his bedroom to go deep into his imaginary world. Therefore, the boy's bedroom could be interpreted as a heterotopia which opens doors to imaginary dimensions. As Bond points out, it is inevitable that the boy creates the extraordinary in the bedroom since he feels the increasing pressures closely with his family and school (Tuaillon, 2015, p. 141). Today's unavoidable environmental factors [family, school, etc.] induce children's personal crises [expectations, exams, etc.] to be simple and commonplace. Children surrounded

by society are not given enough time to develop the necessary competencies to act freely and authentically in the outer world.

In Bond's *At the Inland Sea* (1995), the young boy pays a visit in his imagination to the gas chambers of the Holocaust. Edward Bond has recalled the impact on him of seeing photographs of Nazi atrocities at the end of World War II (when he was 11 years old):

> At that moment, the world became old and mankind unfathomable. It was the ground zero of the human soul, the ice at the bottom of Dante's hell. ... Really, we all died in Auschwitz. I sometimes think humanity itself died there. It didn't make any sense. Instead of the devil lurking somewhere around ready to catch you, suddenly we were confronted with the totality of evil. It was there as a fact even though you had survived. (cited as in Tuaillon, pp. 17–18).

Brecht's (1993) concept of alienation (in German, "Verfremdungseffekt") is a technique used in theatre to distance the audience from the action and characters of the play in order to encourage them to engage with the themes and ideas presented critically. He achieves this by using elements outside of the play's fictional world, such as song, narration, or stage design, to comment on or interrupt the action, breaking the fourth wall, and addressing the audience directly. The goal is to make the audience aware that they are watching a representation of reality rather than reality itself and to encourage them to think critically about the issues raised in the play.

On the other hand, Bond's different worlds and temporalities are all inside, part of, the fictional world of the drama and serve to explore and expand upon the themes and ideas presented within the play. He achieves this by creating different worlds and temporalities within the same play, for example, by having characters move between different eras, locations, or states of mind. The goal of this technique is to create a rich, layered exploration of the themes and ideas presented in the play, but always within the fictional realm.

These places that the boy visits in his imaginary world and the representation of the concentration camps through his stories can be interpreted as heterotopia in the play. Refugee/concentration camps are envisioned as transient settlements where people who have a fear of violence and persecution are forced to flee their homes looking for repose and assistance.

As Uğur Ada and Erdinç Parlak (2020) suggests that,

> The third crisis, which is more dangerous for humanity than previous crises; It can be historical events such as concentration camps [Auschwitz – Gulag], the education system reduced to pure learning activities, the policies of Thatcherism, or broadly the unsolved problems of the twenty-

first century, which we are only in the first quarter. The playwright points to capitalism and its market as the materialized source of the current crisis, which has no specific definition (p. 37).

In this sense, *At the Inland Sea* (1995) presents a serious message in a compelling way, taking the audience on an emotional journey through a representation of the terrors of the holocaust, which contrasts with the seemingly petty issues of the mother and son of the present day. Dramatic imagination in *At the Inland Sea* (1995) is structured traumatically in the sense that it involves traumatic events or structures and the structure of repetition. The boy creates stories and travels into other worlds through his imagination and reveals the dramatic imagination of trauma, which can be regarded as repetitions of ontological, historical, or structural trauma. Also, by dramatizing trauma in his room, the boy produces a space where traumatic historical events can be aroused, and traumatising structures can be exposed.

As Bond (1988) explains that,

> Imagination combines reason and emotion. When imagination is invoked, reason and emotion cannot be separated. When imagination is invoked, it is in a critical state. Anything may become critical in imagination. In some aspects of life, we can use reason and emotion (especially logic and feeling) in isolation (though even then imagination is residually present and may even be dominant in a disguised form). The ability to analyse and calculate is characteristic of isolated reason: when it is combined with emotion, to produce imagination, it becomes 'story-ness' (storyability etc). Imagination is essentially storability. Imagination needs to relate experience as story or potentially storyable. When experience becomes overwhelming or chaotic radical stories and told. (p. 8)

At this point, the act of storytelling of the mind unites the idea of mapping the individual, "A child's world is a map. It learns to live in the world by mapping it. Its map of the world is its means of being. A child could not think or move without a map of the world. Nothing may be unmapped. Anything unmapped would be like a hole in nothingness" (Bond, 1995, p. vii). As Chris Cooper (2005) suggests, "in *At the Inland Sea* the Boy needs the knowledge of a map to live in the world, rather than the knowledge he uses to pass exams. The Woman's and the Old Woman's stories are vital to this process. Without the stories of others, he cannot make his map" (p. 54). On the other hand, the Old Woman could be called the voice of the free word:

Mother: I'm worried sick.

Old Woman: Your son's all right. He'll be here soon. Don't be angry with him. All young people want to change the world. Get an idea and can't let it go. He went for a walk.

Mother: He's all right? (Bond, 1997, p. 22)

As can be seen here, the old woman advises the boy to increase his worldview, go outside and be in contact with the outside world. The map here represents the boy's knowledge of the outside world. The boy, who tries to understand the stories of others by breaking the walls with the stories he develops in his mental world, is trying to gain the ability to live behind closed borders, in a way, like Lear's daughters.

Conclusion

Edward Bond's plays *Lear* (1972) and *At The Inland Sea* (1995) both explore the concept of space and its relationship to education. In "Lear," Bond employs the use of multiple locations and shifting temporalities to challenge traditional notions of space and time. He uses these elements to question the audience's understanding of the play's fictional world and to encourage them to consider their own perceptions of reality. The play's use of heterotopias, or other spaces, furthers this exploration of space and its relationship to education.

In *At The Inland Sea* (1995), Bond continues to use space as a central theme to explore the relationship between education and the individual. The play takes place in an isolated coastal town, and the characters are confined to this space, which serves as both a physical and metaphorical prison. Through this setting, Bond highlights the limitations of traditional educational systems and encourages the audience to consider alternative forms of education.

In both *Lear* (1972) and *At The Inland Sea* (1995), Bond uses space as a tool to question traditional notions of education and to encourage the audience to think critically about their own perceptions of reality. Through the use of shifting temporalities and other spaces, Bond challenges the audience to consider the role of space in shaping their understanding of the world. The plays also serve as a commentary on the limitations of traditional educational systems and the need for alternative forms of education.

"What I wanted Lear to do,' says Bond, 'was to recognise that they were his daughters – they had been formed by his activity; they were children of his state, and he was totally responsible for them" (Smith, 1979, p. 77). As this quote suggests, Bond's objective is to unveil the entanglement of parental responsibility and political injustice. It is the familial bond, the domestic sphere, the plays suggest, that constitutes the nucleus of what lies in the danger of turning into political aggression and abuses of power. Of the utmost importance, therefore,

is being conscious of the situation of humanity, its history, and the spaces that have formed how contemporary culture and audiences view the world. Especially spaces that are 'other' highlight this dynamic as they intensify the progression of young people as they learn and grow aware of their surroundings. The theatrical space, both mimetic and diegetic, is interpreted through the linguistic channel in which the apparent performance area and the hidden theatrical space shift are joined by the language, action and indication of characters and with the benefit of setting.

This paper examines such issues as space, place, heterotopia, family, and education as the connecting element of Bond's dramatic corpus. It depicts the wall, prison, and the bedroom as a heterotopia with the following themes: 'the Wall' represents the protection and influence for Lear, walls as the expression of an isolated field, and family education in the plays *Lear* and *At* the *Inland Sea* are interpreted as the voice of secured, controlled, and hence protected area. As in Lear's creation of the wall in his town, the place expands beyond the restrictive portrayals of heterotopia. His production of space represents the dynamic and the mental as well as the material and the concrete.

References

Ada, U. & Parlak, E. (2020). Edward Bond'un At The Inland Sea oyununda zaman olgusunun kadın karakterler üzerinden temsili. *Ordu Üniversitesi Sosyal Bilimler Enstitüsü Sosyal Bilimler Araştırmaları Dergisi, 10*(1), pp. 34-47.

Ada, U. & Parlak, E. (2022). "What will it be next?": The process of 'dramatic child' in Edward Bond's Eleven Vest. *Söylem Filoloji Dergisi, 7*(1), 94-109.

Assmann, J. (2018). *Das kulturelle Gedächtnis. Schrift, Erinnerung und politische Identität in frühen Hochkulturen.* München: C. H. Beck.

Bond, E. (1972a). *Lear.* London: Methuen.

Bond, E. (1972b). Edward Bond: the long road to Lear, *Theatre Quarterly, January-March*, pp. 3-30.

Bond, E. (1988). Author's Preface. In E. Bond, *Plays 2: Lear, The Sea, Narrow Road to the Deep North, Black Mass, Passion* (pp. 3-12). Berkshire: Methuen.

Bond, E. (1995). *Coffee.* London: Bloomsbury.

Bond, E. (1997). *At the inland se*a. London: Methuen Drama.

Bond, E. (2000). *Hidden plot: notes on theatre and state.* London: Methuen Drama.

Boyer, M. C. (2007). The many mirrors of Foucault and their architectural reflections. In M. Dehaene & L. de Cauter. *Heterotopia and the city: Public space in a postcivil society* (pp. 53-68), London: Routledge.

Brecht, B. (1993). *Bertolt Brecht journals 1934-1955.* (Ed. John Willett). United Kingdom: Methuen Drama.

Certeau, M. de. (2007). *The practice of everyday life.* Berkeley: University of California Press.

Cooper, C. (2005). Edward Bond and Big Brum plays. In D. Davis, *Edward Bond and the dramatic child: Edward Bond's plays for young people* (pp. 49-83). UK: Trentham Books.

Dustagheer, S. (2013). Shakespeare and the spatial turn. *Literature Compass, 10*, pp. 570-581.

Foucault, M. (1986). Of other spaces, *Diacritics 16*(1), pp. 22-27.

Foucault, M. (1992). Andere Räume. In. K. Barck, et al. (eds), *Aisthesis: Wahrnehmung heute oder perspektiven einer andere ästhetik* (pp.34-46). Leipzig: Reclam.

Gourg, C. (2008). The bundle in Edward Bond's plays, an avatar of the unspeakable thing. *Études Britanniques Contemporaines, 35*. Retrieved from https://journals.openedition.org/ebc/5990

Klein, E. Mobley, J.-S. & Stevenson, J. (2019). *Performing dream homes. Theater and the spatial politics of the domestic sphere*. New York: Palgrave Macmillan.

Klein, H. (1995). Edward Bond: An interview. *Modern Drama, 38*(3), pp. 408-415.

Lefebvre, H. (1991). *The production of space*. England: Blackwell.

library-leeds.ac.uk (n.d.). Retrieved from https://library-leeds.ac.uk (accessed Dec 22, 2021).

Lojkine, S. (2005). *Image et subversion*, Paris: Jacqueline Chambon.

Nodelman, P. (1980). Beyond politics in Bond's *Lear*. *Modern Drama, 23*(3), pp. 269-276.

Özmen Ö. (2018). *Re-writing Shakespeare in the twentieth century: Edward Bond's Lear, Arnold Wesker's The Merchant and Howard Barker's Gertrude-The Cry in sociohistorical context*. Unpublished Doctoral Dissertation. Hacettepe University, Ankara.

pab-research.de (n.d.). Retrieved from https://pab-research.de (accessed Dec 22, 2021).

Pfister, M. (1988). *The theory and analysis of drama*. UK: Cambridge University Press.

Schmidt, K. (2005). *The theater of transformation*. Leiden, The Netherlands.

Spencer, J. (1992). *Dramatic strategies in the plays of Edward Bond*. Cambridge: Cambridge University Press.

Smith, L. (1979). Edward Bond's Lear. Comparative Drama *13*(1), pp. 65–85. http://www.jstor.org/stable/41152817.

Sternlicht, S. V. (2004). *A reader's guide to modern British drama*. USA: Syracuse University Press.

Tally, R. (2011). This space that gnaws and claws at us: Foucault, cartographics, and geocriticism. *Épistémocritique: Littérature et Saviors, IX*. Retrieved from https://epistemocritique.org/this-space-that-gnaws-and-claws-at-us/

Tompkins, J. (2014). *Theatre's heterotopias: Performance and the cultural politics of space*. Hampshire: Palgrave Macmillan.

Tuaillon, D. (2015). *Edward Bond: The playwright speaks*. London: Bloomsbury.

Further Reading

Bond, E. (1998). At The Inland Sea. In. E. Bond, *Letters 4* (pp. 139-168) Amsterdam: Harwood Academic Publishers.

Carney, S. (2017). *The politics and poetics of contemporary English tragedy.* Toronto: University of Toronto Press.

Donahue, D. (1979). *Edward Bond: A study of his plays.* Rome: Bulzoni.

Innes, C. (1982). The political spectrum of Edward Bond: from rationalism to rhapsody. *Modern Drama, 25*(2), pp. 189-206.

Klein, H. (1989). Edward Bond: LEAR was standing in my path. - LEAR's progressive journey from blindness to moral insight and action. *Atlantis* 11(1/2), pp. 71–78.

Seema, S. (2014). Revisiting history & creating humanness: A study of Edward Bond's play *At the Inland Sea, IJLTEMAS, III*(III), pp. 2278-2540.

Worth, K. J. (1972). *Revolutions in modern English drama.* London: G. Bell.

Chapter 8

Finding Utopia in Edward Bond's Plays for Young People, or: '*You Have to Learn to be on Your Own*' (The Children, *Bond, 2000b*)

Selina Busby

The Royal Central School of Speech and Drama

Abstract

This chapter focuses on Bond's writing for young people between the years of 1993 and 2001 and by examining his plays of this period, I explore the utopic nature of his work through a close reading of *Olly's Prison, Tuesday, Eleven Vests,* and *The Children*. There is an implicit assumption in Bond's plays, and also stated in his prose, that theatre invites reflection on the world and through this reflection offers the possibility of change. Using theatrical devices that create distance through a series of gaps or pauses in the narrative and structuring of the plays, Bond's young audiences are required to 'make meaning' from what they are shown and reflect on the position of the characters within the performances and ask the question, 'what would I do in that situation?' By doing this, Bond is encouraging the audience to fill the 'gaps' he deliberately creates in the text and to consider alternative choices within the worlds they inhabit. In this way, Bond positions his audience as potential agents for societal change. It is his intention to create reflexive theatre that the audience both perceives and receives at the same time and invites a reconsideration of both what it is to be human and how to become more humane. In the plays the audience witness the representations of young people under the influence and control of two ideological state apparatuses working together; the family, and the education system. Together these institutions can be understood as training young people to be compliant in order to enter the workplace. Each of Bond's young central characters is tested and offered choices that determine their ability to resist the disciplining and regulatory controls at work within society. Those who demonstrate this independence are shown to be able to take responsibility for firstly themselves and then others, becoming more humane as they develop a social conscience and move away from the oppression of existing social structures and move towards forging a more socially just society.

Keywords: Edward Bond, Olly's Prison, Tuesday, Eleven Vests, The Children, theatrical devices

Introduction

Although Bond is not widely viewed as a utopian author, he does frequently talk about his work as hopeful. The focus of this chapter is finding the Utopian alternatives to the dystopic and bleak narratives in his work. I suggest that by showing the audience the negative results of contemporary capitalism in our society, Bond is inviting audiences to imagine a better alternative future. Perhaps controversially, this chapter explores where Utopian impulses can be read into his plays for young people. Bond himself describes his work as hopeful, and therefore I am searching for, and I believe finding, a more optimistic reading of his work. This reading may appear to be counter intuitive to the bare facts of his narratives, but Bond is a sophisticated and complex writer who demands more of his young audiences than a merely superficial reading of his plays and characters; he is challenging them to find better ways of living in contemporary society.

In May 2016, Edward Bond directed the first performance of his play *Dea* at The Secombe Theatre in the borough of Sutton, 10 miles away from London's West End. In conversation with David Hutchinson from *The Stage*, he claimed that English theatre "is patronizing, childish and serves no function" and that "dumbed down productions were steadily making theatre audiences less intelligent" (Hutchinson, 2016). In the 1990s, Bond purposely moved away from writing plays for adult audiences in the UK, claiming that our national theatres "trivialized drama" and were "incompetent to deal with the problems of being human" (Bond, 2000a, p. 1). The problem of 'being human', or questions that ask what it means to be human in contemporary life, are leitmotifs that have dominated all his work. The plays Bond has produced over the last two decades for young people are certainly not 'dumbed' down; they are challenging and demand a good deal of imaginative interpretation from young audiences and performers. Bond's work, unlike many other writers producing work for young people, tackles very serious concerns and is not afraid to confront difficult, or challenging subject matter.

In an interview with Ulrich Koppen for *New Theatre Quarterly*, he outlines that the only way to survive in an inhuman world is to become inhuman (Koppen, 1997, p. 104). This belief has resulted in his work often focusing on the power structures that shape our existence. As a result, his work has frequently placed children, young people, and their families at the center of his plays, from the baby in *Saved* (1965) through to the children and teenagers in

his 1990s work and continues in his work of the twenty-first century. All of Bond's work deals with these core issues of how to become more human and confronts its audiences with events that test both the characters' and the audiences' capacity for humanity. In his post 1995 work, which is specifically aimed at young people, these concerns become more focused through the use of adolescent central characters on the cusp of adulthood. Bond's move to writing theatre for young people shifted both the settings in which his plays are produced and the contexts in which they are set. There is, however, a consistency in the political nature of his plays which is sharpened in his writing for young people.

Bond's plays examine social injustice, and by using children as the victims, survivors, and perpetrators of violence, he positions the audience members to critically consider injustice, the basic structures of society, and how they relate to children. Central to Bond's work is his belief that the social purpose of theatre is to question what it means to be human and to explore alternative ways of living, and his turn to theatre for younger audiences is underlined by his belief that adults have lost the ability to ask the important questions (Mulligan, 1993). This has resulted in most of Bond's work since 1995 being performed in the United Kingdom by a series of Theatre in Education companies and youth and community groups, starting with the collaboration between Bond and Big Brum with the production of *At the Inland Sea* (1997b).

In my reading of Bond's plays for young audiences, it can be seen that by offering representations of children as central characters, he invites the examination of the compliance or resistance to institutions of power that exert influence over children's lives. Each of Bond's young central characters is tested and offered choices that determine their ability to resist the disciplining and regulatory controls at work within society. Those who demonstrate this independence are shown to be able to take responsibility for firstly themselves and then others as they develop a social conscience and search for social justice. This, I believe, makes Bond's writing for young people utopian.

In this chapter, I focus on Bond's writing for young people between the years of 1993 and 2001 and by examining his plays of this period, I explore the utopic nature of his work through a close reading of *Olly's Prison* (1990), *Tuesday* (1993), *Eleven Vests* (1997a), and *The Children* (2000b). As I write this, I am acutely aware that Bond does not stage utopias as such, but that I am reading the deeply tragic circumstances he portrays through a utopic lens. In doing this, I am using Paul Ricoeur's 1986 definition of utopia, which stems from a critical appraisal of the present through which a different or alternative future maybe viewed.

There is an implicit assumption in Bond's plays that theatre invites reflection on the world and, through this reflection, offers the possibility of change. Using

theatrical devices that create distance – although not a Brechtian sense of distance allows for a distanced view of the world of the play. Bond distances the audience through a series of gaps or pauses in the narrative and structuring of the plays that does not alienate the audiences from the characters and their world; its more of a Ricoerian 'distanciation' (1986) – a pause during which the audience is still connected with the characters but in which Bond's young audiences are required to 'make meaning' from what they are shown and reflect on the position of the characters within the performances and ask the question, 'what would I do in that situation?' By doing this, Bond is encouraging the audience to fill the 'gaps' he deliberately creates in the text and to consider alternative choices within the worlds they inhabit. In this way, Bond positions his audience as potential agents for societal change. It is his intention to create reflexive theatre that the audience both perceives and receives at the same time and invites a reconsideration of both what it is to be human and how to become more humane. Bond's theatre and theatrical pedagogy are predicated on the idea that the audience has agency and I suggest that this dynamic between the play, performance, and audience is utopian in spirit. Here I am applying the understanding of utopia as described by Paul Ricoeur (1986), who "does not mean the hope of a better place, but rather the ability to recognize current circumstances, and from this understanding develop the desire and capacity to change these circumstances" (Busby, 2021, p. 11). My reading of these plays is also influenced by Foucault (1977), as Bond's work of the period represents how power over human beings is developed through disciplinary and regulatory techniques, particularly those of the family and education system. This chapter, therefore, considers Bond's work in light of Foucault's theory of the technology of the self as constituted through the dominant structures of power that regulate life.

In the plays I have selected, the audience witnesses the representations of young people under the influence and control of two ideological state apparatuses working together; the family and the education system. Together these institutions can be understood as training young people to be compliant in order to enter the workplace. Each of Bond's young central characters is tested and offered choices that determine their ability to resist the disciplining and regulatory controls at work within society. Those who demonstrate this independence are shown to be able to take responsibility for firstly themselves and then others, becoming more humane as they develop a social conscience and move away from the oppression of existing social structures and move towards forging a more socially just society.

Social (In)Justice: Olly's Prison

For Bond living in and accepting the 'inhuman' world results in a repression of human potential. Bond's examination of the frustration and injustice this creates allows me to make a connection to Foucault's theories of power as being asserted through 'regulatory controls' or the bio-politics of the population. Although Bond's work is more usually viewed through a Marxist lens because Bond too deconstructs power as being based on capital and production, I use a Foucauldian lens that sees the "development of the great instruments of the state, as *institutions* of power [that] ensured the maintenance of production relations" (Foucault, 1991, p. 263). In Foucault's work, the repression of potential is the result of the institutions of power acting as "factors of segregation and social hierarchization," working to ensure "relations of domination and the effects of hegemony (p. 263). These institutions of power work to create productive citizens by ensuring that young people's bodies undergo a "controlled insertion … into the machinery of production" (p. 263). Here the two institutions of power that play the most significant role in this 'controlled insertion' are the family and the school system. Bond's focus on young characters places the family and the school as foundational objects for critique, and through his plays, we witness their contribution to the disintegration of children's potential and humanness.

Bond's concept of 'the human' or 'humanness' has been usefully discussed by the drama educationalist David Davis, who argues that humanness is "the balance we must strike between our "shared welfare and [individual] happiness" (Davis, 2005, p. 92). This balance, and therefore humanness, becomes one of taking responsibility for the welfare of others, as well as of oneself. For Bond (2000a), to 'become more human' involves a search for this balance by resisting the dominant ideology where "authority replaces human responsibility and initiative with conformity" (p. 119). Davis (2005) claims that Bond has created a form of theatre that enables young audiences and performers to strike a balance between selfish individualism and community welfare and, in doing so, start to take responsibility for others and fulfill our potential; a tall, and utopic, order for theatre (pp. xvi).

Children or adolescents within their families provide Bond a metaphor through which to explore these issues, both as the helpless charges who are dependent on adults for survival and as emerging independent beings struggling to form their own identities. This is why children and their parents have been prominent in many of Bond's plays. In his work for young people these figures become more central to this 'basic message' as he explores what Davis (2005) describes as being "the effect on young people of the inhibiting and corrupting culture that Bond identifies as lurking at the heart of the modern capitalist-individualist society" (p. 10). Bond sees the 'heart' of modern society as a

vacuum created by an unjust capitalist structure. This 'nothingness' leads to frustration and ultimately to violence, a violence that is both caused by these social relationships but which also holds the potential 'solution' for a more just society (Bond, 1977, p. 12).

By presenting the young audience with everyday recognisable situations and characters, featuring adolescent characters in extreme positions where they may lose control and become less humane, the audience is positioned to question their own possible actions if placed in the same situation. Imagining yourself in a similar position and contemplating other possibilities makes Bond's theatre of the period utopian by disrupting dominant assumptions. Ricoeur (1986) states:

> Usually we are tempted to say that we cannot live in a different way from the way we presently do. The utopia though, introduces a sense of doubt that shatters the obvious (pp. 299-300).

I suggest that Bond's theatre for young people 'shatters the obvious' by inviting audiences to question what exists, and it is this questioning that allows for imaginative alternatives to be conceived. By having young central characters with whom the young audiences can identify, Bond creates what Ricoeur (1991) might describe as "understanding at and through distance" (p. 84). This 'distanciation' in the moment of performance allows for reflection, enabling the audience to consider familiar settings and contexts in the world outside of the theatre. The role of Bond's plays becomes one of both raising critical questions and finding solutions or, in his words:

> I'm interested in situations and not characters. This is because the situation is the most interesting thing about the characters. I am not interested in what one man does! I am interested in what the situation produces and so in what everyone in it does and what it does to them (Stuart, 2001a, p. 17).

This can be seen in *Olly's Prison*, written in 1990 but first performed as a BBC drama in May 1993, where in the opening scene, the audience is positioned to identify with a frustrated father figure. Throughout the scene, Mike, and the audience, become more distressed by Sheila's obstinate silence. Mike's anguish at being ignored leads him to first plead for a caring and communicative father-daughter relationship and then to an understandable frustration when Sheila still does not respond: "You work hard, try, where does it get you? You don't even know what's in their heads. I don't even know if you're listening" (Bond, 2003, pp. 4-7) until the frustration ultimately leads to anger. In this long and harrowing scene, Mike eventually loses control and strangles his only daughter.

There is an inevitability about the scene, which is both "concentrated and intense" (Bond, 2003, p. 13). In the early stages of the scene, the audience is in what Ricoeur (1984) might describe as a stage of Mimesis 1 or "prefiguration" (p. 55). The length and intensity of this scene is uncomfortable, and the discomfort caused by witnessing the murder works as a means of distanciation. During this prefiguration, the audience makes assumptions about what might happen based on previous knowledge of family relationships before the final chilling moments of the scene. In this distancing, a reflexive gap is created in which the audience is invited to consider the events and their horrific logical conclusion.

Here the audience enters Ricoeur's next stage, Mimesis 2 or "the kingdom of the as if" (Ricoeur, 1984, p. 64). In this stage, the audience members may see that their assumptions in the Mimesis$_1$ stage are justified, in that Mike does murder his daughter, but they are frustrated by the lack of a full explanation. Bond leaves a reflexive pause, or a gap in the narrative inviting the audience to fill the gap with meaning, where the playtext specifically does not give the audience answers but merely lays bare a problem (Stuart, 2001a, p. 225). Throughout the remainder of the play, Mike denies the event whilst the audience tries to find a way to make sense of the murder, but this 'sense-making' is withheld by Bond.

This is akin to Ricoeur's Mimesis 3 or 'refiguration'; the site of an "intersection of the world of the text and the world of the hearer or reader" (Ricoeur, 1984, p. 71) in which the audience members may adjust their comprehension of the real world with that of the play and thus opens up the "possibility of critique of the real" (Ricoeur, 1991, p. 292). Here the audience is exposed to a problem that is familiar to many parents and initially, they are invited to identify with Mike's frustrations.

> Mike slams his hands round Sheila's neck, lifts her straight up out of the chair and strangles her. For a moment she is too shocked to react. Then her hands go up and claw at his hands. Her body wrenches round once so that it is sideways to the table – the chair comes around with her. The shape of her body is contained in his body as if they were one piece of sculpture. The struggle is concentrated and intense – their bodies shake, vibrate, violently judder – like a magnified drop of water on the end of an icicle before it falls. Her hands claw more weakly, they seem to be patting his hands. No sound except breathing (Bond, 2003, pp. 12-13).

The 'concentrated and intense' death scene is reminiscent of the events in Scene Six of *Saved* (1964), where the baby is pinched and stoned to death over a prolonged period of time. As with his earlier play, Bond creates a need for the audience to understand how the actions intensify and in this confrontation, he invites them to ask what it would mean for each of them to lose control in a

similar manner. In doing so, Bond raises questions that challenge the status quo as the audience is forced to examine the structures of society that facilitate violent events. Ideally, such questioning may lead audiences to consider the profound changes that need to happen to the institutions of society to avoid future tragedies.

In discussing his writing for young people, Bond's emphasis is the social role of the imagination, believing that "in adult society the Imagination is controlled" (Stuart, 1998, p. 53). Whereas children are free to imagine and create a different world because they "imagine a world before they have [the] facts of real world" (p. 52). Bond believes that this stimulation of the imagination and, in turn, humanization is the role of drama and especially the role of drama for young people (pp. 6-7). By focusing events on young central characters and their family settings as they reach the cusp of adulthood and define their identities, Bond asks his audiences to engage in critical questioning of the institutions of family and education and their role in the development of young people's identities and codes of behaviour. For Bond, this move to writing for young people in order to harness their imaginations and create agents for change is not a change of focus or theme of his work. This ambition has remained constant through his work, but the question of what it is to be human has become more resolute in his later work. It is possible to see his commitment to this and his belief that young people can be the instruments of this change by examining his portrayal of childhood in his recent plays.

Troublesome and Troubling Children: *Eleven Vests* (1997a) and *The Children* (2000b)

Bond's writing places children and their development, as well as family relationships, at the centre of his work, partly because he is writing specifically for young people, but he rejects the romantic imagery of children as redemptive, and instead positions them as the possible agents for social transformation, and it is this idea of social change that is focused on young people which is at the centre of his work. *Olly's Prison* (1990), *Tuesday* (1993), *Coffee* (1995), *Eleven Vests* (1997a), and *The Children* (2000b) all have adolescents positioned at the threshold of adulthood, and each play has these adolescents facing difficult moral dilemmas.

In Bond's more recent work, he rejects the myths and the polarisation of childhood into good or bad troupes and differs from widely used mythologies surrounding children in a long-standing tradition in British art and literature (Coveney, 1957; Jenks, 1996). His young characters move between childhood and adulthood, and according to theatre scholar Helen Nicholson (2003), "far from presenting a Romantic idealisation of childhood, Bond's young characters are often troubled themselves and cause difficulties for others" (pp. 13-14). For

Bond, then, this development from childhood to adulthood is not a development between two individual and unconnected states, but a process by which the child comes to terms with the injustice of society and, through taking responsibility for itself and others, becomes more humane.

This can clearly be seen through the character of the Student in *Eleven Vests* (1997a), the events of which are based loosely on the murder of Philip Lawrence in 1997[1]. In this play, the audience watches as The Student remains silent throughout the opening scenes, just as Sheila remains silent throughout the opening of *Olly's Prison* (1990). In *Eleven Vests* (1997a), the only person to speak in the opening scene is the Head, who accuses the Student of destroying a book:

> Head: Why? D'you know why? What did you gain by it? Answer me. Do you deny it's your handiwork? Well? I didn't see you do it. No one did. I accuse you because I know none of my other pupils would do it. It has your trademark all over it. And you did it on your own. You couldn't involve anyone else. The others wouldn't be so stupid. Aren't you going to speak? (Bond, 1997a, p. 3).

The audience works to fill in the gaps created by the silent adolescent, questioning why the character is given no words of defence or justification as he is accused first of destroying a book and then the Other Student's blazer. The character's silence continues through his expulsion and ultimately through to his return and stabbing of the Head, leaving the audience to draw its own conclusions about the accusations and the character's continued silence. It is interesting to note here that even though the acts are a consequence of the Student's frustration at a world of injustice, we are given no indication of his responsibility for his supposed acts of destruction. The Heads' assumption that he is guilty because she knows he is and that he is the only one who would do it results in his exclusion from school with no consideration of circumstances or motives. Here we see Foucault's philosophy of power enacted through deduction in action. The Head evokes her power through her "right to seizure: of things, time bodies" (Foucault, 1991, p. 259). Her privileged position allows her to suppress the freedoms of the Student as she expels him, and her power acts as verbal suppression. The Head's power, in Foucauldian terms, "forms one element among others, working to incite, reinforce, control, monitor, optimize and organise the forces under it" (p. 259). In this example, a child, who does not learn the rules of behaviour designed to make good citizens, is expelled, perhaps unjustly. This, in turn, leads him to return; his only tool with which to

[1] Philip Lawrence, the headmaster of St George's Roman Catholic School was murdered defending a 13-year-old boy from an assault at the school gates on 8th December 1995.

assert his authority and outrage at the injustice of his expulsion is (silent) frustration and then violence.

The stage directions for the actual crime are short and swift, as is the playing of them: "The Student stabs the Head. The Head staggers forward" (Bond, 1997a, p. 14). The lead-up to the action is slow and deliberate, with the Student again remaining silent throughout this encounter. This scene is reminiscent of Mike's murder of his silent daughter in *Olly's Prison* (1990); The Student kills the Head and then, in a powerful symbol of defiance and ownership, he reclaims the physical ground from which he has been excluded:

> The Student goes to the gate and looks into the school yard. He stops. The children fall silent. He raises a foot – for a moment it is poised – then he brings it down inside the gate. A single cry from the children. He throws the knife into the yard. It clatters. Silence. He turns and runs down the street (Bond, 1997a, p. 15).

The stabbing results in a prison term for the Student, which enables Bond to demonstrate that prison is not the answer, as "people in prisons are disciplined but not allowed to take responsibility for themselves" (Bond, 2000a, p. 56). This lack of responsibility results in the loss of some of their humane qualities; as we shall see later, it is only by learning to take responsibility for themselves that adolescents will ultimately learn to take responsibility for each other and can become agents of change.

The Student is offered only limited opportunities for employment upon his release from prison, with Bond suggesting that the only employment open to him is the army. Within this institution The Student can be trained to be a fully functional adult whose frustration and violence can be harnessed for the 'good' of society. The scene following the Head's stabbing shows us the Student being trained as a Private in the army, where his lack of ability to wield a knife, ironically, now becomes a concern:

> Instructor: dear-o-dear. Yer disappoint me. I'ad a shufties in the CO's office. Fingered the files. Saw yourn. Was I chuffed! Criminal 'form'! Majesty's pleasure – a misnomer if she 'ad anything t' do with you. File said knife man! Used a blade when 'e was a kid! Dear God – 'ardly bigger 'n a nipper! 'E'll teach me 'ow t' do it! Yer couldn't stick a 'atpin in a quiverin jelly! (Bond, 1997a, p. 18).

The character of the Student is trained in battle tactics and is now encouraged to kill in order to protect the society that incarcerated him for violence just a few scenes before. For the audiences watching the progress of the Student, these combined experiences suggest confusion, as society first frustrates and dis-empowers the young boy and confiscates his freedom for the violence that

results from his unjust treatment and is then reprimanded for refusing to use a knife. Later it comes as no surprise to the audience when the character of the Student stabs a surrendering enemy soldier in retribution for the death of a colleague. This cycle of injustice, frustration and violence is one that Bond wishes to lay bare, and then disrupt.

When pausing to deliberate the killing of the enemy soldier the audience sees the Student "on the boundary between adulthood and childhood where humanness might be taught" (Nicholson, 2003, p. 14). Children are no different to adults in that they exist in "the state in which we all live" (Davis, 2005, p. 13). They do, however, differ in as much as for Bond their imaginations have yet to become corrupted; they are not yet conditioned to be fully 'docile bodies'. This means that they can envisage a different future, enabling them to be agents for change. In the protracted final scene, the audience sees the Student deliberating to kill or not to kill the Prisoner. The performance of the scene, like the murder of Sheila, is measured and calculated, designed to enable the audience to contemplate what their own actions might be under such duress. The Student, after struggling to attach the bayonet eventually stabs his victim as his training has taught him to do. His training takes over as he becomes an example of "the body as a machine" (Foucault, 1991, p. 261). This character demonstrates the results of conditioning, and rather than taking responsibility for his actions, he capitulates to his training and becomes less humane in the process. In this moment, the audience witnesses his crossing the border between childhood and adulthood.

The 'boundary', or this period of adolescence, is interesting to Bond because this is a time when it is most likely that our imaginations, and therefore our humanity, may be corrupted. Imagination, in this sense, is the conduit to critical reasoning that can take place within a current ideology but sees the possibility of alternatives. In this way, it is akin to Ricoeur's social imagination. Bond differs from Ricoeur by insisting that only young people have the ability to see past the dominant ideology "and seek to create the world as it is, not as market democracy wants it to be, and that is what it means to be human" (Bond, 2000a, p. 5). This is not, in Bond's view, possible for adults because "we are mostly [too] busy. We may be too busy to know who we are or what we're doing (Stuart, 1998, p. 96). In *Eleven Vests* (1997a) each scene is performed in a linear narrative structure, but there is no character development or dramatic exploration of the years that pass between each scene. Thus, the audience is left to fill in the 'gaps' in the Student's life.

In *Eleven Vests* (1997a) and Bond's other plays for young people, the characters of children are portrayed like adults in their susceptibility to corruption and are depicted as being capable of both inhumane behaviour and compassion depending on their lived experiences. Ian Stuart's edited collection

of Bond's letters and notebooks is evidence that Bond believes children become cruel or violent because that is what they are shown by adults. He states that:

> the world of the adult into which they're being inducted is so cruel, arbitrary and absurd and as a result they behave just as adults do and imitate adult crimes. (Stuart, 1998, p. 24).

In Bond's plays and theoretical writings, his view is that it is the adults who care for and teach children who are the problem and not the children themselves. Thus, Bond's plays question the institutions of the school, the family, and the military and their role in maintaining the status quo and teaching young people to accept inequality, which inevitably leads to an unjust society.

This is evident in Bond's play, *The Children* (2000b), which focuses on the character of Joe, who, in the opening scenes, is persuaded to commit a crime on behalf of his mother. In the first production of *The Children* (2000b) at Classworks Theatre of Manor Community College in Cambridge, school pupils played the children. The play centres on the character of Joe, who stands on the cusp of adulthood as he strives for independence. In Scene Two, his Mother recognises his fragility and emotionally manipulates him into committing a crime by using his position within the family against him:

> You can't always be a child. You grow up. Have to make hard choices. They can't teach you that at school. Some children inherit money from their parents – I inherited poverty from mine ... I don't ask for gratitude or recompense. But if you love me you'd do what I ask (Bond, 2000b, p. 12).

She asks him to burn down a neighbour's house. Joe's character is shown to be mature enough to know that the responsibility for the crime would be his and his alone, and he tells her, "If I do it I'm to blame" (Bond, 2000b, p. 17). The character imagines the crime, knows it is wrong, and yet is persuaded to undertake the act. In Bond's words, Joe's imagination, or sense of right, is 'corrupted' by the reasoning of an adult (Stuart, 1998, p. 96).

As in *Eleven Vests* (1997a), the Student is 'corrupted' by the army, his family, and the education system; here Joe is corrupted by his mother. Bond presents the character of Mum as also being vulnerable and damaged by society, but he focuses on the adolescent character as this is where the possibility of an alternative future sits. Joe flees after a boy dies in the resulting house fire. Joe and his friends run away together to find a new way of living, trying to take responsibility away from the corrupted adult world. On the journey to this new life, he and his friends rescue and take with them an injured Man, who paradoxically preys on the children as their journey progresses and kills all those characters that have elected to stay with Joe. The final scene shows Joe to

be the only survivor. He now carries nothing, and no one, but his declaration of adulthood: "I've got everything. I'm the last person in the world. I must find somebody" (Bond, 2000b, p. 52). This need to find somebody else is driven by Joe's need to fulfil a connection to and responsibility for others that demonstrate his new found, or re-found humanness.

Throughout the course of the play, Joe learns to be on his own. We see in the opening scene of this play Joe talking to a puppet – this puppet can be seen to personify his childhood, and the audience understands that Joe knows he must leave the puppet and his infancy behind him. At first, he is unable to abandon the toy and all it represents even though he tells both the puppet and, therefore, himself, that "you have to learn to be on your own" (Bond, 2000b, p. 6). By the end of the play, Joe leaves the puppet behind symbolising the shedding of his ties to childhood. Unlike the Student in *Eleven Vests* (1997a), by the final scene of the play, Joe has accepted responsibility for himself and others, demonstrating a humanity that is beyond the Student's capabilities. Here the audience is exposed to the idea that change is possible due to the potential of young people to take on new ideas and to change and to choose something other than what is offered to them by the adults in their lives. This, in turn, implies that human beings have the capacity to change, adapt, learn, and reject docility and find new ways and structures of living just as Joe does.

Children as Docile Bodies: *At the Inland Sea* (1997b) and *Tuesday* (1993)

Bond argues that young people have the potential to take on new ideas, to be responsible for the change, and that they should be "helped to make change more human" and therefore make the world more humane (Bond, 1997a, p. 86). For Bond, drama plays a vital role in this process as it "deals with the problems and people of this world" and "lets children come to know themselves and their world and their relation to it. That is the only way they can know who they are and accept responsibility for being themselves" (Stuart, 1998, pp. 112-113). The education system is a potential mechanism of power and control with the aim of creating 'docile bodies'.

In a potentially Foucauldian reading of the school system, Bond is on record as saying that:

> Children are going to be educated into being adroit and disciplined at taking instructions in school – and that means, in later life, orders – without the sensitivity to ask themselves if they ought to follow their orders and without the understanding of society and psychology to enable them to give a human answer (Stuart, 1998, p. 1).

The child in contemporary society has become a highly visible commodity, and children are under constant surveillance both for their own protection and

that of the future they represent. Nowhere is Foucault's metaphor of the panopticon (Foucault, 1977) more entrenched than in childhood. The world of the child is ordered to a strict timetable that governs both time and space; children, therefore, exist in a state of almost constant surveillance both in and out of the home. Every aspect of their lives is scrutinised both by professionals and parents – or parental figures – to ensure that they are cared for, but also it could be argued that they grow into productive and useful members of society.

This view is clearly reflected in Bond's *At the Inland Sea* (1997b). In this play the Boy is preparing to take his exams under the watchful eye of his mother. The results are prized as the route to entering a productive working life at a level that will ensure them both future financial security. The Mother tells the Boy:

> You don't have to worry. The teacher said you'll pass. As long as you concentrate. That's your trouble. Always staring out the window. I think you'll end up a window cleaner. No good just scraping through. You need good passes. Keep up with the high-flyers (Bond, 1997b, p. 1).

Bond's critique of the current education system is reminiscent of Foucault's disciplinary technologies. The disciplinary technologies produce docile bodies by formally moulding human beings by linking a variety of forms of power. An important part of this process is space, "the disciplinary space is always basically, cellular" (Foucault, 1977, p. 143). In schools, the space is not exactly cellular, but classes are arranged in such a way as to:

> know where and how to locate individuals, to set up useful communications, to interrupt others, to be able to at each moment to supervise the conduct of each individual, to assess it, to judge it, to calculate its qualities or merits … aimed at knowing, mastering and using (Foucault, 1977, p. 143).

"The control of activity" is achieved via the timetable and aided by hierarchical observation and judgement; the timetable is designed to "establish rhythms, impose particular occupations, regulate cycles of repetition" (Foucault, 1977, p. 149). This is often mirrored in the family home, in which children's activity is controlled by parents who also regulate cycles of repetition within the home and who encourage children to learn the required skills and knowledge in order to achieve success at school and therefore be more likely to enter the labour force so as to become productive, useful citizens.

In many ways, the classroom is a clear example of disciplinary apparatus in that it is possible "for a single gaze to see everything constantly" and where the teacher is in an optimum position (Foucault, 1977, p. 173). In *At the Inland Sea* (1997b), the character of the Mother compares her son's ability to study and, therefore, to get a good job with Mrs. Lacey's son, Ron. Throughout the play, she hovers over her son as he revises for his exams, determined that he will not be

"ending up in a dead-end job" (Bond, 1997b, p. 2). Here the school and the family can be seen to work together coercively. The school system tests and examines children with the support of the family, and these measuring devices are used to determine the 'normality' of the bodies that are observed. Thus, the school, aided by the family, could be seen like the military, creating docile bodies whereby in Bond's words: "it's preparing the mentality which makes it possible to use people as apparatuses of government" (Stuart, 1998, p. 1).

Bond illustrates this particularly poignantly in both *Eleven Vests* (1997a) and *Tuesday* (1993) where each play features an adolescent who enlists in the army, either rejecting or conforming to this role of state apparatus, having been 'ejected' from the school system. In both *Eleven Vests* and *Tuesday*, the role of the adolescent is one of exploitation. The Student in *Eleven Vests*, as I have argued, is alienated and silenced by the school system. The injustice he experiences leads to frustration and violence and then to incarceration. Although the audience does not witness the Student in prison (the cellular space), control of activity and hierarchical observation is presumably employed to re-train him into a docile body, ready for enlistment.

In *Tuesday* (1993), we see the character of Irene's father also ejected from the school system and adopted by the army and trained to kill for his country and eventually discarded by this institution with the only qualifications of how to be violent and with no legitimate target on which to use these skills. Here we see the Father as the adult version of the Student from *Eleven Vests* (1997a) – it's no surprise that these plays were written at the same time. Both of these plays examine the tragedy of wasted potential as the characters demonstrate how social structures train individuals to be exploited. Both feature characters whose failure to pass school exams leaves them with no route to employment and, therefore, no route to becoming productive citizens apart from joining the army, where they are trained to commit violent acts in the name of the state. They are trained to follow orders without question and therefore are trained to take no responsibility for their actions or themselves. The training process, as a result, strips them of their humanity, and their ability to be human is destroyed in the process. This can be seen in the description that Brian, a young army recruit, gives of the killing of a wounded enemy soldier:

> One of ours – nerves gone – goes over to theirs yelling shut it, shut it...
> Ours screaming: not words now – warning – orders – reasons – praying
> Ours: screaming with a bayonet on judgement day ... puts the bayonet
> in – in the wounded belly – and theirs arms go up as if to embrace – then
> fall back to sides ... and ours stops jabbing ... ours mutters as he wipes
> his bayonet on their jacket ... The fag still in his mouth (Bond, 1997a, p. 65).

In Brian, Bond offers the audience an example of a character who attempts to escape this future and reject his social conditioning by running away from the army to return home to his girlfriend, Irene. This act demonstrates an attempt to regain responsibility for his actions. He believes that Irene will make his world safe by offering an alternative to the restrictive and prescriptive regime, which removes his ability to make decisions for himself. Unfortunately, Irene has already accepted adult society and lost her humanity as a result of her father's conditioning. The audience witnesses the juxtaposition between the representations of these two young people, Brian and Irene, whose lives have been mapped out for them, where each child is expected to do their duty for both family and state.

Both *Tuesday* (1993) and *At the Inland Sea* (1997b) feature central characters who are young people studying for forthcoming exams and who have parents who want the academic success and opportunities for their children that they themselves were denied as this success will enable them and their parents to climb up the 'heap'. We see this clearly in *At the Inland Sea* (1997b):

> Mother: ... I worked hard for these exams. Gave you all the extras. Books. Bits and pieces for your computer. I had to do overtime. You are taking the exams for *me* – not just you. I'm going to pass. I deserve it ... I am fed up with being on the bottom of the heap. I want a bit of life for a change (Bond, 1997b, p. 5).

Bond is critical of both the families of these young characters and an education system that creates a competitive atmosphere that sets one child against another in the race for results. He argues that this prepares future generations for the capitalist society, which they will enter upon leaving education. He states that:

> the class group combines two things: groupness – be together – with individuality – pass this exam or receive this approval and show you are better than the others in the group (Stuart, 1998, p. 34).

Bond believes that education should prepare young people to take responsibility for themselves and others while "enabling children to acquire the great hunger for knowledge" (Stuart, 1998, p. 10). Bond sees the role of theatre as encouraging true democracy and citizenship by inviting audiences to imagine a more optimistic future.

Social Optimism

Bond's alternative to a highly regulated education system is to use drama to engage the imagination. He believes that theatre allows the participants to reject docility by proposing and testing solutions that encourage them to take

responsibility for themselves and their peers. This testing allows them to become the agents for future change. To invite this taking of responsibility, Bond presents his audiences with a 'gap' or a void, specifically in terms of social injustice and a lack of social responsibility. In other words, the 'gap' stimulates the audience's social imagination. Through physically playing and empathising with the central characters in his plays, the young actors face this gap and, therefore, can consider their own social responsibilities.

The use of these gaps in the narrative and structure of the plays also positions the audience members to examine their own social responsibilities. This involves exposing young people to moral dilemmas and posing 'profound questions' that:

> ... take young people back to important basic situations and enable them to question what it means to be a human being (Bond, 1997a, p. 102).

Bond poses these questions in his drama for young people but also aims to re-establish the more important question: 'how can I become more human?' This is rather than the question adults ask themselves in later life; "how can I survive my job?" (Bond, 1997a, p. 102). By asking these questions in the theatre, Bond believes that it is possible to address them in life in order to become 'more human', or more capable of behaving like "Human beings – not animals" (Bond, 1997a, p. 60).

This question of becoming more human is intrinsically part of Bond's Marxist politics. Marx's own writings on the concept of what it is to be human are inherently bound in his notion of 'species being', being part of something bigger than ourselves and needing to be in a state of "constant co-operation" (as cited in McLellan, 1977, p. 121). This 'constant co-operation' is similar to Bond's notion of social responsibility. For Marx, this development is inhibited by capitalism, which dehumanises individuals via exploitation and alienation. Marx claimed that to overcome the effects of capitalism, people have to reclaim their humanness (as cited in McLellan, 1977, p. 28). Bond takes this a step further, claiming that capitalism not only alienates but leads directly to frustration and then to subsequent violence. This also dehumanises the individual who then asserts their desires above those of others and does not take account of those the violence directly affects or the society in general. To be human in this sense is, therefore, to take responsibility for oneself *and* others. Bond's own social optimism is rooted in this Marxist ideal and his own belief that drama can provide this more 'human' quality, allowing participants to think and act as others and, through doing so, develop a sense of commitment to the species or a sense of duty to others.

Much of the weight of this responsibility is borne by Bond's Theatre Event or TE, or a time in the performance when: TE can be understood by comparing it to a whirlwind or cyclone. The centre of the cyclone is calm and quiet. In a TE the spectator stands in the still centre. It is the site of the TE. In it everything is seen with great clarity (Bond, 2000a, p. 17).

In Bond's TE, the development of the plot is suspended to allow the audience time to consider the central question being posed by the drama and imagine how they might react in the same situation. David Davis describes Bond's use of the TE as "a temporal distortion ... the integrity of the story is not broken, but crucially ... there is no 'right' way to respond ... Here, in Bond's TE, we are genuinely provoked" (Davis, 2005, pp. 37-38). Bond himself says that the "TE dramatizes the situation's meaning. It alienates within the situation by creating commitment. It may be provocative. It is not distance from situations. The point of view creates meaning" (Bond, 2000a, p. 40). For Bond, the possibility of change is found in the Theatre Events, and it is these that create social optimism in his work. In my reading of Bond's work, which I am linking to Ricoeur's concept of the social imagination, these Theatre Events make Bond's theatre a reflexive theatre in that it leaves gaps or 'temporal distortions' in which the audience may produce meaning through interpreting the signs and symbols provided by the play.

In *At the Inland Sea* (1997b), one such event, or moment of reflexivity, is centred on a cup of tea. Throughout the play, we see The Boy learn to take responsibility for history through his interactions with a Woman and her child who were murdered in the Nazi gas chambers. The Woman begs him to save her child as he witnesses the events that lead up to their deaths. As the Woman first reveals herself and asks for his help, "... the Boy starts to tremble slightly. He steadies the mug with both hands and wedges it against his chest" (Bond: 1997b, 2). When the woman approaches him, his "arm straightens," and "he holds out the cup to the Woman ... The tea starts to drip from the cup and then slowly spill" (Bond, 1997b, p. 3). For Bond, it is in these moments that the performers and the audience are "invited to create the connections" (Bond, 2000a, p. 48). Once these connections have been made, Bond believes that the meaning-makers "must take responsibility for them" (Bond, 2000a, p. 48). In other words, once understanding has taken place, social responsibility is inevitable. These Theatre Events, or reflexive interstices, enable the audience to read the situation and re-consider history in its contemporary context. For Bond, this means that the audience understands the past and individually takes responsibility for the actions that occurred historically. Clearly, this is not meant literally, but the audience is enabled to feel the weight of the lack of humanity exhibited in the past that allowed atrocities to take place.

These moments where the audience is invited to take responsibility form the basis of the optimism in Bond's work. I have previously argued that:

> Bond's work is utopic because it invites questioning, and engages the social imagination in such a way that it becomes possible to see the present from a distance and thereby consider possible alternatives (Busby, 2021, p. 133).

I believe this to be especially true of Bond's plays for young people, where it can be seen that his work is optimistic or utopic precisely because it places the child as the potential agent for change. His belief in drama's ability to release this potential in the hope of creating a "society that properly understood how to use drama" would therefore "never have need to punish anybody – child or adult" (as cited in Stuart, 1998, p. 6). Underpinning this theory is the belief that the key to our humanness and for taking responsibility for ourselves and others is the power of the imagination, which may be released through drama.

This notion of the imagination as the key to social responsibility can be seen in *At the Island Sea* (1997b). Despite the Woman's appeals for help, the Boy can save neither the mother nor the child nor change history. But through this journey into the past, he emerges from a rite of passage knowing that he must accept responsibility for the past and all its horror, and in doing so, he emerges as an adult, claiming that he is "not a child" (Bond, 1997b, p. 34). This declaration indicates the moment in which he has marked and then taken responsibility for the past. Having done so, he can now potentially take responsibility for the future. This newfound sense of responsibility can be seen in the tiny gesture contained in the last words of the play, "I made some tea" (p. 34). This brief line shows The Boy has started to put into practice his ability to take responsibility and that he has started to care for his mother rather than expecting her to care for him. In this play for young people, Bond has addressed an adult dilemma, and the audience witnesses the Boy learning more than he can in the conventional classroom. Bond explains the political implications of this play:

> The theme must not be only about (an) adolescent problem. It must concern the choices which the world confronts adolescents with. It's not a question of reminding them of morality! – but of responsibility. Transcend the classroom! – and its horizon of exams (Stuart, 2001a, p. 320).

This play, although full of violent and unsettlingly imagery, ends on an optimistic note because it implies that change is possible and thus is utopic.

Bond has always claimed that his work and outlook are optimistic, that he envisages the future as a large white sheet where anything is possible (as cited in Stuart, 2001b, p. 127). He is on record as saying that the silence at the end of

Saved is a silence filled with possibilities and that *Saved* (1964), as the title suggests, "is almost irresponsibly optimistic" (Bond, 1977, p. 309). In the final moments of this earlier play, the characters are held in an almost companionable silence. This silence is also echoed at the end of *Olly's Prison* (1990), the last line of which sounds bleak:

> Frank murdered my daughter an' your son. 'E wasn't there when it 'appened – didt 'ave t'be. 'E did – just as 'e blinded Olly. For the same reason. 'Ow can I make anyone understand that? See the connections. They can't. That's why we go on sufferin. Olly's prison. 'E'll never get out. We're all in it now (Bond, 2003, p. 71).

However, there is an optimistic note here; Frank and Ellen might not be able to make anyone else understand the connections, but they see them and have come to understand them as they lie in "the large single bed. Naked, still" (Bond, 2003, p. 71). In these moments, the audience sees that Frank and Ellen have come to the realisation that they are responsible for each other and everyone else who is in 'Olly's prison' – in other words, everyone in the species they have become 'species-beings' with a duty of care to others.

Despite its bleak conclusion, there is also optimism at the end of *The Children* (2000b). The character of Joe insists that he and his friends carry the Man through much of the play, although this slows down their progress and is literally killing them one-by-one. Joe is seen to be developing a sense of justice that drives him to take responsibility for those who cannot take responsibility for themselves, in this case, a murderer. Through this, he recognises his guilt and acknowledges it by asking for forgiveness from the victim he killed when he sets the house on fire at the behest of his mother. In doing so, he also concedes his liability for the deaths of his friends at the hands of the Man. Having accepted his culpability, he is now ready to re-enter society and work as an agent for change. In the last scene, Joe is alone, all his friends having been murdered by the man they helped. The stage directions describe Joe's isolation. "Joe come[s] on. He carries nothing" (Bond, 2000b, p. 52). Joe is alone and has nothing, but yet claims: "I've got everything. I'm the last person in the world. I must find someone" (Bond, 2000b, p. 52). Having been stripped of everything and having learnt to take responsibility for himself, he is capable of starting again and to take responsibility for others" (Bond, 2000b, p. 6). The play ends here, allowing the audience the reflexive space to envision what form that alternative social structure might take. This does not necessarily lead to action, as a critically active audience does not necessarily lead to activism, but it does lead to questions about what Joe's utopia might look like and, therefore, a troubling with the current unjust systems.

Bond's work for young people is replete with closing images of optimism. Examples include the cup of tea the boy makes his mother in *At the Inland Sea* (1997b); the Student taking the vests at the end of *Eleven Vests* (1997a); Irene's plea for life in the midst of death at the end of *Tuesday* (1993); Nold's survival and the crying child at the end of *Coffee* (1993-93); and Grig's silence at the end of the "scene of the seven howls" (Bond, 2003, p. 269). Each of these plays contains a character that is striving to become more human by taking responsibility for and caring for others. Each also has a central character for which the plot provides a rite of passage from childhood to adulthood. In *Tuesday* (1993) this role is fulfilled by Irene. At the start of the play, she is a child who seeks her father's advice when her boyfriend runs away from the army. The course of the play is her rite of passage, and she emerges as a strong independent woman who can accept responsibility of her actions (including the attempted shooting of her weak and dependent father) and can face the world alone. In the last moments of the play, she falls asleep clinging to life with the plea, "Let me live. Let me live" (Bond, 1997a, p. 79).

At the centre of *Tuesday* is the image of a child walking into the desert:

> A child is lifted from its mother – the cord stretches. It walked away. From its father – mother – us. ..It walked away from everyone. We hate and kill. It had had enough. Children have begun to walk away from human beings (Bond, 1997a, p. 62).

Here is Bond's hope for the future; children will walk away from the 'inhuman' world in which they exist, turning their back on the violence and injustice and strive to live in a different way. The image of the child alone in the desert is echoed by the toddler, who during the gun fight, "climbs down from the neighbour's arm ... crosses between the others and Brian ... chuckles and points its stubby finger at the gun" (Bond, 1997a, p. 68). It appears that the child is questioning the violence and laughing at its incongruity. Irene, herself, also resembles the image of the desert child when after shooting her father, she takes full responsibility for her action and is left alone – just as alone as the child walking into the desert and away from human beings and as alone as Joe on the side of the port at the end of *The Children* (2000b).

Bond states that the words of the two adults who perform in productions of *The Children* (2000b) should be 'performed as they are printed', however, the young people should improvise some of their words:

> [The children] perform their roles, as they are printed in Scenes One, Two, Four, Eleven and Twelve. In all other scenes they should create their own parts, guided by the situations and words given to them in the text (Bond, 2000b, p. 4).

This enables the young performers to draw on their own experiences improvising the characters' words so that the youth can consider how they might feel and what they might say given similar circumstances. In this way, it is possible to see how Bond's work may provide a rehearsal for life and promote the undertaking of responsibility. Bond believes drama will enable them to use the imaginative tools developed in rehearsal to play with alternatives and adopt a similarly imaginative approach to life outside the theatre. In using drama in this way, it becomes an educative tool through which to examine the human condition and identify it as being constituted by power-relations and the technologies of domination established through disciplining techniques and regulatory controls. Therefore, Bond's work is utopic in outlook, and it is possible to see that the central characters may become agentic in a social cognition sense. In practice, it places an overwhelming responsibility on the theatre-making process. It is a view that has, optimistically informed Bond's writing and the development of the techniques he used within all of his theatre but has been sharpened in his work for young people.

Bond rests the weight of his optimism on children, whom he sees as being the architects of transformation as they can use their imagination to see possibilities for change and to trouble social concepts. Joe, the Boy from *At the Inland Sea* (1997b), and Irene in *Tuesday* (1993) can both be seen to have rejected their family relationships and *to have* learned to 'be on their own' and, in doing so, to take responsibility not just for their actions, but those of society, both present and past. The optimistic and utopic notes that these plays end on is that when these individuals do re-join society, they will do so with this sense of responsibility and new 'humanness' intact. Nicholson (2003) has stated that "this connection between imagination and humanness turns on the belief that becoming human is an act of self-creativity; it is a process which has to be learnt" (p. 13). In *At the Inland Sea* (1997b), the Boy is visited by the Mother and her baby and travels with them into the Holocaust. Clearly, this journey takes place in his imagination which allows him to witness "The people. All ... together. Breathing. Together. Dying" (Bond, 1997b, p. 33). He then returns, no longer a child, but a man who has seen what it is to be inhuman and thus who can take responsibility for the past by envisioning a future where such atrocities cannot be allowed to happen, and hence the Boy becomes an agent for change. Bond's belief is that others who witness this rite of passage from child to responsible adult can also envisage and create a more human society.

The plays discussed in this chapter create moments of critique or distanciation through both their form and content, and this invites critiques of ideology. Therefore an alternative becomes more feasible, or at the very least, "the ability to avoid perceiving present reality as natural, necessary, or without alternative" is created (Ricoeur, 1986, p. xxx). This then opens up what Ricoeur calls the

"field of the possible" (p. 16). The field of the possible allows for the "development of new, alternative perspectives [which] defines Utopia's most basic function" (p. 16). Once it has been accepted that alternatives are possible, then starting from this knowledge offers an imaginative variation on the nature of social structures and a "chain reaction of change" can occur (p. 289).

In my reading of the plays discussed here, what ultimately is at stake in the utopic endeavours displayed to audiences is the apparent 'given of the social structures and that each play is political in that they provide the space for critical reflection on what *is* and therefore imply alternative ways of living, paving the way for what might be, or what is not *yet*. All the plays discussed here are reflexive theatre, in that they offer audiences gaps in the narratives in which they may reflect on what is and then imagine the not *yet* or what could be. And the hope is that what could be is just and equitable future in which all young people can reach their true potential.

References

Bond, E. (1977). *Plays 1*. London: Methuen.

Bond, E. (1993). *Tuesday*. London: Methuen.

Bond, E. (1997a). *Eleven Vests & Tuesday*. London: Methuen.

Bond, E. (1997b). *At the Inland Sea*. London: Methuen.

Bond, E. (2000a). *The hidden plot*. London: Methuen.

Bond, E. (2000b). *The Children*. London: Methuen.

Bond, E. (2003). *Plays 7*. London: Methuen.

Busby, S. (2021). *Applied theatre: A pedagogy of utopia*. London: Methuen.

Coveney, P. (1957). *Poor Monkey*. London: Rockcliff.

Davis, D. (2005). *Edward Bond and the dramatic child*. UK: Trentham Books.

Foucault, M. (1977). *Discipline and punish: The birth of the prison*. London: Penguin Books.

Foucault, M. (1991), Governmentality. In G. Burchell, C. Gordon & P. Miller, The *Foucault effect: Studies in governmentality* (pp. 87-104). Hemel Hempstead: Harvester Wheatsheaf.

Hutchison, D. (2016, February 9). Edward Bond: English theatre is dead. The Guardian. Retrieved from https://www.thestage.co.uk/news/edward-bond-english-theatre-is-dead

Jenks, C. (1996). *Childhood*. London: Routledge.

Koppen, U. (1997). Modern and postmodern theatres, *New Theatre Quarterly*, *13*(50), pp. 99-104.

McLellan, D. (1977). *Karl Marx: selected writings*. UK: Oxford University Press.

Mulligan, J. (1993). Interview with Edward Bond. Retrieved 26/11/2021 from https://www.jimmulligan.co.uk/interview/edward-bond-tuesday

Nicholson, H. (2003). Acting, creativity and social justice: Edward Bond's *The Children. Research in Drama Education, 8*(1), pp. 9-23.

Ricoeur, P. (1984). *Time and Narrative.* (Trans. McLaughlin K. & Pellauer D.). Chicago: University of Chicago Press.

Ricoeur, P. (1986). *Lecturers on ideology and utopia.* New York: Columbia University Press.

Ricoeur, Paul. (1991). *From text to action: essays in hermeneutics II* (Trans. Kathleen Blamey & John B. Thompson). USA: Northwestern University Press.

Stuart, I. (1998). *Edward Bond: Letters 4.* Amsterdam: Harwood Academic.

Stuart, I. (2001a). *Selections from the notebooks of Edward Bond: Volume two: 1980 to 1995.* London: Methuen.

Stuart, I. (2001b). *Edward Bond: Letters 5.* London: Routledge

Chapter 9

Transcending Vulnerability and Resilience: Bondian Female Youth in the Big Brum Plays

Susana Nicolás Román

University of Almeria, Spain

Abstract

Female protagonists and powerful secondary characters abound in Edward Bond from the beginning of his career. Yet, the metaphysical human condition Bond describes is not gender-specific. Bond's approach to the feminine universe focuses on the importance of social and historical context inscribing its figures under the term 'human' subsuming both genders without prevailing conditions. It will be argued that cultural standards, social change and the nature of individual-social relations are all significant aspects of the context for analyzing the female young characters in *Tuesday* (1993), *Chair* (2006) and *The Hungry Bowl* (2018). This chapter therefore vindicates how Bond transcends the representation of vulnerability in her female young characters by arguing active resilience. We begin by outlining vulnerability and resilience studies, focusing in particular on their connections to precarity issues. The analysis of the plays further demonstrates that vulnerable characters in extreme situations might offer opportunities for creating new forms of recognition that do not ignore the significant differences between those who experience precariousness and oppression as well. By drawing references to Butler, Cole and other authors, we especially emphasize the potential in the claims of subverting traditional assumptions as renewed awareness that may prompt responses out of fear and injustice. These female voices and their self-recognition of being inferior by class, age and gender constantly explore the characters' resilience to survive offering a panorama of responses to structural forms of vulnerability (Bright, 2016). Furthermore, the Bondian conception of vulnerability underlying the Big Brum plays means that it is always possible for resistance to be opted. By pointing at the precarious lives of these vulnerable characters, Bond intends to

mobilize empathy and action in his audience in order to make them rediscover their ethical obligations.

Keywords: Edward Bond, Tuesday, Chair, The Hungry Bowl, female, vulnerability

<div align="center">***</div>

Introduction

Female protagonists and powerful secondary characters abound in Edward Bond's plays from the beginning of his career. Yet, the metaphysical human condition Bond describes is not gender-specific. Bond's approach to the feminine universe focuses on the importance of social and historical context, inscribing its figures under the term 'human', subsuming both genders without prevailing conditions. Drawing on Butler (2004, 2012), Cole (2016), and other scholars, this study claims the relevance of Big Brum plays to examine the intersections between gendered forms of vulnerability, social precarity, and resilience. It will be argued that cultural standards, social change, and the nature of individual-social relations are all significant aspects of the context for analyzing the young female characters in *Tuesday* (1993), *Chair* (2006), and *The Hungry Bowl* (2018). These plays disturb actors and audiences alike because characters depict particular female archetypes picturing her responsibility to the vulnerable burden traditionally associated with gender, age, and class. The present chapter will suggest that far from being inconsequential portrayals of women, these powerful characters can provide audiences insight into ways in which we ourselves may understand and confront our own rationality.

Bond has always challenged the conservative sense of theatre, which, he argues, distances from the real problems of young audiences. His understanding of Theatre in Education is inextricably linked to young people's development and education for sustainable development. The fruitful collaboration of the playwright with the Big Brum Company evidences this commitment to focus on the young responses to drama. For him, educational settings should strive to foster not only educational achievement but also to help students develop into socially responsible, healthy, and civically engaged individuals. It is the intention of this chapter to acknowledge the most relevant aspects of Bond's dramatic method in consonance with the discussion of the reality of the youth in issues such as violence, family dynamics, authority, and freedom. The potential for resilience we focus on in this study demonstrates the possibility that the process of precaritization in contemporary society might produce increased recognition of shared social vulnerability and thus form the basis for new political, social, and human connection.

Vulnerability and Resilience

Vulnerability studies respond to and have been shaped by, debates in the 1980s and 1990s over oppression, identity, and agency. In the latest years, some innovations of recent scholarship explore vulnerability as an alternative language to conceptualize injustice and politicize its attendant injuries. New perspectives on the topic foster the inherent and relational – though unequally distributed – quality of all life that can serve as a strategic position for resisting the structural oppression of vulnerable subjects (Butler, 2021; Butler, Gambetti & Sabsay, 2016; Butler & Yancy, 2020). Reconceiving vulnerability as a multidimensional concept, we thus recall here Butler's (2012) distinction between ontological and situational vulnerability, that is, between the vulnerability that is a condition of life (precariousness) and the vulnerabilities that are embedded in specific structures of power (precarity). She clearly interrelates the two concepts stating that "precarity exposes our sociality, the fragile and necessary dimensions of our interdependency" (p. 148).

The present interest in vulnerability might be attributed to several factors, including the rise of precarious jobs, economic volatility, or the fear of terrorism and pandemics, among others. In a humanist sense, Brown (2012) states that vulnerability is shown to be the catalyst for courage, compassion, and connection and is "the core, the heart, the center, of meaningful human experiences" (p. 11). These humanistic bases –the medium to bring forth political change based on an ethics of care – are also materialized in Bondian plays, as the discussion of this chapter will visibilize.

In 2016, Alyson Cole offered a detailed analysis of vulnerability critique, envisioning the term not only as "a condition that limits us, but one that can enable us" (Gilson, 2014, p. 310) as well. A "proper" appreciation of vulnerability, Fineman (2012) instructs, acknowledges the "generative" side: "vulnerability presents opportunities for innovation and growth, creativity and fulfillment" (p. 126). This is the approach in which we read Bondian drama by presenting vulnerability as a potential for change, particularly in his Big Brum plays. He has extensively theorized about the transformative power of young people and the dramatizing structure of the neonate's imperative. According to Bond, the self becomes accustomed to mainstream ideology while radical innocence, though existent, remains repressed and dormant in the psyche (Chen, 2016). Consequently, the possibility of surviving the constraints of society is much more validated in young people and particularly through the activation of imagination after exposure to the drama experience.

Some scholars commit to destigmatizing the concept of victimhood associated with vulnerable groups (gender, age, social class, race, etc.) and reject the passive construct traditionally linked to the term (Bottrell, 2009;

Fineman, 2008). Butler's example of *girling the girl* demonstrates the number of practices, customs, and norms from birth through which gender identity is performed (Butler, 1990, p. 11). The subject's agency to subvert these norms is re-imagined through the resilient subject. Thus, the recognition of the self becomes a powerful site when young people might challenge the expectations and assumptions of accepted vulnerability. As Bottrell (2009) suggests, resilience within a neo-liberal framework of individualism may mean the emphasis shifts from "positive adaptation despite adversity to positive adaptation *to* adversity [emphasis in original]" (p. 334).

Adversity should be identified as a collective experience with an important role in community/social work. Individual responses could be less effective than engaging with young people's critiques and involving 'others' in the deconstruction of oppressive discourses and conditions. Other forms of regulation may provide a stronger advocacy base for resources to strengthen and support disadvantaged young people's resilience (p. 336). It is the purpose of this chapter to offer the three plays under investigation as examples of dramatized resilience showing the subversion of vulnerable attributed values.

Tuesday, Learning From War Terror and Domestic Violence

Tuesday (1993) was Edward Bond's second play for television (BBC English File Series) and his first written for young people of 14 – 17 years. The narrative thread is about a soldier, Brian, who has gone absent without permission after his tormenting experiences in a recent desert war. Armed with a gun, he seeks refuge in the house of his girlfriend, Irene. She persuades him to give her the weapon, and then, suddenly aware of the way her father has oppressed her, Irene tries to kill her father, but the gun is not loaded. Her father then telephones the police, who, thinking Brian is armed and dangerous, burst in and shoot him.

With the construction of this plot, Bond provides an opportunity to reflect upon war, responsibility, and authority from young people's perspective. In an interview with Jim Mulligan, he acknowledges that the objective of *Tuesday* (1993) was for "the students to think and feel about these images and compare them to our society" (Mulligan, 1993). For Bond and his theory of subjectivity, trauma can be a transhistorically ontological concept. In fact, extreme situations might force the subject to experience the constraining and traumatizing effects of socialization. Michael Rothberg (2014) notes that event-based trauma theories should include the perspective of structural violence and consider individual psychic effects that derive from structural victimization (pp. xiv-xv). He understands memory in a multidirectional approach that "both hides and reveals that which has been suppressed" (Rothberg, 2009, p. 14). Similarly, Bond argues that dramatic imagination is also structured traumatically in the

sense that it involves traumatic events comprising justice, truth, and madness. Most characters in Bond's production explore trauma as a potential initiator for resilience. The imaginative encounter with trauma not only enhances a subjective process of "acting out" but also prepares a hermeneutic space for "working through" (Chen, 2018). More specifically, *Tuesday* demonstrates a site where the subject undergoes explicit trauma events in a new distribution of meanings beyond traditional ideology.

The recognition of the young girl in the play explores the post-traumatic subject in a pursuit of truth that needs to be experienced subjectively. The narrative of war tragedies through her boyfriend's voice not only mirrors her subjective response but also further shapes her later responses to violence. After realizing her repression and disconnection from reality, Irene's attempt to kill her father is elucidated as the main moral problem of the play. *Tuesday* is ultimately compounded by the narrative strategies that derive from the vulnerability and resilient dealings with violence, respectively. According to Bond's theoretical structure of subjectivity, the subject will seek justice when the source of legitimizing authority is contested.

This structural process is particularly developed in Part Three of the play when the initial vulnerable nature of Irene is unexpectedly turned into aggressiveness and self-assurance. She repeatedly refuses to apologize for her attempt of shooting while the Father tries to masquerade the reality: "I can't believe it. Never. Something happened to you ... Are you trying to drive me mad? ... You're lost-you'll destroy yourself ... All you have to do is say you're sorry" (Bond, 1997, p. 74). The repressed teenager admitting submission turns into a resilient subject after a process of recognition (Butler, Gambetti & Sabsay, 2016). Moreover, she initiates her own path to maturity and understanding by being exposed to an extreme situation of violence. The introduction of these *theatre events* in Bondian philosophy will demonstrate how the actress is expected to both experience the situation emotionally and be aware of it reflectively from a distance. It is not only the psychological reaction but the meaning to be enacted through the character that is expected to reveal the truth to the audience. In the attempt to analyze Irene's change, it is appropriate to recall Butler's denunciation of stereotypical gender identity in father-daughter relationships. The Father understands education as submissive obedience: "I'm answerable to no one in this house! What I do in this place is right because I say so! (Bond, 1997, p. 53). Yet, the acknowledgment of the devastating war events provokes a new recognition of Irene's position in the world and in her domestic environment as well. Following Butler (1990), the gender performativity of the girl rejects feigned qualities that eventually contribute to the subversion of gender. As Natalie Morse, one of the actresses

performing Irene, asserts: "sometimes when you are in an unthinkable situation, you have to do something which is unthinkable" (Bond, 1997, p. 107).

At the end of Part One, Irene timidly states her growing empowerment: "Sometimes there is a little tragedy. You have to play your part" (Bond, 1997, p. 59) by drawing attention to her performative changes to identify the truth and leave vulnerability aside. Bond here considers the potential stigmatization of vulnerable subjects as powerless forms of alterity as well as a condition for the empathic engagement that emerges from visibilizing forms of vulnerability in oneself and others and the social and political responses it can activate (Butler, 2004, 2009). This Butlerian assumption correlates with Bond's advocacy for truth, particularly in young people. It is not coincidental that many of his Big Brum play deal with characters facing maturity and becoming resilient against their conditions of vulnerability by age, gender, and social/cultural status. The problematization of subjective truth, innocence, and crime persists throughout the whole play with tremendous pressure on the protagonist to the point that she experiences a sort of 'clairvoyant trance' during the chaotic scene of policemen and doctors chasing Brian. *Tuesday* (1993) particularly explores the gap between adults' and teenagers understanding of this situation. The Father urges Irene to maintain their old life together and forget war events while she has been totally transformed:

> Irene: Food in the freezer -sew the buttons- in and out-crying-shouting- yah yah yah-But I saw. For a moment. I understood. I did it ... I'm sorry people are unhappy- but it will be different then-it will change- I know- it will be mine too- they will change. (Bond, 1997, p. 77)

Her refusal to apologize aims to display a new order in the parental relationship. The end of the play is involved in a nightmarish atmosphere of constant war images and fragments of Brian's traumatic memories: "there's sand in my mouth ... scraping my gums ... the little boy's dead ... the sand scraping his little bones ... scraping the wind ... Why? Why? Why?" (Bond, 1997, p. 79). Irene strongly portrays the need for answers to all this horror against the passive acceptance of her Father. The vulnerable discourse here further reveals the potential capacity to be transformed through self-recognition and understanding of the other. In the *Dramatic Child*, the accompanying notes for *Tuesday*, Bond (1997) states that "the child seeks meaning while adults struggle to maintain the system" (p. 86), claiming that "children must be helped to make change more human" (p. 90). Young individuals can thus be subjected to meaning and extended connections.

The Father fails to reconcile with Irene and is depicted as totally helpless and abandoned, while the young girl becomes stronger and takes responsibility as a way to justify the self-preservation of living: "Let me live. Let me live" (Bond,

1997, p. 79). In her desperate call for life, Bond here dramatizes the hopes and anxieties of children and their isolation from the corrupting culture of adults. Drawing attention to the search for meaning, the play places Irene in an extreme situation to reflect on who she is and what she would like to become. Irene felt 'obligated' to raise new ethics after realizing the war crimes narrated by Brian, while the adult figure preferred to avoid the truth to maintain his life. The relationship father-daughter is ultimately depicted as sterile and dead. Bond is particularly critical of oppressive authority against young people. In fact, these dramatic narratives of abuse prompt a critical reflection on the vulnerable youth. His criticism aims at the use of physical means and crude authority to force the behaviour of teenagers instead of debating with them as equals. Recalling Butler's claims, "we can be alive or dead to the sufferings of others," but only when people are committed to the equal value of lives is there a possibility to grasp the global connections of "here" and "elsewhere" (Butler, 2012, p. 150).

The end of the play holds much promise to enact social change and transformation through youth engagement. The example of Irene might personify the *justice – oriented citizen*, a term that relates to an understanding of the processes of systemic, social, cultural, economic, and political forces and critically analyses social problems and injustices, considering collective strategies to address root problems of social ills (Westheimer & Kahne, 2004). Bond definitely advocates the extension of individual recognitions to larger community objectives. Engaging in social action thus materializes the needed empowerment of the youth to address injustices. Abandoning the passive reception of authority, Irene engages in self-reflection by focusing on the globalized wars that are normalized as distant and explicitly integrates this learning experience in a social justice framework.

Chair, the Revolutionary Act of Being Human

Chair was first broadcast on BBC Radio 4 on 7 April 2000 and was staged at the Avignon Festival on 18 July 2006, directed by Alain Françon. Set in 2077, the play explores an austere theatricality of fear and horror, envisioning a haunting Orwellian dystopia in which security supersedes freedom. Bond fictionalizes a controlling system in which the characters have internalized the entire loss of freedom and the prohibition of all the actions activated by imagination. The unfolding plot suggests that only by confronting traumatizing structural anxiety can alternative political and ethical envisioning of freedom and justice be made possible (Chen, 2018, p. 150).

The dark atmosphere significantly epitomizes the control of the army to the point of voluntary imprisonment. The beginning of the play shows Alice looking through the window while Billy draws pictures. Therefore, the poignant

contrast between reality and imagination is identified as one of the main examinations offered by *Chair* (2000). Billy is abandoned and found by Alice, the mother figure of the play, who obsessively entraps him in a childish world as protection from society and its evils. Similarly, Billy is always scared of being discovered, so he cannot go out, living secluded in a permanent state of terror. No light, closed curtains, and low voices appear as the natural setting of this inhuman future of perpetual alert. The interaction between the maternal figure and the adoptive son exhibits how the intersubjective relationship is conditioned by the external world of totalitarian control (Chen, 2018, p. 143). Billy argues: "*(crying)* Why can't I go out? I want to play in the street. You never let me do anything" (Bond, 2006, p. 114). This suffocating scenario responds on structural grounds producing terror and fear in potential dystopian settings. As a humanist, Bond views totalitarian control as a real possibility in contemporary society. Here, the playwright explores the limits of humanity through the dystopian concept of *technomachia*, an imagined systematically totalized world controlled by consumerist ideology and technological reason:

> The Technomachia is faceless. Communities will be divided. People will live in rich ghettos or prisons, both as big as cities. They will be administered efficiently. The violence needed will pass as normal. … Fighting will be formalized into execution. The consumer economy has no structural need of justice and as long as it can administer crime efficiently society has no need of humanness (Bond, 2000, p. 160).

In this totalitarian scenario, the conception of vulnerability is doubly enhanced by the mental disability of Billy and the parental abandonment he suffered. Moreover, the specific structure of external military power and extreme isolation further construct a taxonomy that intertwines inherent and situational vulnerabilities. Following Butler (2012), Billy might embody the *persecuted subject* defined by his own victimization and sense of absolute innocence. Likewise, Alice is also initially identified with vulnerability since her actions are fully determined by constant repetitions. Reframing her own recognition will reinscribe her with an insightful understanding of justice and equality after the main theatre event of the play.

The act of offering a chair to the Soldier and the Prisoner transgresses the established order as a vivid example of Bondian radical innocence in its imaginative potential activated in extreme situations. Unexpectedly, Alice will transcend her own vulnerability and turn into a rebellious empowered figure resisting a dangerous and unpredictable act of humanity. Looking at the Prisoner and the Soldier through the window, she acknowledges the repression outside and inside herself. Thus, her "generative" side presents "opportunities for innovation and growth, creativity and fulfillment" (Fineman, 2012, p. 126). For Bond, "Alice is a rebel. … So she claims there is a part of her that they will

never possess, and this is a shared humanity" (Tuaillon, 2015, p. 189). The cruel interpretation of the situation by the Soldier is totally subverted by the female figure, strengthening the impression of her understanding and awareness.

The reconceptualization of the chair into a familiar object for her renders the only possible way to reconcile this unexpected kindness with her normality. A simple object like a chair enlarges its meaning to propose symbolic interpretations for the audience. This complex imaginative process is coined by Bond as *cathexis*. This Greek term entails Freud's idea of psychological energy of a libidinal but also emotional nature, which is intensely concentrated on an object or being (Davis, 2005). In psychoanalysis, *cathexis* refers to "the fact that a certain amount of psychical energy is attached to an idea or a group of ideas, to a part of the body, to an object" (Laplanche & Pontalis, 1973, p. 62). Although Bond intentionally approaches the object psychoanalytically, *cathexis* indicates his idea of how the self can subjectively attach certain meanings to the chair. This particular object provides the opportunity for interaction between Alice and the Prisoner:

> Alice: My dear-tell me-please- (The Prisoner *grasps the chair struts. Alice tries to fondle the back of her hands.*) Put your hands through the bars-
>
> Prisoner: Uh-uh
>
> Soldier (*turns. Sees* Alice): She's kneelin with the-! Up! I cant 'ave that-no thass-. They're all there. Watchin. Be'ind their bloody winders! Witnessin the! Yer get us all shot! (Bond, 2006, p. 121).

Bond states how the chair can become a cage or even a prison with bars and how the Prisoner is devastated by emotion when she meets her daughter (Tuaillon, 2015). Restraining emotions during the entire scene aims at the unpredictable bite of the helpless woman who showed her vulnerability as a relational concept between individuals and society. Along the line of Fineman (2010), *Chair* (2000) draws the attention of the audience toward vulnerable life situations, social processes, society, and its institutions to reduce further negative consequences. Bond's imperative for freedom is posited to guard against causal determinism and authoritative control. As he states: "ideology seeks to impose the determinism and necessity of nature on us, the human imperative seeks the freedom it does not have" (Bond, 2006, pp. 221-22).

After this dramatic event, Alice will eventually emerge as a resilient figure in its transformative sense (Bottrell, 2009; Fineman, 2008). By abandoning her safe world to offer the chair to the soldier, not the prisoner, in an unexpected act of compassion, the young woman will prompt the following events in a complete destruction of the previous world. One of the main symbolic changes that the viewer perceives focuses on the drawing activity. Previously, Alice insisted on its positive effects on Billy, while now she tears and eliminates

pictures. They form part of the imaginative childish world, which has been completely devastated. Billy cannot understand this change in his mother's behaviour: "No! No! Why! You're cruel! Wicked!" (Bond, 2006, p. 125). His psychic balance and neonatal innocence ends up desensitizing the essence of the character that will ultimately follow the example of new awareness acknowledged by Alice.

The next section, the Welfare Officer's investigation, deciphers all the details of the chair incident in the atmosphere of authoritarian and repressed regimes. Her constant obsession with recording Alice's answers also entails the obligation to prove pieces of evidence to superior departments. In addressing the cultural memory of historical events like this, the empathy of the spectator and the process onstage is considered to explore the effect of cultural traces. Bond then discusses the definition and understanding of pity in this scene:

> Alice: (*flat*). I brought the chair for the soldier. She thought it was meant for her.
>
> Officer: She saw pity in you. That's why she kissed you.
>
> Alice: She bit me. ... She'd forgotten what pity was. She wasnt used to it. I was the only person who didnt hit her. She took that for a sign of kindness. It was the kindness that frightened her. She bit me (Bond, 2006, p. 136).

The inquiry actually attempts to categorize this unexpected response out of fear. The unnamed Officer states that "criminals are public enemies" and "pity for them is an insult to the law" (Bond, 2006, p. 134). For the repressive figure, it is completely unconceivable to behave outside the regulations and erroneously identify this sign as fragility. Drawing on Butler (2012), this event is emphatically local and global as well since what is happening 'there' also happens in some sense 'here' and vice versa envisioning a more global response of ethical recognition. The exhaustive analysis of emotions and sounds in this act evidences the unconscious, semantic – semiotic and structuralist ideas that obviate the hierarchy of various levels of consciousness and absolutize the function of language as an endless stream of combining cultural signs, symbols, texts, and associated meanings.

After the investigation, Alice urges Billy to escape: "Walk and see everything. There's so much for you to see. You'll have such a good time" (Bond, 2006, p. 142) and determines her suicide. As Chen (2018) points out, Alice's death like her adoption of Billy and her taking the chair for the Prisoner, seeks the space of freedom and resistance over totalitarian control. Alice's hanging body forces the cognitive assimilation of the trauma for Billy, who will end up being shot after running from home. The audience might find the ending to be a version of what Lauren Berlant (2011) has described as "cruel optimism." In this view,

neither Billy's attempt at an elusive potential change nor Alice's recognition signify attachments that can produce tangible and positive realities. Despite the tragic end, *Chair* calls for action and "becomes a symbol of defiant humanity in an oppressive society" (Billington, 2012).

Although Alice's suicide and Billy's death evidence the violence of the political order, Alice's compassionate acts and Billy's biological existence, which is defined as abnormal, also demonstrate the 'radical relationality of life' – the ethical dimension entailed in the sphere of human contact (Edkins, 2014). Bond's conception of radical innocence presumes that there exists psychic potentiality that is not completely ideologically determined. Consequently, radical innocence designates the possibility of defying the established legitimate order. This is not dissimilar to the moral imperative to be resilient and understanding of recognition depicted by the characters in the play. Determining death as the resistance to being 'controlled' turns out to be the only possible way of acting out freedom against totalitarianism. In the technocratic world portrayed in *Chair*, the responses of Alice and Billy radically subvert the traditional vulnerability associated with certain marginal groups emphasizing the possibility of distinguishing between subordination and liberation.

The Hungry Bowl, Mother – Daughter Universe

The Hungry Bowl was originally produced by Big Brum in 2012 under the title of *The Broken Bowl* and finally published in the volume *Plays: 10* in 2018. In a city towards the end of 2077, a family with unnamed members lives on rationing because of food shortage. Despite this, the Girl has an imaginary friend, and she keeps feeding him. While the Mother thinks the imaginary friend only reflects the Girl's natural psychological need, the Father cannot bear the Girl's imaginary friend, who keeps consuming their food. In the middle of the play, however, the Girl's imaginary friend appears as No One, dressed in a white jumpsuit. Later, the Father can see No One, and this shocking event makes him abandon the house with his wife to find a new life. The end of the play shows the Girl alone with No One, re-termed now as Someone.

The setting depicts a family living in extremely precarious conditions within a chaotic society approaching social and ecological breakdown. The polarization of the responses to the fearful relations in the nucleus articulates the major concerns of the play. While the Father responds aggressively, the Girl clings to the imagination as the only refuge to survive. Meanwhile, the Mother figure ambivalently supports her daughter but with loyalty to her husband at the same time. The speeches by the Girl openly suggest the hostility of the family atmosphere;

Girl: Its dangerous outside. I wont let them send you away. I couldnt live without you. I gave up all my friends for you. When I tried to tell them about you they laughed. They said I was silly. So I sent them away. They're jealous. They havent got a friend they can trust like you. They're always falling out and quarrelling. We never quarrel. You're always happy and quiet. Even my father cant upset you.[…]. We'd have lovely times together and find all sorts of things to do. When Im with you Im awake but its nice and comfy and warm like being asleep […] My mother pretends. She doesn't think you're here. She wants me to think she does but she doesn't. If she did she'd be happy like we are. Not all tense and crinkly inside. My dad's afraid of you. (Bond, 2018, p. 186).

She can sense the connection between her father's fear and the danger outside but she can only make meaning of this by feeding No One. In a recent email, Bond (2021) states that adults use imagination to escape from reality – children use it to create reality. Transcending her own vulnerability through the invented figure of the spectre, the Girl attests to her strong resilience to the precarious situation of her family and outside. Drawing from Levinasian understanding of the precariousness of life, Butler (2004) argues: "To respond to the face … means to be awake to what is precarious in another life or, rather, the precariousness of life itself" (p. 134). Yet, the condition of being awake to the precariousness of another life requires that another life should be 'recognized' as a life. Indeed, this constitutes the main use of No One/Someone in the play. For Bond, this recognition of the Other is easily understood by young people. As the Girl says: "We are in our own world … Grownups are like silly children. Always fighting because they are frightened" (Bond, 2018, pp. 183 - 194).

The Mother–daughter universe punctures ideologized preconceptions about motherhood and question our underlying assumptions. The Mother is paralysed by the fear and relies upon her husband's interpretation of events to govern her own behaviour and beliefs. Yet, other moments define her contradistinction to victimization: "If it makes her happy at a time like this, we should be grateful" (Bond, 2018, p. 185). At issue are not only matters of female vulnerability but the fraught relationship among expected behaviours, the misunderstanding of recognition, and the different strategies to overcome extreme traumatic situations. The efforts of the Mother to tie the family together establish her particular ambivalent dynamics upholding vulnerability–as–interconnectivity (Cole, 2016).

As the family reaches a crisis point, the Girl begins to offer food from her own bowl to No One, imploring him to save them. The spectral figure epitomizes here the possibility of being apprehended despite being an unrecognized being. In the attempt of survival, the young character humanizes the situation of precariousness, sharing her scarce food with her 'radical innocence' – the only transgressive action of freedom to find a new reality (Žižek, 1994). Thus,

the subject's agency to subvert norms is re-imagined through the resilient subject in Butlerian elucidation.

While the father insists on chopping up the furniture to hide it from the looters roaming the Streets, the Girl protects No One's chair, convinced that he remains the family's only hope of survival. In a theatrical *tour de force*, No One appears in the room in an idealised image in pure luminescent white (Cooper, 2018). More importantly, the (in)visibility of the imaginary friend destabilizes the norms of recognizability. At the beginning of the *Hungry Bowl*, the Father refers to No One as a 'zombie,' but later, he will be able to see it deconstructing all his previous rationality:

> Mother: (*drags* Father *away*) There's no one!
>
> Father: (*Bewildered. Turns back to look.*) But I saw it. Saw something-
>
> Mother: Imagined it! Worry-fear-so you thought you saw-
>
> Father: No-there was no one! But I saw it! Am I mad? She made me mad. Where are we? What is this-what place is this where-whose house is this-? ... (Bond, 2108, p. 203)

By making the friend appear as a living human being, Bond refutes the Girl's authority materializing her constructive sense of justice. The Mother's attitude now rejecting this recognition as 'imagination' dilutes the possibility of totally connecting the mother-daughter universe. In this critical moment of the play, Bond presents a potential imaginative Father but corrupted by fantasies of ghosts and zombies rejecting to see 'the other'. As Cooper (2018) points out, the Girl–in her active and complex character – "negotiates the boundaries of sanity in order to come out the other side as an autonomous being, leaving childhood behind and venturing into young adulthood" (p. 182). In this apocalyptic setting, Bond articulates his theory of drama and imagination through the Girl's recognition:

> We are human because we can do that. Being human is always a cultural, shared, creation ... but being a good human being depends on your imagination's ability to dramatise reality. Even this isn't enough. Drama is the most public of cultural activities because if you can enter other people's subjectivity they can enter yours. Drama is not the naked truth, in drama we become naked before the truth. ... The play is the entry into human reality (Bond, 2014).

The characters in Bondian drama generate the transformation of the self in the situations the plays explore. In opposition to Aristotle, this follows the basis of tragedy that the meaning of life is more important than life itself. For Bond, the possibility of attributing different values to reality envisions that the self is a gap that resists the totalization of value attribution and the closure of

signification. The final dichotomy/unification between No One and Someone in the play vindicates that "truth can be spoken only in falsehoods. ... The human truth is always in the process of becoming. Reality is always emergent" (Bond, 2012, p. xxxviii). Interrogations about categorical truths also contribute to visibilize the varied approaches of the characters to the extreme. In this sense, the subjectivities displayed materialize organically the bodily and psychic symptoms faced by subjects who suffer from violent dystopian situations as the play depicts.

The final picture of the play speculates about the Mother's particular resilience in going out to fetch the Father, who has fled into the street. Her dubitative ambivalent behaviour in the situation totally contrasts with the Girl's firm understanding. In a powerful image, she offers her Mother the protection of a blanket and one for her Father too. She then begins to clear up the mess of scattered bowls and cutlery and spilled and trampled food. At this point, Someone/No One arrives, "I thought you – You're like someone I knew" (Bond, 2018, p. 205).

Bond's theory of subjectivity and reality is then dramatized:

> Girl (*Touches his arm. Silence*): We have to feed the hungry don't we.
>
> Someone: Yes.
>
> Girl: And feed the poor.
>
> Someone: Yes. Something's happened in the streets. They're empty. Shall we go to see?
>
> Girl: Yes.
>
> Someone *and* Girl *go out through the door. The tin bowl is on the chair.* (Bond, 2018, p. 205).

The final gesture calls for ethics in the most extreme form of Levinas' imperative of total altruism, that one should give the food in one's mouth to others. In fact, Bond uses No One/Someone as a spectre not only to embody the Girl's psychological need for security but also to interrogate the ethics in a period of precarity. As Butler (2009) points out, any act of recognition presupposes recognizability that consists of selective norms and power operations (p. 5). *The Hungry Bowl* (2012) is a disturbing exploration of power structures through the narratives of the speakable and the unspeakable, through visibility and invisibility, reality and imagination. As Butler (2005) states:

> To tell the truth about oneself involves us in quarrels about the formation of the self and the social status of truth. Our narratives come up against an impasse when the conditions of possibility for speaking the truth cannot fully be thematized, where what we speak relies upon a formative

history, a sociality, and a corporeality that cannot easily, if at all, be reconstructed in narrative (p. 132).

In this line, the play suggests that a shared feeling of precarity, insecurity and vulnerability encourages the recognition of our social selves and invites us to respond to the 'Others' not only as an ethical issue but also as a sociopolitical one. In Bond's interpretation of the contemporary world, young people embody the potential to create a more human society by understanding themselves in relation to the world. His speech for 25th Big Brum anniversary puts forth that "drama does not prepare children to enter society; it prepares them to enter more fully into their humanness" (Bond, 2007). The Girl can thus help raise social awareness after her newly gained ontological depth of vulnerability and can foster resilience and agency in the responses of others.

Conclusions

This chapter, therefore, vindicates how Bond transcends the representation of vulnerability in her young female characters by arguing for active resilience. We begin by outlining vulnerability and resilience studies, focusing in particular on their connections to precarity issues. The analysis of the plays further demonstrates that vulnerable characters in extreme situations might offer opportunities for creating new forms of recognition that do not ignore the significant differences between those who experience precariousness and oppression as well. By drawing references to Butler (2004, 2009, 2012, 2021), Cole (2016), and other authors, we especially emphasize the potential in the claims of subverting traditional assumptions as renewed awareness that may prompt responses out of fear and injustice. These female voices and their self-recognition of being inferior by class, age, and gender constantly explore the characters' resilience to survive, offering a panorama of responses to structural forms of vulnerability (Bright, 2016). Furthermore, the Bondian conception of vulnerability underlying the Big Brum plays means that it is always possible for resistance to be opted. By pointing at the precarious lives of these vulnerable characters, Bond intends to mobilize empathy and action in his audience in order to make them rediscover their ethical obligations.

Throughout his career of fifty years, Bond has been concerned with the needs of young people and strongly supported theatre-in-education. His collaboration with Big Brum Company was built upon a shared understanding of the urgency of the current socio-economic, political, and cultural crisis and the importance of drama facing it. According to Bond, drama is our reality because it is in our psyche. And we transcend ourselves through the power of imagination, which unites the existential with the ontological (Cooper, 2018).

These texts challenge a posthumanist reconceptualization of vulnerability as the means to enable more emotionally and ideologically empathic responses to vulnerability in others. By exploring the potential of imagination through audience activation, *Tuesday, Chair,* and *The Broken Bowl* explore and communicate it in a register that is strikingly different from other contemporary plays. The three female characters imagine possibilities that might emerge by virtue of embracing radical changes and profound recognition. Irene voices the transcendence of the self over paternal authority. Alice exposes a *shared* vulnerability in her defence for a radically renewed humanism while the Girl problematizes the cohabitation with the Other through an ontological redefinition of imagination and its multiple interfaces.

Even though the plays examined in this chapter are not grounded in discernible real-life situations, they subvert traditional dystopian settings by a high degree of fictionality and reality and intricate figurations of subjectivity. The strategies that are used to evoke vulnerability are also used to suggest potential connections between people. In this sense, the plays entirely dissolve the individual in favour of a collective responsibility that resonates with the Levinasian concept of precarious Being or Being – with (the Other). No doubt, Bond confronts his audiences by extending vulnerability across the limits of the stage in a constant process of self-exposure. Interestingly, the timely urgency of Bondian drama for young audiences is also epitomized by the performance of young characters with the clear objective of experiencing their real problems. The essence of this drama challenges the understanding of inner selves and advocates for future reinterpretations that enable educational benefits for both performers and the audience.

References

Berlant, L. (2011). *Cruel optimism.* New York: Duke University Press.

Billington, M. (2012, May 15). *Chair.* Review. *The Guardian* Retrieved from https://www.theguardian.com/stage/2012/may/15/chair-theatre-review

Bond, E. (1997). *Eleven Vests and Tuesday.* London: Methuen.

Bond, E. (2000). *The hidden plot: Notes on theatre and the state.* London: Methuen.

Bond, E. (2006). *Plays: 8.* London: Methuen.

Bond, E. (2007, May). *Young civilization.* Retrieved from http://www.bigbrum. org.uk/.

Bond, E. (2012). The third crisis. In. E. Bond, *The Chair Plays* (pp. xxi-xlii). London: Methuen.

Bond, E. (2014, May 8). *Estranged new world.* Retrieved from http://www.edward bond.org.

Bond, E. (2018). *Plays: 10.* London: Methuen.

Bond, E. (2021). Email to the editor.

Bottrell, D. (2009). Understanding marginal perspectives towards a social theory of resilience. *Qualitative Social Work 8*(3), pp. 321-339.

Bright, G. (2016). The Lady is not returning!: Educational Precarity and a social hunting in the UK coalfields. *Ethnography and Education 11*(2). pp. 142–157.

Brown, B. (2012). *Daring greatly*. New York, NY: Gotham Books.

Butler, J. (1990). *Gender trouble*. London: Routledge.

Butler, J. (2004). *Precarious life: The power of mourning and violence*. London: Verso.

Butler, J. (2005). *Giving an account of oneself*. New York: Fordham University Press.

Butler, J. (2009). *Frames of war: When is life grievable?* London: Verso.

Butler, J. (2012). Precarious life, vulnerability, and the ethics of cohabitation. *Journal of Speculative Philosophy 26*(2), pp. 134-151.

Butler, J. (2021). *The force of nonviolence: An ethico-political bind*. London: Verso.

Butler, J. Gambetti, Z. & Sabsay, L. (2016). *Vulnerability in resistance*. North Carolina: Duke University Press.

Butler, J. & Yancy, G. (2020). Interview: Mourning is a political act amid the pandemic and its disparities (Republication). *Bioethical Inquiry*. https://doi.org/10.1007/s11673-020-10043-6

Chen, C. (2016). Edward Bond's dramaturgy of crisis in the chair plays: The dystopian imagination and the imagination in dystopia. *Platform 10*(2), pp. 32-50.

Chen, C. (2018). *The later Edward Bond: Subjectivity, dramaturgy, and performance* (Unpublished Doctoral Dissertation). UK: Royal Holloway.

Cole, A. (2016). All of Us are vulnerable, but some are more vulnerable than others: The political ambiguity of vulnerability studies, an ambivalent critique. *Critical Horizons 17*(2), pp. 260-277.

Cooper, C. (2018). Strong and active women in the Big Brum plays. In S. Nicolás. (Ed.), *Women in Edward Bond* (pp.151-188). Berlin: Peter Lang.

Davis, D. (Ed.). (2005). *Edward Bond and the dramatic child: Edward Bond's plays for young people*. UK: Trentham Books.

Edkins, J. (2014). Time, personhood, politics. In G. Buelens, S. Durrant & R. Eaglestone (Eds.), *The future of trauma theory: Contemporary literary and cultural criticism* (pp. 127-39). London: Routledge.

Fineman, M. (2008). The vulnerable subject: Anchoring equality in the human condition. *Emory public law research paper* no. 8–40. *Yale Journal of Law and Feminism 20*(1), pp. 1–23.

Fineman, M. (2010). The vulnerable subject and the responsive state. *Emory Public Law Research Paper* No. 10-130.

Fineman, M. (2012). 'Elderly' as vulnerable: Rethinking the Nature of individual and societal responsibility. *Emory Legal Studies Research Paper* 12-224, pp. 102-142.

Gilson, E. C. (2014). *The ethics of vulnerability: A Feminist analysis of social life and practice*. New York: Routledge.

Laplanche, J. & Pontalis J. B. (1973). *The language of psycho-analysis*. London: Hogarth Press and the Institute of Psycho-Analysis.

Mulligan, J. (1993). *Interview with Edward Bond.* Retrieved from https://www. jimmulligan.co.uk/interview/edward-bond-tuesday

Rothberg, M. (2009). *Multidirectional memory: Remembering the Holocaust in the age of decolonization.* Stanford: Stanford University Press.

Rothberg, M. (2014). Preface: beyond Tancred and Clorinda – Trauma studies for implicated subjects. In. G. Buelens, S. Durrant & R. Eaglestone (Eds.), *The future of trauma theory: Contemporary literary and cultural criticism* (pp. xi-xviii). London: Routledge.

Tuaillon, D. (2015). *Edward Bond: The playwright speaks.* London: Bloomsbury.

Westheimer, J. & Kahne, J. (2004). What kind of citizen? The politics of educating for democracy. *American Educational Research Journal 41*(2), pp. 237–269.

Žižek, S. (1994). The spectre of ideology. In S. Žižek (Ed.). *Mapping ideology* (pp. 1-33). London: Verso.

Further Reading

Lorey, I. (2015). *State of insecurity: Government of the precarious.* London: Verso.

Chapter 10

'To Be or Not To Be at Home': Humanness in the Dual World of *Tune*

Uğur Ada

Tokat Gaziosmanpasa University, Türkiye

Abstract

In his later plays, Edward Bond deals with philosophical issues, particularly in home situations, which are depicted as the household reflection of wider social, economic, cultural or political problems. He depicts home as "a boundary between the world inside and outside the self" (Bond, 2015b, p. 120). This liminality of home as a dramatic space reveals the hidden search of dreams, expectations, assumptions, etc., of common people who are mostly characterized as family members in his later plays. But these subjective narratives are interrupted by the social world outside. Within the meeting of these worlds, the underlying rationale of humanness emerges "with an action and reaction to be at home" (Bond, 2006, p. 215). Within this context, *Tune* (2007) focuses on the relationship between a worried mother and a troubled son, which reveals a daily life to reflect the universality of "normal abnormality" (Bond, 2015a, p. 132). In the play, the playwright creates a journey that begins at home and continues on the street which presents young people's constant search for justice in the world. This one-way direction of journey reveals the internal and external conflicts of young people within the destructive ideologies of adult world, and the need to find alternatives to have a right to live at home.

Keywords: Edward Bond, Bondian Drama, Tune, Young People, Home

Introduction

Considering all of the writings, from scientific research papers to newspaper articles, Edward Bond is predominantly depicted as one of the most controversial playwrights of modern British theatre. The underlying reason for this consistent statement is mainly seen as the provocative voice of his plays. As a prolific

playwright, Bond maintains his way of thinking against capitalism and its widespread effects, such as violence, social injustice, degeneration, etc., since his first play, *The Pope's Wedding* (1961). With more than 50 plays, adaptations, and translations in 62 years, the playwright has challenged pre-established rules and conservative understanding advocated by governmental institutions such as schools, theatre, etc., by means of *transcendentalism* (Bond, 2009, p. xxii).

Bond's plays, "translated into different languages ... and staged in more than sixty countries" (Ada & Parlak, 2022, p. 95), is prevailing but unilateral viewpoint of justifying his radical stance. Apart from his notable role as a playwright, he acts as a drama theorist and keeps up with sharing his views in every public sphere. The radicalism of his statements such as "English stage is dead" (as cited in Hutchinson, 2016, para. 4) can be noticed in his writings published generally as foreword or afterword to his plays and in newspaper articles, drama notes, personal letters and e-mails which are also released in his website (edwardbonddrama.org). He published papers on theatre in education and young audience in Theatre and Education Journal and SCYPT Journals and attended the conferences of SCYPT and NATD (1989, 1999, and 2004) as keynote speaker. In 2000, he conveyed his thinking on theatre, including the substantial relationship of drama with life, politics, education, and future generations, with his book, *The Hidden Plot.* According to David Davis (2005),

> His drive to tell truth and call a spade a spade has led him to be seen as a person who seeks to be merely confrontational, but this is the opposite of the truth. He confronts us with reality and we often do not like it. We fight back and then he will confront us, to challenge us to open our eyes. He will defend himself if attacked: he is not a pacifist (p. xiii).

On the other hand, Bond plays a determining role in the production of his plays. He collaborates with theatre companies based in England and abroad, attends rehearsals and workshops, and witnesses the reactions of the audience. The playwright does not delimitate his responsibilities by ensuring stage notes and stays in constant touch with actors and directors as well. He worked with Britain's most prestigious theatres, such as The Royal Court Theatre [1965 – 1975], Royal Shakespeare Company [1977 – 1985], and National Theatre [1978 – 1982]. In the 1990s, he decided to break ties with the mainstream stage because of his disappointment with the loss of creativity and social function of British national theatre companies (as cited in Hutchinson, 2016, para.4) and inclined to local or amateur theatre groups. Most remarkably, his creative partnership (1995 – 2014) with Big Brum Theatre in Education Company in West Midlands (bigbrum.org.uk, n.d.) marked the beginning of a new series of plays especially for young audiences; *At the Inland Sea (1995), Eleven Vests (1997), Have I None (2000), The Balancing Act (2003), The Under Room (2005),*

Tune (2006), A Window (2009), The Edge (2011), The Broken Bowl (2012), The Angry Roads (2014). Beyond his leading role as a playwright, he directed several workshops and open rehearsals as a co-director of the company and mostly observed the audience's reactions like a theatre critic (Big Brum TIE, 2012; 2013). Although the collaboration of this partnership brought international success for the company, which had serious financial problems (Cooper, 2013, p. 155), the demanding and tiresome nature of the process provoked a crisis in terms of their priorities and brought to an end sixteen years of unity. In this sense, Edward Bond still advocates his conflicting views, which also keeps the abovementioned argument – controversial playwright – alive:

> I left Big Brum because the company – of adults – could no longer use the texts properly. They hankered to be able to reduce them to propaganda. I think all propaganda is lies – because it seeks to change the site but doesn't change the people in it. The biological-existential join isn't exposed for what it is – and because of this propaganda becomes another form of control an eventually repression. That is the history of the last century. Stalin took the wrong turning on the corner of history. It is also a fault of Lenin and Brecht. I regret it but I can no longer call any of my plays The Big Brum plays. They need a new collective name. And both young people and adults can equally relate to them. Drama doesn't teach, even when its used in student, school, settings. It makes the audience creative. Creativity is always "what comes next?" It doesn't teach answers, it allows, enables, demands, questions. Sport isn't drama, its a source of health and co-operation and skill –but it doesn't teach humanness because the players know where the goal is. Remember Hitler's Olympics (Edward Bond, personal communication, October 10, 2021).

As an influential stakeholder of theatre with various responsibilities, Bond never leaves his plays to the mercy of the corrupted world. Calling himself an extremeophile (Billington, 2008, para. 1), he keeps dealing with controversial issues and leading the especially young audience to seek answers to authentic questions on justice, innocence, violence, society, etc. While re-describing the hidden reality of life with a constant search for hope for future generations, he "retains a stubborn faith in humanity: what he calls the contradictions of human-ness" (para. 4).

The Ontological Struggle of Human Existence in *Bondian Drama*

The later plays of Edward Bond "signal the emergence of a new ... stage and vision in his dramatic intentions, aims and craft" (Billingham, 2013, p. 102). This exceptional understanding, namely, *Bondian Drama*, re-questions the

meaning of being human against stereotyped beliefs and common social perceptions. The playwright draws upon the educational theatre's characteristics and creates a divergent perspective of social interaction to help young audiences develop a *self* within the extremity of the real world. In an attempt to reinterpret the conflicts of human situations such as justice, violence, etc. with the young audience, Bond (2016) asserts;

> ... specific questions they [*children*] are interested in not because they are minor questions ... The quality of the questions is the same. The physical consequences are very different but the motivation, the angle of revenge, is the same. That is an important point. ... What I am saying is the mind is fully human from the moment it starts working. A newborn child cannot reach a distant toy because it cannot use its hands. But suppose he could reach the object, he would laugh with joy because he had done something related to the world. If you learn the geometry of the physical world, then you learn the morality of the human world because the two go together (p. 263).

Within the context of this constant and deepening concern, Bond creates fictional worlds of the later plays in familiar settings. The playwright deals with philosophical issues, particularly in home situations, which are depicted as the household reflection of wider social, economic, cultural or political problems. In his later plays, "the kitchen table," which is an essential part of the domestic issues among characters, is oriented to "the edge of universe" (Bond, 2011a). Thus, a home which is an ordinary place for common people transformed into space with a restricted escape for the ontological narratives of humans:

> When you write a play you have to choose situations where something anomalous, out of ordinary, takes place and the consequences can be extraordinary and affect everything. But it is important that everything starts from the mundane, normal world, or what is based on it. ... One of their functions is to show everything ordinary so that the audience can identify with the world – then the play can dig into that set up to look the stresses inside normality and dramatize the reactions people have towards them, and it goes on the world becomes stranger and stranger (Bond, 2015a, p. 131-132).

In *Bondian Drama*, Edward Bond depicts home as "a boundary between the world inside and outside the self" (Bond, 2015b, p. 120). The liminality of home as a dramatic space reveals the hidden search of dreams, expectations, assumptions, etc., of common people who are mostly characterized as family members. But these subjective narratives of children or mothers, etc., are interrupted by the social world outside. The realities of society burst onto the scene through critical situations with an old woman from the past (*At the*

Inland Sea, 1995), headmaster (*Eleven Vests*, 1995-97), a new family member (*Have I None*, 2000), or intruders (*The Under Room*, 2005), etc. No matter how ignored, forbidden, hidden, delayed, or prevented by the protagonists, the in-betweenness of a house makes this conflicting dramatic process inevitable in the later plays of the playwright. Home standing on the borderland creates the adequate conditions to bind two worlds:

> We live in two worlds. Both are real. Human reality is the interaction between the two. But because we are socially mad the motive that produced innocence in the child's world, primarily the world of imagination, is the same motive that produces corruption in the other, material, world. The two worlds are not distinct. If they were there would be no problem, we could always know which world we were in. But the imagination can understand itself only in terms of the material world, and our material world exists only by depending on the imagination. We never meet ourself. We live in the gap between the two worlds and struggle to draw them closer. We are not like a blind man tapping the pavement with his white stick to find where he is in the world. Our state is stranger. It is as if the blind man tapped us to find what world he was in – and that was the only way we had of knowing what world we are in (Bond, 2000, pp. 166-167).

Bond argues that the underlying rationale of humanness emerges within the meeting of these worlds – subjective and social – "with an action and reaction to be at home" (Bond, 2006, p. 215). Within the context of *Bondian Drama*, this intrinsic need is the prerequirement of "the imperative to be human in the world" (p. 210), and this can only be achievable with the creative power or act of imagination. "Imagination is basically the desire for the world to be a home" (Allen & Handley, 2017, p. 310) in the world. It empowers us to challenge what the child owns in order to reach self-consciousness. The answers to the questions related to the world derived from the trigger of imagination. Thus, our future depends on the state of our imagination. "As being the source of the highest and lowest in humans, it can lead to both terrors of madness and the inspiration of ideas" (p. 66).

Since "imagination is the knowledge given by time that we live and die" (p. 15), the roots of this lifelong process originate in the childhood period. According to Bond, the child is not born as human. And also, they[1] cannot be referred to as primitive people or animals. Because a child does not trust in their instincts (as cited in Ada & Parlak, 2022, p. 96). Although being "adaptive

[1] Throughout the chapter, the pronoun, '*they*' and its possessive determiner, '*their*' are generally used as a generic third-person singular pronoun to refer to noun, *child*.

and contriving, instincts are just set and circumscribed responses to stimuli" (Bond, 1995, p. xix). Apart from instincts, the child needs to question life to find true explanations for various struggles in different situations. "They can attain the logic of humanness by creating themself as a thinker and doer" (Bond, 1998, p. 59). So, humanity becomes a process that needs to be experienced by the child with the guidance of imagination.

Bond (2011b) claims that "Newborn child does not know that they are in the world" (p. xiii). They have no explanation about life and any map to follow their own way in society. They only have a feeling of ubiquitous presence without any restriction of place and time. Everything is presented to the child without any meaning in the middle of "*nothingness*" (Davis, 2005, p. 211). This imposes a permanent and serious responsibility on the child. Since the child has just a right to live, they must create their consciousness and be in the world as God (Bond, 1998, p. 61). Without any influence of outsiders, they create distinctive maps, give value to things and make sense of events to survive. They are only worried about their own place in the world, and within this context, the world belongs to them. Their universal egoism is a presumption that "the infant believes that its right is that the world should be its home" (Bond, 2002).

Bond introduces this early recognition of nothingness as the initial stage of humanness. Within this closed world, the child first encounters life-sustaining things or other living creatures such as plants, animals, etc. (p. 136). But there is no meaning in this relationship with nature or life. Since there is no escape (Bond, 2011b, p. xiv), the child takes responsibility of the world. In order to be rational and intelligible, they benefit from imagination to create everything. "They are at home in the imagination and places all objects in it just as they imagine the world to be in it" (Bond, 1995, p. xv). Without any intervention, they come to terms with the world anthropomorphically. "Trees speak, chairs are tired, storms angry, winds spiteful, plates hungry and demons wait in the darks" (as cited in Chen, 2018, p. 81). These fantasies make sense to the child because they allow the child to exist in the world. The search for an explanation is a requirement for a secure place to exist in the world. In other words, the process of creating a map is the process of creating a home too. This is a lifelong responsibility for the child. Since "they cannot accept that they should not be at home" (p. 65) in the world, they will never leave the desire to create a peaceful world.

Nevertheless, the belief in the right to be at home faces an outer world when the child grows up. In this social world owned by adults, the child realizes the truths different from their own: "Trees do not speak" (Bond, 1995, p. x) in this new world. The child's imagined map created to seek justice is not in tune with the logic of the outer world. The child is no longer part of the world they used to be. They become one of the members of society which bridges the gap

between the needs of humans and what the earth offers. Society fulfills this obligation through the authoritarian ownership of adults using transcendental elements such as education, church, technology, politics, etc. The child needs a new way or maps to feel secure and be coherent again in this instrumental organization which needs to sustain its own system too. Since today's world left the rites of passage such as folk or church festivals and rituals (Bond, 1994, p. 116), the child is accepted to modern society in three ways:

> First, they learn the use and value of instrumental systems – how to instrumental ends, to make, buy, sell, own. This is mechanical, largely – or sufficiently – a matter of facts. In this way the child acquires the skills, habits, customs, vices and uses of his society ... Second, society adopts and extends the child's anthropomorphism. Land is not only earth to use but the fatherland or motherland. We must love it, its people and their ways. Anthropomorphism is usually generalized not detailed – details are too stubbornly close to facts. ... The third way in which children enter society combines the first two ways into an immediate and potent power: the family. In large part the family is the child's first world outside the monad. The family ... is not exclusively an instrumental system because it has Value (Bond, 2000, pp. 126-127).

The value of family comes from the idea that the child "interprets the cosmos domestically and the domestic [home] cosmically; for the child they are the same" (Bond, 1995, p. xxix). They believe in their parents and benefit from their knowledge while understanding the outer world, but they cannot surpass their imagination. In order to act as human, "childhood anatomy of imagination needed to be extended into adulthood" (p. xxxi). Upon learning the falsity of their previous childhood map, the child must create new meanings from outer facts and establish new relations between old values and new reality. Since they desire to preserve the right to be at home with justice, they must get accustomed to reality without avoiding imagination:

> Imagination and reality are different aspects of the same thing. We are conscious of reality but we are also self-conscious. But we could not be self-conscious without imagination. We would do things as machines can and feel things as animals can - but we would not know ourselves or have a history, politics, society, morality or theatre (Bond, 2000, p. 57).

Home as a domestic place for family members functions as a gap between imagination and reality during the transitional phase between childhood and adulthood. In this blank space between two worlds, the child meets with the contradictions of real-life issues. While the child insists on their toys to imagine the world, the family, as a reflection of social, political, and economic realities, introduces God, the devil, miracles, patriotism, nationalism, discipline, obedience,

etc. Although it is portrayed as a democratic responsibility to grow up, the child needs to abandon their own values created with radical innocence for justice (safe, peaceful home/world) to gain a place in the corrupt and violent society. According to Bond, this is a kind of survival paradox – imagination to destruction, sanity to madness, happiness or tragedy – for all living human beings:

> We look for mechanical explanations of human behaviour. But human behaviour is always paradoxical. This is because it is not derived from mechanical *whats* but from existential *whys*. ... The child believes it has a right to exist and that the world should be its home. That would make it a good child in a good world. But if the world is not its home but a bad world then the child will be bad. It will assert its right to exist by being bad – it will have an existential right to be bad, it will be its good. This will bring it into conflict with society's insistence that it is good (in its terms) and so the paradox escalates into disaster. As power increases such conflicts become endemic in our society, it is why it deteriorates. We are part of our society, and when it is unjust we are either bad or righteous and revengeful - and none of these things are just (Bond, 2000, pp. 66-67).

Unfortunately, the survival paradox has become an invariable nature of humanity since the invention of the first primitive weapons. "The *outer* world is at *endless* war with itself" (Edward Bond, personal communication, October 10, 2021). Surviving the tragedy of the First and Second World Wars, it is now on the edge of a third crisis (Bond, 2013, p. xxxix). The war between Russia and Ukraine, leaving Afghanistan to its own fate, the discourse of returning to normality after the coronavirus pandemic, the humanitarian crisis in Syria, and the riots in Iran, etc., are the prodromes of the next unexpected devastation. This is a willful destruction of normality, even in peacetime, with the help of modernity (Edward Bond, personal communication, October 10, 2021). The facts, ignored by adults for the sake of a practical life structured with ideology, religion, and economy, leave no secure place for the child to be at home on its own.

Since there is no chance to change the conserved realities of the present world, Bond emphasizes the need for good drama for a young audience. For a better future and a secure home, the rational structure of drama enables the child to deal with the complications of self and society and handle their own adulthood and social responsibilities (Edward Bond, personal communication, May 07, 2022). The child's quest for creating new meanings can only be realized through drama which bridges the blank space between children's inner world and distorted values under the rule of a certain minority. In order to sustain the sense of justice (security, peace, individuality, etc.), Bondian Drama "transforms real values into multi-faceted human narratives" (Ada & Parlak, 2022, p. 99). It

helps children to "explore the creation of a different model of dramatic interaction" (Nicolás, 2016, p. 259) – asking existential whys instead of mechanical whats (Bond, 2000, p. 66) – for the sake of the future. Thus, Bond dramatizes "a collapsing home, collapsing world" (Edward Bond, personal communication, October 10, 2021) where parents are deceived by putting young people "not at the center of present social crisis but at the foundation of continuous humanity" (Edward Bond, personal communication, September 01, 2021) in his later plays. The playwright underlines that his plays are

> ... written to take young people back to important basic situations and enable them to question what it means to be human being. Young people ask very profound questions. What is the meaning of life? What is the meaning of the world? But later on they learn to ask how can I survive my job? ... The questions tend to get narrower as people get older. But there is a way of stopping this. There is always built into human societies non-conformity or the need to question (Bond, 1997, 101-102).

The Opposing Perceptions of Home in the Dual World of *Tune*

Tune (2011c) is first staged by Big Brum Theatre in Education Company on 22 February 2007 for junior school students. With a new challenge in his playwriting career [9 – 12 years age group as a young audience] (Big Brum TIE, 2012) and limited resources of the theatre company [2 adult and young performers] (Román, 2019, p. 22), the playwright created a human situation based on the facts of everyday life in an ordinary place [a wooden kitchen table, chair, and wall] – Home. Denying the "love or fairy stories" (Nicolás, 2016, p. 262) for children, Bond focuses on the relationship between a worried mother and a troubled son, which reveals "the daily routine in a different way to expose the reality behind its ordinaries, ... a consciousness of the extraordinary that resides the mundane" (Amoiropoulos, 2013, pp. 324-325). Bond (2015a) emphasizes that the universality of this "normal abnormality" (p. 132) can easily be observed in the reactions of the audience:

> I saw a performance of it in Birmingham in front of an audience almost entirely British Asians. They were very young kids, nine and ten, very much under the influence of their parents, with teachers wearing a veil – the girls in headscarves. My play deals with London children in the world I grew up in, so I wondered how could these children understand what it is about. What could I say to them? But the kids immediately owned the play. It is basically about the relationship of trust children have their parents, so they could identify the various tensions that were shown in the play. They had no problems in relating to it. A girl got very

disturbed and had to be taken out – but after the interval she insisted on coming back and following the play through. I was told one of the characters was like someone in her own life – so it was as if the play was written for her (Bond, 2015c, pp. 49-50).

The opening scene of *Tune* (2011c) initially reveals the crisis which will intensify throughout the play. Without any detailed exposition, the play begins with a discussion of protagonists in a domestic situation – a classic dispute between an anxious mother and a son who locked himself in his bedroom. The playwright introduces the counterparts of this ongoing dispute at home as archetypical representations of wider social problems between adults and children. Within this context, Bond's dramatic method portrays the characters according to their previously defined place in society. While the social and psychological world of adult protagonists – Sally, a widowed mother, and Vernon, an unexpected visitor, and lover – is clearly visible to the young audience, Robert, a troubled teenager, is out of sight and speechless at home. The dramaturgy based on the in/visibility of the characters on stage urges young audiences to discover both the hidden realities of the adult world and the narratives desired to be shared by children, which presents the opposing perceptions of home in the worlds of adults and children. Katafiasz (2019) emphasized that "These loosened relations between social and physical realities have the effect of sending meaning into flux for their audience who have to work to integrate their auditory and visual experiences" (p. 131).

Bond uses visual experiences to conduct young audiences into the daily life realities of adult characters under the influence of the outer world at home. Sarah acts as an affectionate mother who raises her only child alone since she lost her husband a long time ago. She is being "locked out of a room in her own home for four days" (Bond, 2011c, p. 157) due to Robert's reaction against her new lover, Vernon. Robert's persistent silence cannot dissuade her from fulfilling her maternal functions. She defends her son against Vernon's intervenient attitudes and consciously acts as a sorrowful mother in a play created as a reflection of Robert's own world at home:

> Sally: … I play your games. You pretend you're starving yourself. So I make your meals and leave them on the table. I go to work and you come out to eat. I make the meals too big so you can leave some and we can both pretend you haven't eaten. 'O poor Robert's starving. My hearth's broken.' We cant even that get right in this house (Bond, 2011c, p. 161).

This play in play has to come to an end at home because Sally is "tired of coping on *her* own" (p. 161). She feels that "*her* future's in *his son's* hands" (p. 161), so she needs to reverse roles with Robert to deserve the opportunity hardly obtained at her age. "Driven by … the dominant discourse in her

community" (Katafiasz, 2019, p. 138), Sally "is looking for a man and father figure for her son" (Cooper, 2019, p. 164). With the help of Vernon, she will not be emotionally, economically, and socially vulnerable anymore. She "feels lucky to – to get an interest – any interest from a man who's not out of the door as soon as he's got what he wants" (Bond, 2011c, p. 170). This decent and popular man will enable the status she lost after her husband's death. While the promised or bought expensive gifts such as a conservatory and a mountain bike assure her better days, the shared parental responsibilities will relieve the tension at home. But Sally wishes based on the necessities of real life do not make any sense to Robert. The broken windscreen of Vernon's car and the conservatory smashed by Robert hinder "Sally's romantic idea of Vernon" (Katafiasz, 2011, p.195):

> Sally: ... You've got a grudge against him. He cant get anything right. ... I am sitting here talking to a wall. ... What I am supposed to believe? Robert I'm asking you to help me. Since your father died I've depended on you for everything. I lived for you till Verny came. That wasn't fair. I put a strain on you. A woman cant depend on a child. It's her job to protect. I'm asking you to help me – perhaps for the last time. Afterwards Verny'll be here to help both of us. ... My future's in your hands (Bond, 2011c, p. 161).

In the meantime, Bond depicts the other adult character, Vernon, as the "interloper into the home" (Cooper, 2019, p. 164). Vernon creates a conflict between mother and son for the sake of his own desires. He occupies the home with his presence, manipulative discourse, and actions against Robert. He not only "owns the visual signs and cues" (Katafiasz, 2011, p. 132) at home but also "generates the visual signs and cues of his own" (p. 132). In contrast to Sally, who is not eager to leave her son behind for social acceptance, Vernon has "cunning of a scheming man" (Cooper, 2019, p. 165) and acts with the adults' "corrupted imagination" (p. 165) by "constructing carefully verbal and visual lies" (Katafiasz, 2011, p. 131) against Sally and Robert. He wants to get everything he can in this relationship, such as the money inherited from his old husband and the home itself.

Like transcendental elements getting the lives of adults under control in the outer world, Vernon manipulates Sally by directing her attention to a violent act that is accepted as vandalism by herself – in the microcosm of the world – at home. By taking advantage of Robert's silence on the stage, Vernon accuses Robert of the broken windscreen of his own car. "Having planted the idea in our minds that Robert is delinquent" (Katafiasz, 2019, p. 132), he reflects Robert's own criminal attempt as the hatred of a teenager against his mom's compassionate care and his help. In order to take the key to the house for more oppression of the family, he pretends to take responsibility for the teenager who does not

obey the rules of home and real life instead of reporting the case to the police. "Positioning himself as a bit of a hero" (p. 132), Vernon does not even hesitate to speak on behalf of silent Robert to convince Sally:

> Vernon: I've made a bargain with Robert. He owns up he broke the windscreen. To you. Not me. He doesn't have to say sorry. I wont charge him for the replacement. Wont bully him. His age I could've done the same. It's the principle Robert. You say it so I can hear. We don't want any soft-hearted mums lying to save their boy's skin. ... you can speak like a man (Bond, 2011c, p. 160).

In addition to gender-based oppression, Vernon drives Robert to crime by creating an unfair fight. Whenever Sally is off-stage, he urges Robert to behave like a grown man but takes advantage of Robert's age. Realizing the spy hole on the wall which Robert hides behind, he demonstrates that everything is under his control as an adult experiencing the realities of the world. Vernon's verbal aggression, such as confessing that he broke his own windscreen to manipulate Sally, and what he really wants from his mum, exposes Robert to psychological abuse resulting in crisis, and smashing of the conservatory. Intentional power imbalance of this offensive affair (Kempe & Kempe, 1997) threatens the world Robert has constructed with *justice* and *innocence* (Bond, 2000, pp. 6, 65) at home. Vernon – a representation of the *wilderness* and *chaos* (pp. 15, 191) in the outer world prevailed by adults – is occupying the *coherent* and *sane* (pp. 91, 92) world at home recklessly:

> Vernon: ... She wont believe you. She'd cry and the neighbours'd laugh. No one'll believe anything you say after the windscreen. You broke it. The windscreen was your last chance to tell the truth and be believed. ... Your mum's given me the runaround long enough. Had to beg for the key! She'll pay for that. Your dad left her money. When I get my hands on it I'm off. I cant stand her voice. ... Tell her I'm a villain. Tell her what I'm saying now. Try. You're out of your league little man. Don't try to play with the big man (Bond, 2011c, p. 164).

Until Scene 4, Robert sustains his resistance behind the wall in his room. He has to struggle with the dilemmas of the outer world which is different from his own realities structured with childish needs and care. He was suddenly withdrawn into a complex social and psychological conflict created by adults in his own place. He is gradually losing "the right to be at home" (Bond, 2000, p. 64) because the social ownership of the home – apart from his room – is not maintained by him anymore. The oppressive tension at home provoked him "to take Vernon's bait – placing a glazier's glove outside the room – and smash the new conservatory in full view of the neighbors" (Katafiasz, 2019, p. 134). The collapse of the justice at home urges him "to use violence to change the world.

Unjust society is mad. It requires its members to behave in ways which it would regard as criminal and morally insane" (Bond, 2000, p. 117). Robert cannot protect his childish innocence in his mother's eyes anymore behind the wall. Facing the threats of Vernon such as reporting to the police and blaming him as a vandal in his mother's eyes, he reacts Vernon by expressing himself verbally for the first time: "Never!" (Bond, 2011c, pp. 162-163). According to Katafiasz (2019), the enraged and anxious "voice repeating the word never is like hearing a death cry in ancient Greek tragedy" (p. 134).

Like an ancient tragedy protagonist, Robert decides to face his own destiny, and the playwright "made him literarily walk through a wall when he has been hiding in his bedroom" (Edward Bond, personal communication, January 28, 2021) by using stage prop: "the back wall appears to be solid, but it is made of a malleable material such as cloth" (Bond, 2011c, p. 154). Bond materializes Robert's presence with "a figurative or iconic image" by "his moving body under a fabric" (Katafiasz, 2019, p. 134). He is on stage but still not seen by the young audience. His physical in/visibility emphasizes his declaration of "freedom and the strength" (Bond, 2015b, p. 119) he found at himself. He "reverses the meaning of wall" which can protect him and keep people out also imprison him – and "turns his weakness into strength. The point is that he feels as strong as wall" (p. 119). Though, the violent reaction of reality opposes the resistance of Robert. Vernon cuts Robert's hand with a piece of broken glass. In addition to the witness of neighbours, he is now marked with this slash as the perpetrator of the crime (Cooper, 2019, p. 165).

The image of glass, such as car windscreen, a conservatory used as "an object of destruction" by Vernon leads to an inescapable "social-human situation" (Edward Bond, personal communication, January 28, 2021) between Robert and Sally. Despite all the evidence, Robert is still hopeful of returning good old days with the help of his mother. He wants Sally to defend against Vernon by asking a lie that he did not break the conservatory. Since he pleaded guilty to a broken windscreen for his mom's sake, he begs for the same act from her this time. On the other hand, Sally "wants her son to grow up and fit in well with society. … She can cook his food and wash his wounds but … can't make the gesture of love by lying for her son: it would teach him to lie in is way when he entered society. … That would break the social code (Edward Bond, personal communication, January 28, 2021). Sally decides to be "part of the adult world, her lover Vernon's world" (Román, 2019, p. 23), which is violent and against "the son's young understanding and need for humanness" (Edward Bond, personal communication, January 28, 2021):

> Sally: Stop it! You frighten me. You've no right to keep asking me. It's not right. The devil's got into you. I cant help you. I was never like this in the

past. Those days'll never come back. I wish your father was here. You'd listen to him (Bond, 2011c, p. 169).

In the play's final scene, Robert leaves home since there is no place left for him at home anymore. He is "physically and emotionally wounded yet empowered through the ordeal to embark upon his own journey" (Billingham, 2013, p. 130). He meets a nameless girl who lives on the street because she has run away from traumatic family life, too. The girl "spreads her hands over her blanket" (Bond, 2011c, p. 172) as if it is warming her like a campfire. She believes that the colour of her blanket protects her from the cold on the street. Robert decides "to challenge his new friend in an equivalent way to that which he had tried to open his mother's eyes" (Billingham, 2013, p. 131). Bond emphasizes that Robert is aware of the difference between the blanket and the wall at home. Although he was aware of the physical lie, the wall empowered him to oppose the social decay at home (Edward Bond, personal communication, January 28, 2021). But, the girl's teeth are chattering because of fever. So, it must be the blanket that warms the girl, not the colour as it must be home that warms Robert, not the wall. In order to save a girl from "the state of disassociation" (Katafiasz, 2019, p. 137), Robert takes and folds the blanked to "force her to return to her body and notice how cold she is" (p.137). And the play ends with a journey with a wish to find a new home: "Go somewhere. Find somewhere" (Bond, 2011c, p. 176).

Conclusion

In *Tune* (2011c), Bond sets the dramatic play in two sites – home and street – because these two sites have different laws and young people should be creative in them (Edward Bond, personal communication, January 28, 2021). The journey that begins at home and continues on the street is young people's constant search for justice in the world. During the journey, "words change their meanings, crime becomes law, and violence becomes policy" (Bond, 2000, p. 5) under the supervision of adults. Since the process is a transition from childhood to adolescence, it is inevitable for children to avoid the divergence between them and society: "A world of misery opens before them" (p. 5). That's why "the play ends with Robert travelling onwards with Girl to no certain resolution or hope" (Billingham, 2013, p. 131). They have a right to live in this violent world, so they do not have any chance to return home. The one-way direction of this journey should lead to a just place where children are at home. In order to protect their humanness, Robert, Girl, and the young audience need to "extend the childhood autonomy of their imagination into adulthood" (Bond, 1995, p. xxxi) and find alternatives to use that without the destructive ideologies of the adult world.

References

Ada, U. & Parlak, E. (2022). What will it be next?": The process of 'dramatic child' in Edward Bond's *Eleven Vests. Söylem, 7*(1), 97-109.

Allen, D. & Handley, A. (2017). Being human: Edward Bond's theories of drama. Retrieved from https://czasopisma.uni.lodz.pl/textmatters/article/view/2245

Amoiropoulos, K. (2013). *Balancing gaps* (Unpublished Doctoral Dissertation). Birmingham City University, Great Britain.

Big Brum TIE (2012, December 10). Interview with Edward Bond on Tune [Video File]. Retrieved from https://www.youtube.com/watch?v=A-DrblsTkuw

Big Brum TIE (2013, May 8). The EDGE Interview [Video File]. Retrieved from https://www.youtube.com/watch?v=MQPrDzQN5Q0

Billington, M. (2008, January 3). If you're going to despair, stop writing. The Guardian. Retrieved from www.theguardian.com

Billingham, P. (2013). *Edward Bond: A critical study*. Great Britain: Palgrave Macmillan.

Bond, E. (1995). Notes on imagination. In. E. Bond, *Coffee* 1st ed., pp. vi-xxxv). London: Methuen.

Bond, E. (1997). *Eleven vests & tuesday*. London: Methuen Drama.

Bond, E. (1998). *Letters 4*. Amsterdam: Harwood Academic Publishers.

Bond, E. (2000). *The hidden plot: Notes on theatre and the state*. London: Methuen.

Bond, E. (2002). The Quality of Children's Theatre. Keynote speech at Children's Theatre Seminar, Birmingham, 9 July 2002. Retrieved from www.artscouncil.org.uk

Bond, E. (2006). Freedom and drama In. E. Bond, *Plays 8* (1st ed., pp. 205-222). London: Methuen Drama.

Bond, E. (2009). *Saved*. London: Bloomsbury.

Bond, E. (2011a). 'Notebook Extract – 06-12-11 – Drama and Reality'. Retrieved from http://www.edwardbond.org/Notebook/notebook.html

Bond, E. (2011b). Jesus and Hitler swept. In E. Bond, *Plays 9* (1st ed., *pp*. ix-xxvi). London: Methuen Drama.

Bond, E. (2011c). Tune. In E. Bond, *Plays 9* (1st ed., *pp*. 150-176). London: Methuen Drama.

Bond, E. (2013). *The chair plays*. UK: Bloomsbury Publishing

Bond, E. (2015a). The kitchen table and the edge of the universe. In D. Tuaillon, *Edward Bond: The playwright speaks* (1st ed., pp. 131-154). London: Bloomsbury.

Bond, E. (2015b). Objects are people. In D. Tuaillon, *Edward Bond: The playwright speaks* (1st ed., pp. 111-130). London: Bloomsbury.

Bond, E. (2015c). Language is an octopus with a million leges. In D. Tuaillon, *Edward Bond: The playwright speaks* (1st ed., *pp*. 40-70). London: Bloomsbury.

Bond, E. (2016). Interview. In S. Nicolás, The trigger of the truth is in your hands: Conversation with Edward Bond. *Contemporary Theatre Review, 26*(2), 258-266.

Bond, E. (Oct 10, 2021). Personal communication - Email to Uğur ADA.

Bond, E. (Sept 01, 2021). Personal communication - Email to Uğur ADA.

Bond, E. (May 07, 2022). Personal communication - Email to Uğur ADA.

Bond, E. (Jan 28, 2022). Personal communication - Email to Uğur ADA.

Chen, C. (2018). *The later Edward Bond: Subjectivity, dramaturgy, and performance,* (Unpublished doctoral dissertation). Department of Drama, Theatre & Dance. London: Royal Holloway.

Cooper, C. (2013). Tell me a story: Interview with Chris Cooper. In P. Billingham (Ed.), *Edward Bond: A critical study* (1st ed., pp. 155-166). Great Britain: Palgrave Macmillan.

Cooper, C. (2019). Strong and active women in the Big Brum plays. In S. N. Román (Ed.), *Women in Edward Bond* (1st ed., pp. 151-188). Berlin: Peter Lang.

Davis, D. (2005). *Edward Bond and dramatic child.* London: Trentham Books.

Hutchinson, D. (2016, February 9). Edward Bond: English stage is dead. Retrieved from www.thestage.co.uk

Katafiasz, K. (2011). *Drama and desire: Edward Bond and Jacques Lacan* (Unpublished Doctoral Dissertation). University of Reading, Great Britain.

Katafiasz, K. (2019). Castrated Ladies: Bond's Mirthless Mothers. In S. N. Román (Ed.), *Women in Edward Bond* (1st ed., pp. 129-151). Berlin: Peter Lang.

Kempe, R. S. & Kempe, C. H. (1997). *Child abuse.* Cambridge: Harvard University Press.

Nicolás, S. (2016). The trigger of the truth is in your hands: Conversation with Edward Bond. *Contemporary Theatre Review, 26*(2), 258-266.

Román, S. N. (2019). My female characters. In S. N. Román, *Women in Edward Bond* (*pp.* 13-24). Germany: Peter Lang.

Further Reading

edwardbonddrama.org

Index

philosophical, 13, 92
Plato, 94
play text, xi
playwright, xi, 1, 20, 38, 56, 60, 74
political, xii, xiv, xviii, 38, 60, 61, 74, 135, 151, 155
post-war British theatre, 38
power, xii, xviii, 2, 8, 10, 11, 14, 19, 38, 43, 51, 54, 55, 62, 70, 74, 93, 134, 135, 136, 137, 141, 145, 146, 151, 154
practitioner, 3
prison, 142, 147, 152, 155
problem, xvii, 39, 42, 43, 45, 49, 54, 55, 56, 64, 90, 134, 145
problematic, 9, 39, 45, 48, 67
process, xii, 1, 4, 5, 7, 9, 13, 15, 16, 18, 40, 41, 42, 47, 50, 54, 61, 64, 141, 143, 145, 146, 147, 154
progressive, 3
promote, 3, 5, 154
provocative, 38, 74, 150
proximal, 5
psyche, 4, 37, 39, 44
psychic, 9, 10
psychological, 10, 11, 20
public, xii, 2, 42, 55

Q

quest, 16, 54
question, 6, 10, 14, 15, 16, 45, 50, 53, 56, 60, 74, 135, 136, 138, 140, 144, 147, 149, 150, 151

R

radical, 4, 12, 41, 42, 53, 54, 60, 68, 91
radicalism, 60
recognizability, 11
reflection, xiv, 45, 70, 135, 138, 155

reform, 3
relationship, 3, 5, 9, 15, 16, 42, 44, 45, 46, 47, 48, 49, 52, 53, 55, 56, 65, 138
responsibility, xvii, xviii, 2, 13, 17, 18, 38, 39, 40, 44, 51, 67, 68, 69, 135, 136, 137, 141, 142, 143, 144, 145, 147, 148, 149, 150, 151, 152, 153, 154
Restoration, 38, 60
rhetoric, 54
rhythms, 40, 146
Ricoeur, 15, 139, 143, 150
Royal Court, xii, 38
Royal Court Theatre, xii, 38

S

sanity, 2, 81
Saved, xi, xii, 38, 60, 134, 139, 152
school, xiii, 2, 39, 137, 141, 142, 144, 145, 146, 147
self, xviii, 3, 4, 5, 9, 14, 15, 16, 17, 18, 19, 40, 44, 48, 49, 50, 52, 53, 54, 55, 56, 70, 91, 94, 136, 154
Seneca, 76, 94
Shakespeare, viii, xii, 61, 74, 93
shocking, 38, 52
silence, xii, xiii, 17, 45, 47, 49, 50, 55, 56, 66, 138, 141, 151, 153
situation, xviii, 3, 12, 16, 47, 48, 49, 51, 52, 53, 54, 55, 56, 60, 136, 138, 150
society, vii, xvii, xviii, 2, 12, 13, 20, 38, 39, 40, 42, 43, 44, 45, 50, 51, 55, 60, 74, 90, 135, 136, 137, 140, 141, 142, 144, 145, 148, 149, 151, 152, 154
sociocultural, 5
soldier, xii, 6, 7
specific, 4, 12, 18, 41

Milton Keynes UK
Ingram Content Group UK Ltd.
UKHW050245230324
439834UK00013B/441